THE US GIANT MONSTER MOVIE

THE US GIANT MONSTER MOVIE

Size Does Matter

DAVID SIMMONS

LIVERPOOL UNIVERSITY PRESS

First published 2024 by
Liverpool University Press
4 Cambridge Street
Liverpool
L69 7ZU

Copyright © 2024 David Simmons

David Simmons has asserted the right to be identified as the author
of this book in accordance with the Copyright, Designs and Patents
Act 1988.

All rights reserved. No part of this book may be reproduced, stored
in a retrieval system, or transmitted, in any form or by any means,
electronic, mechanical, photocopying, recording, or otherwise, without
the prior written permission of the publisher.

British Library Cataloguing-in-Publication data
A British Library CIP record is available

ISBN 978-1-83553-737-4 cased

Typeset by Carnegie Book Production, Lancaster
Printed and bound by CPI Group (UK) Ltd, Croydon CR0 4YY

Contents

Acknowledgements ix

Introduction 1

1 "The Whole World Will Pay to See This!": The *Kong* Cycle and the Origins of the US Giant Monster Movie 25

2 Atomic Terror! Big Bug Movies and the 1950s' Giant Monster Movie Boom 53

3 Nature Attacks: Politicising the Giant Monster Movie During the 1970s and 1980s 77

4 65 Million Years in the Making: *Jurassic Park* and the Rise of CGI in the US Giant Monster Movie 105

5 Remakes, Reboots and Shared Universes: The US Giant Monster Movie in the Contemporary Era 129

Conclusion 155

Works Cited 163

Index 177

Figures

0.1 A giant spider perches threateningly atop the US Bank Tower. 9
0.2 King Kong gazes in wonder at the Hollow Earth's sky. 18
1.1 Reverse shot of Professor Challenger and a travelling companion looking in awe at a brontosaurus [off-screen]. 29
1.2 The beast from 20,000 fathoms attacks a rollercoaster. 51
2.1 The giant tarantula's face peers menacingly into the window of Deemer's isolated house. 61
2.2 Close-up of an unconvincing *papier-mâché* crab monster. 74
3.1 Giant ducks dancing alongside teenagers to the Beatle-esque music of The Beau Brummels. 79
4.1 Drs Alan Grant and Ellie Sattler gaze in wonder at herds of dinosaurs in *Jurassic Park*. 108
5.1 The detached head of the Statue of Liberty comes to rest on the streets of Brooklyn. 137
5.2 Two scantily clad cheerleaders fight in the middle of a sports stadium as the crowds gaze on. 142

Acknowledgements

The road to publication is often a long one, involving numerous individuals who play an integral part in bringing a work towards completion. I have done my best here to highlight those I can remember but, to everyone involved, know that I am grateful.

Thanks first to John Atkinson, who contracted *The US Giant Monster Movie: Size Does Matter* at Auteur Publishing. A series of changes at various publishers meant that for a while it seemed as though this book might never get through what proved to be an especially difficult gestation period. Without John's foresight and belief in the project this book might well not exist, so thank you. Thanks also to the editorial team at Liverpool University Press, including specifically Ally Lee, Sarah Davison, and the peer reviewers whose constructive feedback and comments made this book much stronger than it otherwise would have been.

I am immensely fortunate to work alongside a group of excellent colleagues in the Film and Screen Studies department at the University of Northampton. Michael, Lorna, Abigail, Anthony, and Rhiannon, many thanks for the efforts you put in daily combating the monsters that come with working in higher education; you're the best team anyone could wish to be a part of. My gratitude also goes to the Centre for Cultural and Literary Studies at the University of Northampton for their financial help in procuring the book's cover image.

Finally, thanks to those people who have helped me over the course of this book's development; either directly by providing feedback or suggestions for revisions, or indirectly just by being there when things got tough: Nicola and Steinbeck, thanks for the memories, I will keep them with me, Richard and Lisa, thanks for your ongoing friendship, Rod, Drew and Caroline, thanks for being there. I am grateful to Becky for her love and support, to Stephen for his constant willingness to discuss 1960s and 1970s cinema, to Ginny (go *The Meg 2*!), and to Darby

for always being excited to see me. Lastly, I reserve a special thank you to my parents for their ongoing love, and to my brothers Brian and Paul, with whom I first watched many of the films that are central to this book.

Introduction

This book aims to provide a critical account of the US giant monster movie, charting the chronological development of the form; the thematic concerns of the (sub)genre; and the reasons for its continuing popular success. In their pioneering work on the giant monster or *kaiju* movie, scholars Camille D. G. Mustachio and Jason Barr note that "[e]ven though the *kaiju* film has yet to gain much critical acceptance in the world, the very concept of a *kaiju* has become an intrinsic part of both American and Japanese pop culture" (2). Mustachio and Barr go on to claim that the *kaiju* label "seems to be extraordinarily inclusive of any number of cinematic creations" (4), specifying that those films and figures that we associate most closely with the genre (*Godzilla* (1954), *King Kong* (1933)) should more accurately be termed *"daikaiju"* (4) to signify the combined concepts of strangeness *and* largeness. It is with the examples that embody this point of synthesis that I am interested in this study. My own approach is one of inclusivity, designed to capture both those examples that are indelibly associated with the idea of the giant monster – *King Kong, Them!* (1954) – and films in which we find only slightly enlarged creatures that (even so) have had a decisive influence on the development of the genre (such as *Jaws* (1975)). More specifically, given that extant work (including Mustachio and Barr's work and William Tsutsui *Godzilla On My Mind*, 2004) seems to focus on south-east Asian instances of the *daikaiju*, including their influence on US popular culture, this book instead seeks to examine the long and interesting history of giant monster movies of US origin.

Given the USA's long-held "taste for the monstrous in all its forms" (Poole 4), coupled with its love for "the colossal, the exaggerated and the brash" (Tsutsui 166) it is not surprising that the giant monster movie has been a key genre in Hollywood film making as far back as the 1920s

and 1930s with Harry O'Hoyt's ground-breaking *The Lost World* (1925),[1] and Merian C. Cooper and Ernest B. Schoedsack's hugely influential *King Kong*. In fact, as critics including Ken Hollings and Cynthia Erb have pointed out,[2] it is Cooper and Schoedsack's film that originates the genre, laying a template that is later emulated by a host of international film makers hoping to capitalise on *King Kong*'s runaway success (the Japanese Toho Studio foremost among them). The popular success of the US giant monster movie continued throughout the twentieth century, including the 1950s, when many film makers explored nuclear era anxieties in examples such as *The Beast from 20,000 Fathoms* (1953) and *Them!* The advent of the blockbuster era in the 1970s and 1980s, with its growing reliance on high-concept properties, brought with it big-budget monster movies such as *Jaws* and *King Kong* (1976), alongside lower-budgeted examples including *Alligator* (1980) and *Q: The Winged Serpent* (1982); both sets of films demonstrating an increasing familiarity with tropes and conventions and a willingness to self-reflexively refer back to older instances of the form; a trend in the genre that would only expand as time went on. As the end of the century approached the arrival of computer-generated imagery (CGI) saw the US giant monster movie undergo a rebirth of sorts as Hollywood studios (re)focused on creating ever more spectacular images on screen, with films including *Jurassic Park* (1993) and *Cloverfield* (2008) pushing the boundaries of what it was possible to depict on screen. Significantly, in an age in which "almost any imagery [can now be] realized on screen" (King 2006, 338), examples of the giant monster movie still experience immense popular success, with Legendary Pictures' *Godzilla vs Kong* (2021) breaking viewing figures for a film released during the coronavirus pandemic, at the time of writing.[3]

[1] While I appreciate Jason Barr's proposal that dinosaurs do not count as *kaiju* because they "actually existed and are not unnatural" (4) I do intend to include them in this study. This is because, in a US context, films featuring dinosaurs have had a substantial influence on the wider giant monster movie genre, both on the genre's ongoing popularity and on the way it has developed. Most obviously, there may well not have been a *King Kong* without the previous success of *The Lost World*, and the box office figures for *Jurassic Park* demonstrated the financial potential of computer-generated imagery (CGI) for realising monsters on screen in the 1990s and beyond.

[2] Erb, Cynthia. *Tracking King Kong: A Hollywood Icon in World Culture*. 2nd edn. Detroit, MI: Wayne State University Press, 2009. Hollings, Ken. "Gojira Mon Amour" in *Science Fiction/Horror: A Sight and Sound Reader*. Ed. Kim Newman. London: BFI Publishing, 2002. 138–144.

[3] Komoi.com Team. "*Godzilla vs Kong* Box Office Update: Monster Saga Doubles Its Investment to Become a Huge Success". 16 May 2021.

Nevertheless, despite this long-standing popular success, until recently the genre had been largely neglected by critics. Extant work, including Cynthia Erb's *Tracking King Kong* (1998) and Paul Bullock's volume in the Constellations series on *Jurassic Park* (2020), tends to examine specific, iconic films; or explores specific subgenres such as Katarina Gregorsdötter, Johan Hoglund, and Nicklas Hållén's *Animal Horror Cinema: Genre, History, and Criticism* (2015), and Liam Hathaway's unpublished thesis "Monsters by the Millions: An Eco-Cultural History of the Killer Bug Film" (2021). There is, however, very little work that considers the US giant monster movie comprehensively, as a continuous genre. One of the reasons for this negligence may be because of what Mustachio and Barr see as the often "campy" or "cheesy" nature of the films themselves" (2). The perception seems to be that, because many giant monster movies do not take themselves seriously, they are not worthy of serious scholarly attention. Interestingly, this viewpoint has led some "critics to divorce [such] films [...] from the rest of the genre" (Barr quoted in Mustachio and Barr 4), resulting in a dubious process wherein the supposedly worthwhile instances of the genre are differentiated from those that do not deserve sustained discussion. Yet, as Simon Dentith urges, we should remember that "parody can serve [...] as criticism" (32), by "reordering the elements in the system" (33), leading to a process of productive renewal as conventions are foregrounded and then (re-)evaluated. My approach is not to exclude films on the basis that they take a comedic approach to their subject matter; instead, this study suggests that humour is often an integral part of the genre. Films such as *Attack of the 50 Foot Woman* (1958), *Eight Legged Freaks* (2002), *Mega Shark versus Crocosaurus* (2010), *Big Ass Spider!* (2013), and *Notzilla* (2020) speak to a recurrent emphasis on parodic excess. Consequently, I use ideas derived from the work of Mikhail Bakhtin to productively explore the multiple ways in which the US giant monster movie offers subversive pleasures tied to the depiction of the monster challenging established hierarchical structures.

At first glance, the work of a twentieth-century Russian literary theorist might seem to have little direct relevance to a supposedly lowbrow form such as the US giant monster movie, but Bakhtin's ideas have been fruitfully applied to the study of popular cinema in a number of surprising ways. Central to my own framework in examining the US giant monster movie will be his concept of the carnivalesque. In *Rabelais and His World* (1965; 1984) Bakhtin examines the writing of the French

Available at: https://comicbook.com/anime/news/godzilla-vs-kong-box-office-100-million-goal-update/

Renaissance writer François Rabelais and his depiction/s of the medieval carnival as a subversive occasion when normative societal conventions were temporarily overturned:

> carnival celebrated temporary liberation from the prevailing truth and from the established order; it marked the suspension of all hierarchical rank, privileges, norms and prohibitions. Carnival was the true feast of time, the feast of becoming, change, and renewal. It was hostile to all that was immortalized and completed. (Bakhtin 7)

One of the implications of Bakhtin's work is that in providing a release from the restrictive rules and regulations of normal life the carnival enabled a subsequent questioning of our complacencies and a highlighting of the constrictions that we live under outside the carnival space. In this manner the carnival, and the "culture of comedy" it involves (10), can be viewed as a force for renewal; encouraging us to laugh at, and in the process, recognise, the inadequacies of the present hegemony and its systems.

Crucially for the purposes of this study, while Bakhtin suggests that the subversive spirit of the carnival was largely eliminated from real carnival celebrations by the end of the Renaissance, during the eighteenth century this spirit was gradually assimilated, albeit in a less radical form, into art and literature: "the contents of the carnival-grotesque element, its artistic, heuristic, and unifying forces were preserved in all essential manifestations in the [...] *commedia dell'arte*" (Bakhtin 34). Working from this belief that art can contain a sense of the carnivalesque, scholars including Robert Stam (1989), Barbara Creed (1995), Xavier Mendik and Steven J. Schneider (2002), and Ernest Mathijs and Jamie Sexton (2011), have persuasively argued that cinema can offer a sense of the carnivalesque. In *Subversive Pleasures: Bakhtin, Cultural Criticism and Film* (1989), Stam suggests that "[t]he category of carnival, defined in Bakhtinian terms [...] has broad relevance for cinematic expression, potentially applying to a wide gamut of film texts" (110). His suggestion is founded on his belief that there is a long-standing association between American cinema and the carnival-like spaces of the fairground and the theme park:

> The link [...] is both metonymic and metaphoric: metonymic in that Cinema grew up, as it were, in the shadow of the side show, as an entertainment quite literally situated near the fairground and the penny arcade; and metaphoric in the sense that countless films cite the regressive pleasures of commercial carnivals – roller

coasters, carousels, Ferris wheels – to analogize those of the cinema itself. (113)

These metaphoric citations might include the exhibition of Kong as a Broadway attraction by Carl Denham in *King Kong* and the rhedosaurus' coming ashore at the Coney Island Amusement Park in *The Beast from 20,000 Fathoms*, to name but two examples that are specific to the giant monster movie. Indeed, as explored in much more depth in Chapter 5, the US giant monster movie is a particularly self-reflexive genre, frequently commenting upon the spectacle-making process in its diegesis. *King Kong*'s "self-reflexive dynamic" (Erb 64) instilled the genre with an often-inward-looking focus that seems strangely at odds with classical Hollywood cinema's emphasis upon a storytelling style of 'invisible' continuity.

While Stam focuses on comedic films, such as those produced by the British Monty Python troupe and the US director Mel Brooks, much of the existing work applying Bakhtin's theories to film has clustered around the horror genre. My own application of Bakhtin's ideas of the carnival to the giant monster movie is indebted to the work of Barabara Creed and her "Horror and the Carnivalesque: The Body Monstrous". In this essay Creed utilises Bakhtin's theories to "argue that Horror cinema constitutes an arena into which carnival practices have been displaced" (131); in particular, she suggests that the horror genre embodies a distinctly carnivalesque "populist critique of high culture" (130). The influence of Creed's reading can be seen throughout much of the scholarly work on the horror film that follows. For instance, in her overview of the genre, *Horror Fiction*, Gina Wisker states that horror as carnival provides an ideological space in which "the mechanics of an ordered society are allowed to be questioned and the complacencies destabilised" (160), while Mendik and Schneider apply Bakhtin's ideas to the gross-out cinema produced by the low-budget film studio Troma, concluding that its "marginalised but militant cultural formations ensure the continuation today of a genuine carnival spirit" (209). Though there are some significant differences (and points of convergence) between the horror film and the giant monster movie, Bakhtin's theory (by way of Creed's interpretation) seems a useful tool for discussing films in which the audience is encouraged to find satisfaction in seeing "big creatures stomping on things and causing wholesale destruction" (Barr 123).

The subversive attractions of the giant monster movie – the pleasure it encourages audiences to take in witnessing the destruction caused by the monster – have very definite echoes of the horror film, of which

Robin Wood notes: "Central to the effect and fascination [...] is their fulfilment of our nightmare wish to smash the norms that oppress us and which our moral conditioning teaches us to revere" (72). Whether it be King Kong running amok in downtown New York, a giant octopus attacking the Golden Gate Bridge in *It Came From Beneath the Sea* (1955), or the titular monster knocking the head off The Statue of Liberty in *Cloverfield*, the genre shares horror's recurrent and carnivalesque emphasis on disrupting the status quo.

It is important to note that in choosing to read the giant monster movie as subversive this book is running against the grain of some of the existing work on the genre. For example, in his influential study of the monster's cultural relevance Jeffrey Jerome Cohen identifies the "monster of prohibition [which] exists to demarcate the bonds that hold together that system of relations we call culture, to call horrid attention to the borders that cannot – must not – be crossed" (46). This monster punishes "mobility (intellectual, geographic, or sexual) delimiting the social spaces through which private bodies may move" (45). While several examples of the genre that will be discussed in this book support this interpretation of the monster as conservative, the argument will be made that these films – including *King Kong*, *The Relic* (1997), and *Kong: Skull Island* (2017) – perpetuate these ideas while also working to destabilise them. The depiction of non-Western peoples and locales as inherently exotic and dangerous, and the act of border crossing as inherently unsafe, is undermined when the Western protagonists are unsympathetic, "abstract puppetlike figures", and the crossing of borders begets their carnivalesque "beatings, dismemberment, and even death" (Stam 137) by the monster.

This paradigm is evident in 2004's *Anacondas: Hunt for the Blood Orchid*. The film concerns a team of researchers who work for the US pharmaceutical firm Wexell-Hall as they try to locate the titular plant. Wexell-Hall believes the flowers of the Blood Orchid contain a chemical that can "significantly prolong cellular life" and hope to synthesise it to create a "pharmaceutical equivalent to the fountain of youth", something "bigger than Viagra" that will make them "billionaires". However, the orchid only grows in the deepest, most remote jungles of Borneo and flowers for a scant two weeks, once every seven years. In contrast to the Wexell-Hall scientists who seem to represent modernity and progress, the film positions Indonesia as an exotic and dangerous environment. The film's prologue depicts two indigenous tribespeople who, when out hunting a tiger in the thick undergrowth, end up being attacked, and killed by a giant anaconda. Considering this prologue, it is significant that the Wexell-Hall crew that set out to collect the

flower are depicted as remarkably ill prepared for what they are likely to face. The group is made up of inexperienced graduate students; they arrive in the middle of the rainy season; and initially they lack any means of travelling from their initial base to the far-flung island on which the orchid grows. Indeed, the film seems to go out of its way to foreground how poorly equipped the Western characters are for this jungle environment; the head Wexell-Hall scientist runs screaming when she first encounters a boat captain's pet capuchin monkey, and later accidentally falls overboard while speaking on the phone. The only strengths the Wexell-Hall group do have are in funding (they promise to pay $100,000 to the only boat captain willing to travel upriver during the rainy season) and in access to the latest global-positioning system (GPS) and satellite-tracking technology. However, this technology is soon rendered redundant when the boat ends up capsizing over a waterfall and the equipment is destroyed.

The crew start dying as soon as they enter the jungle. Here they are attacked by a giant anaconda, "the biggest one I've ever seen by far, a freak of nature", which drags one of the group's more obnoxious members, Ben, underwater before swallowing him whole. While this incident should have acted as a warning to the group not to continue its journey, the crew persevere, convinced that the anaconda will be digesting the kill for weeks and therefore the way for them to proceed is safe. However, this is not the case, and the crew are in fact travelling into further trouble. The Blood Orchid and the anacondas are symbolically linked in the film's narrative; the film's human villain, Dr Jack Byron, works out that the snakes have got so big because the flower is part of the food chain, and we later discover that the anacondas choose to mate in close vicinity to the plant. Consequently, anyone that tries to get close to the orchids is killed by the anacondas. First, another boat captain on his way to rescue the crew ends up being blown up in an explosion caused by an anaconda attack; then a member of the group, who has been poisoned by Byron, is swallowed alive by a snake. The group (*sans* Byron) fall into a cave and the boat captain's right-hand man, Tran, is drowned and eaten by an anaconda. Finally, and in keeping with the positioning of the anacondas as the Blood Orchid's protectors, the worst fate is saved for Byron, who, following the film's logic, is the guiltiest in so much as he has been the most committed to reaching the flowers and the wealth they represent. At the film's climax Byron is paralysed by a spider bite and then falls into the anacondas' mating pit, where he is eaten alive by a host of amorous snakes.

It seems clear that the audience is meant to enjoy watching *Anacondas'* one-dimensional characters get picked off one by one by the film's

giant snakes. Cohen suggests that as much as the monster's behaviour is frequently coded as abhorrent its disruptive actions concurrently enable our "fantasies of aggression, domination, and inversion" (49). When we consider that Wexell-Hall are in fact punished for attempting to exploit non-Western cultures for their own gain in the film and that the audience are encouraged to see that punishment as a form of poetic justice, it becomes possible to suggest that the US giant monster movie retains a carnivalesque, subversive aspect even when the monster appears to embody a culturally conservative ideological stance.

While it is possible to read a carnivalesque impulse into many giant monster movies, the subversive elements of the genre are perhaps most overt in its more self-reflexive examples. Films such as *Alligator*, *Eight Legged Freaks*, and *Big Ass Spider!* take enjoyment in having their titular monsters turn the world upside down, encouraging the audience to celebrate, rather than fear, the chaos they engender. These often overtly comedic films provide monsters whose destructive actions can be read as "a redemptive assault on manifestations of 'decadence'" (King 2000, 144).

In some senses the title of *Big Ass Spider!* exemplifies the film's approach to its material: the film makers take great delight in signalling their awareness of genre conventions. The film's protagonist Alex Mathis is an insect exterminator down on his luck, who finds himself involved in a desperate attempt to stop the titular giant spider from destroying much of Los Angeles. That the film is set in LA, the home of Hollywood, seems appropriate, not least because *Big Ass Spider!* offers an incredibly knowing and self-referential low-budget take on the genre movies of the 1950s. The character of Alex is a burlesque of the conventional qualities of the giant monster movie protagonist. In contrast to the physically capable hero of the 'big bug' movies of the 1950s Alex is played by the sardonic, middle-aged actor Greg Grunberg. Spoofing the typical hero's innate understanding of the creatures he faces Alex claims to have an uncanny insight into the spider's mindset, suggesting at one point "I know what spiders are thinking, I get into a spider's head, I think like a spider, I move like a spider [...] I become a spider to catch a spider." His techniques also involve imitating the skittering noise a spider makes when it runs across a hard surface.

The film contains several scenes which directly parody contemporary cinematic conventions. The *Alien* franchise (1979–) seems to be a recurrent target for parody in the film, perhaps because the series has established numerous stylistic tropes as iconic. When pursuing the spider in the early part of the film, Alex has to enter the hospital's air vents. Kitted out with a homemade headtorch fashioned out of a pair

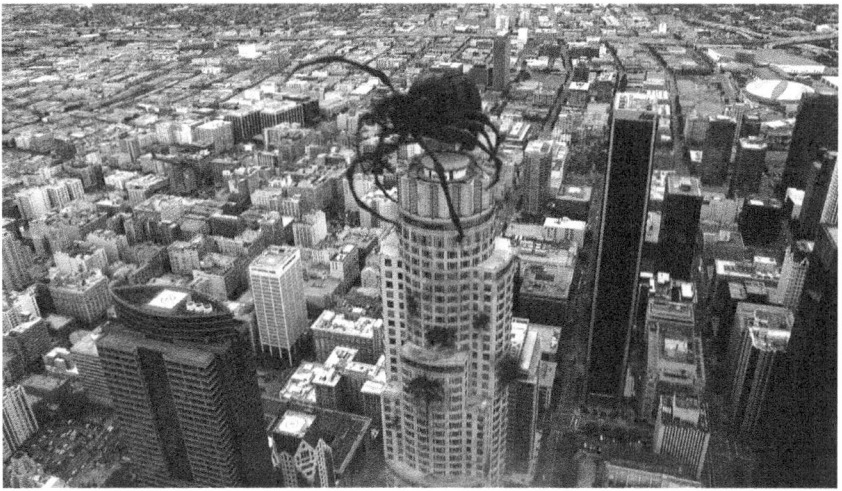

*Figure 0.1 A giant spider perches threateningly atop the US Bank Tower.
Source Epic Pictures Group, 2013*

of safety googles, he clambers through the vents frantically communicating by walkie talkie with the hospital's security guard, Jose Ramos, in an amusing homage to the sequence in the first *Alien* in which Dallas is pursued through the air ducts of the *Nostromo* by that film's titular extra-terrestrial. Later in *Big Ass Spider!* we view a group of special forces soldiers through their green-tinted, live headcam footage as they uncover the webbed remains of 20–30 people under the LA river, imitating a similar scene in *Aliens* (1986) in which Ripley watches as the marines find a bunch of cocooned colonists that are being used as incubators for the creatures' offspring. Imitating a monster movie of another kind, in the finale of *Big Ass Spider!* the giant arachnid climbs to the top of the LA bank tower in an echo of King Kong's ascension of the Empire State building.

Big Ass Spider! is also carnivalesque in the emphasis it places upon the grotesque potentialities of the body. Numerous scenes focus on the destruction of the human body, graphically depicting the consequences of the spider's attacks. At one point Alex examines the location of the spider's first appearance only to find a half-eaten corpse in a body bag. Alex discovers that the spider must have "got inside this guy's body and dug his way out through his lungs or his stomach, or something", creating remains that are "so gross" his companion Jose won't even look at them. Later in the film we find out that the spider attacks some of

its victims by spraying acid in their faces, melting the skin away from the bone in a display of low-budget, yet nevertheless convincing special effects.

While this emphasis on body horror is unusual in the genre, one thing the film does share with other instances of the giant monster movie is its anti-authoritarian stance. Alex agrees with the exclamation by one of his clients that "you can never count on the government for anything", something that is further emphasised when he finds out that the spider is the result of an "accident" caused by government scientists experimenting with alien DNA. Indeed, Alex gets involved with the initial attempt to catch the spider because it is a means of paying off his exorbitant hospital bill, including "$2,000 for gauze". Many of the spider's attacks take place across civic spaces (a hospital, a park) yet those in power, as represented by the hard-ass army major Braxton C. Tanner, seem incapable of effectively policing these locations. At the start of the film Tanner overrides the hospital's director in placing the building in lockdown, but this does not successfully protect the public from the spider, which kills a patient and then escapes into the sewer system. Similarly, Tanner is shown as powerless to stop the spider attacking Los Angeles residents even with all the army's firepower at his disposal. Significantly, as if to emphasise their ineffectiveness, Tanner and his associates are repeatedly pictured watching the results of the spider's actions on cameras and screens, suggesting that they are always playing catch-up while it is Alex and Jose who are "out in the field" chasing the spider down. One of the mottos of Alex's extermination company is "we care", underlining the split in the film's characterisation between the compassion that informs the actions of blue-collar heroes like Alex and Jose and the misplaced arrogance of those in power who cannot function effectively when confronted by something outside the ordinary.

The comedic take on genre conventions offered by *Big Ass Spider!* reflects another of the reasons why the US giant monster movie may have been neglected by critics, namely that, in taxonomic terms, the form often seems to combine elements drawn from several different (though occasionally interrelated) genres; constituting what Erb notes constitutes "a hybrid work" (13). In particular, the giant monster movie frequently includes parts in common with the horror, disaster, science fiction, and action and/or action-adventure movie genres. This is to say nothing of the more specific instances of hybridisation we might find in examples such as the buddy comedy of *Tremors* (1990) or the romantic melodrama of *King Kong* (2005).

Alongside its subversive appeal the most obvious point that the US giant monster movie has in common with the horror film is in

its inclusion of a monster. Glossing Wood's hugely influential work on the horror film, Harry Benshoff explains "Wood suggested that the thematic core of the [horror] genre might be reduced to three interrelated variables: normality [...] the Other (embodied in the figure of the monster) and the relationship between the two" (226). Much as Wood suggests the monster is central to the horror film so it is difficult to conceive of the giant monster movie without a monster. Rampaging across a recognisable cityscape or otherwise terrorising the representatives of humanity, the figure is a fundamental part of the genre. While Justin Mullis has suggested that the positioning of the monster in US giant monster movies tends to be more one-dimensional than in equivalent *kaiju* films from Japan – "in Hollywood films monster[s] are usually restricted to the role of villains" (quoted in Mustachio and Barr 8) – the reality is decidedly more complex. As this book will demonstrate, the US giant monster movie offers audiences a range of different types of monster; some sympathetic, some less so. For example, Erb notes that "[o]ne of the more intriguing aspects of the King Kong story resides in the invitation to identify with the position of a tormented monster" (11). Like Frankenstein's creation, it is possible to see Kong as "the central figure of identification" (64) in the story. Indeed, this (re)positioning of Kong as victim has been expanded in the various retellings of the narrative, including Peter Jackson's 2005 remake in which Kong becomes a "grieving, melancholy hero" (210), and Legendary Pictures' *Kong: Skull Island*, where Kong is presented as a "morose, lonely god" (Vogt-Roberts quoted in Smith).

Regardless of the intentions of the monster, as Stephen Keane points out in his book *Disaster Movies: The Cinema of Catastrophe* (2006), genre conventions dictate that the creature's "awkward size" mean that "accidental moments of destruction" (87) still take place. The centrality of these moments of destruction aligns the US giant monster movie with the disaster genre. In the influential "The Bug in the Rug: Notes on the Disaster Genre" Maurice Yacowar foreshadows my own carnivalesque interpretation of the disaster movie, writing that the genre "exploits the spectacular potential of the screen and nourishes the audience's fascination with the vision of massive doom" (277). This claim chimes with what I propose are the attractions of the US giant monster movie. This correlation is perhaps unsurprising, given that Yacowar identifies the "Natural Attack" and the "Monster" as two of the eight basic instances of the disaster genre. For this author, these two categories encompass films including *Them!*, *Jaws*, *King Kong*, *The Beast from 20,000 Fathoms*, *Godzilla*, *The Giant Gila Monster* (1959) and *Tarantula* (1955). These films are defined by "a

mood of threat and dread" which frequently culminates in scenes of "general, spectacular destruction" (285). Yacowar's analysis becomes even more relevant to this study in his discussion of the importance of scale to the disaster movie. Though his suggestion that disaster movies work on a societal scale – "the effect is the sense of the entire society under threat, even the world" (285) – seems at odds with his discussion elsewhere of the genre's focus on small groups of people isolated from exterior sources of help, his assertion that the scope of the problem in disaster films links to their didactic message seems relevant to an analysis of the US giant monster movie. One of the suggestions made throughout this study is that the scale of the giant monster often reflects the size of the problem that the creature represents, be this the consequences of (mis)using nuclear power in the 'big bug' films of the 1950s (discussed in Chapter 2) or the harmful effects of humanity's actions on the natural world in the 'nature attacks' films of the 1970s (examined further in Chapter 3).

Any examination of what the giant monster movie shares with the science fiction film should perhaps start by acknowledging the blurred nature of the boundaries between science fiction and horror. Roger Luckhurst notes that any attempt to differentiate between the two

> rarely works well; they are both products of the same industrial and scientific modernity [...] They share the context of modernity's ceaseless creative destruction, sometimes inflecting it in different ways, but often in fantastical forms that are very difficult to distinguish. (56)

More relevant to a consideration of the giant monster movie is Susan Sontag's proposal in "The Imagination of Disaster" that "there is little difference between mass havoc as represented in [...] monster films and what we find in science fiction films" (44). Sontag is not alone in this slippage between the monster movie and science fiction. To give just two recent examples: *The Lost World, Tarantula, It Came From Beneath the Sea, The Deadly Mantis* (1957), and *Monsters* (2010) all feature in the British Film Institute's (BFI) book-length celebration of science fiction, *Sci-Fi: Days of Fear and Wonder* (2014). While *The Beast from 20,000 Fathoms, Gojira* (aka *Godzilla*), *Them!*, and *Jurassic Park* are discussed, fruitfully, in *The Routledge Companion to Science Fiction* (2009).

While these kinds of conflation might be inevitable given that "science fiction is not one thing" (Kincaid 50) it is worth noting that it is giant monster movies from the 1950s that are most frequently classified as science fiction. Perhaps because their stories frequently

involve transgressive 'mad' scientists inadvertently 'creating' monsters through irresponsible activity involving atomic power, such instances of the genre can be easily interpreted as "*Frankenstein*-esque morality tales" (Bullock 16), in which the 'horror' of the monster is the result of "a race of nuclear-armed Frankensteins" (Colavito 267) wielding power in increasingly irresponsible ways.

Sontag's essay also reminds us that, in its appeal to audiences, the giant monster movie often shares much in common with what Stacey Abbott has called the "Blockbuster SF Film" (468). Her term refers to a merging of the characteristics of the blockbuster – enhanced production values, large-scale story – with the genre trappings of the science fiction film to create a format that is calculated to effectively "showcase developments in new cinema technologies" (468). Abbott goes on to suggest that the blockbuster SF film will often "deliberately pause to allow the audience to enjoy the dramatic reveal of both objects of wonder and the special effects that created [them]" (470). Such sequences mirror those moments of spectacle in many giant monster movies in which the creature is first revealed in all its awe-inspiring magnitude, or when a recognisable urban landmark is toppled through the monster's destructive actions. More broadly, Hollywood has long emphasised cutting-edge special effects as a means of distinguishing itself from its competitors; what Ted Hovet calls its "representational prowess" (quoted in Hall and Neale 36). In comparison to the relatively low-rent nature of the 'suitmation' approach adopted by Toho Studios, "vast spectacle [is] central to many of the high grossing blockbuster productions around which the fortunes of the Hollywood studios have primarily revolved" (King 2006, 334). Consequently, Hollywood's giant monsters might be thought of as embodiments of the superior production values enabled by its unique industrial practices, not least the often-phenomenal production budgets afforded to its films, reflecting King's suggestion that "[i]n the contemporary global-scale moving-picture economy, Hollywood creates a territory on which it, alone, can compete" (339).

If, as Charles R. Acland notes, "[g]iants and the gigantic appear oriented toward display [...] and hence link with [...] spectacle" (135), it should not be surprising that the giant monster has played such a central part in realising the heightened visual spectacle beloved by Hollywood. It is a genre that lends itself to "[t]he ability to create spectacular images (translatable into box-office and subsequent media revenues)" (King 2006, 342). Since its inception in the 1920s and 1930s the genre has showcased cutting-edge special effects: from Willis O'Brien's painstaking employment of stop-motion animation in *The Lost World*,

King Kong, and *Mighty Joe Young* (1949); and the 'Dynamation' technique his protégé Ray Harryhausen used in films including *The Beast from 20,000 Fathoms* and *It Came From Beneath the Sea*; to the CGI extravaganzas of the contemporary era, created by large teams of highly skilled special effects artists. The centrality of spectacle to the giant monster movie is evident in the praise lavished upon those who help to realise such creatures on screen; one review of *King Kong* suggesting "neither the story nor the cast gains more than secondary importance [...] technical aspects are always on top" (quoted in Gregersdötter et al. 22), while *The Motion Picture Herald* proposed of *The Beast from 20,000 Fathoms*: "the real stars of [the film] are the special and technical effects men" (quoted in Harryhausen and Dalton 58). Indeed, the level of interest that still surrounds specific individuals who have worked in the genre (an exhibition devoted to Harryhausen's work ran as recently as 2021) testifies to the appreciation that many have for the important role of special effects.

Brad Peyton's 2018 film *Rampage* exemplifies some of the ways in which the giant monster movie is used to demonstrate Hollywood's representational prowess. The film was marketed with the tagline "Big meets Bigger", clearly positioning its appeal to potential cinema goers as based on witnessing its muscular star, ex-wrestler and American football player Dwayne Johnson, confront the film's (re)creation of several *kaiju*-like creatures drawn from the 1980s cult videogame of the same name. For King films like *Rampage* represent "the enshrinement of a form of cinema in which Hollywood, because of its superior financial resources, cannot be rivalled" (King 2006, 339). *Rampage* places the kind of heightened spectacle that is unavailable elsewhere in the entertainment marketplace (whether domestically on television, or in the products of international competitors) as its key selling point, foregrounding the pleasures of visual spectacle through all aspects of its marketing, narrative, and casting.

Rampage opens with an expansive exterior shot as the (virtual) camera zooms in on the Athena space station as it floats high above the Earth. In doing so the film immediately signals it's reliance upon a heightened form of spectacle as the audience are made aware that the events being depicted have repercussions for the whole planet. Forced, by her superiors, to go back to save the pathogens that the gene manipulation company Energyne have been developing, we watch an astronaut narrowly escape the attacks of what appears to be a giant mutant rat only for the station she is on to then blow up in an unforeseen explosion upon its re-entry into Earth's atmosphere. The film then cuts to the San Diego Wildlife sanctuary where former US Army Special Forces soldier

Davis Okoye (played by Johnson) is working as a primatologist. Okoye has befriended a rare, oversized, albino gorilla that he has called George. George is realised on screen through motion capture, a technique whereby the actions of real performers are used to help animate an on-screen digital character. George eventually becomes one of a trio of animals (with a wolf and an alligator) who are inadvertently infected by the pathogen from the film's prologue. These pathogens cause George and the other animals to grow exponentially and to become hyper-aggressive. What then follows are a series of action sequences that tease the audience with the spectacle of the escalating size of the infected creatures; giving them carefully managed glimpses of the monsters, before all three creatures are revealed in a more sustained manner in the film's second half and the human characters, led by Davis, try to defeat them, and return things to the status quo. Through this structuring of the narrative *Rampage* employs a recurrent and paradoxical trope of the Hollywood blockbuster, whereby "technology is itself glorified through its presentation, [but] often critiqued through the narrative" (Abbott 471). Peyton's film uses the escalating size and promise of seeing the monsters causing havoc to fuel much of the narrative's appeal, while the plot simultaneously condemns the 'evil' corporation that has constructed the pathogen which has enabled this growth to occur in the first place.

As with *Rampage*, size has always been an instrumental factor in how Hollywood has marketed its films. In their study of *Epics, Spectacles and Blockbusters* (2010), Sheldon Hall and Steve Neale note that the terms that give their book its title were invented to highlight the "size and expense" (5) of the movies being discussed as much as to say anything about their narrative content. Interestingly, the giant monster movie may have played an integral part in birthing the blockbuster by informing the promotional practices adopted by the US film industry. The authors note that the process of 'blitz' booking whole territories was popularised during the 1950s by RKO's head publicist, Terry Turner. Turner was behind the decision to open *Mighty Joe Young* in "358 theaters in New England and upstate New York, accompanied by intensive press, radio, and even television advertising" (171). Turner then repeated this blitzkrieg approach for the third rerelease of *King Kong*: "to the industry's amazement, the reissue grossed a reported $1.6 million" (171). As a freelancer, Turner went on to successfully employ similar techniques for other monster movies including Warner's *The Beast from 20,000 Fathoms* and *Them!* Turner's tactic of heavily advertising on television as well as releasing films in as many cinemas as possible foreshadowed the strategy taken by major film studios in marketing

spectacle-oriented films, such as *Jaws* and the 1976 remake of *King Kong*, as 'events' in the 1970s. Thanks to Turner's approach, then, the impression of the 'size' of a film became central to its potential for commercial success, something that the inherently expansive nature of the giant monster movie was well suited to convey.

In his attempts to construct a taxonomy of the monster Noel Carroll identifies size as an important strategy for creating an effective creature: "Along with fission and fusion, another recurring symbolic structure for generating horrific monsters is the *magnification* of entities or beings already typically adjudged impure or disgusting" (48). His concept of magnification has obvious relevance to the giant monster movie. To name just a few examples: *King Kong* contains a giant ape, giant ants appear in *Them!*, a huge octopus features in *It Came From Beneath the Sea*, *Anaconda* (1997) features a giant snake, *Lake Placid* (1999) focuses on a giant crocodile, and *Eight Legged Freaks* includes a number of oversized arachnids. As these examples demonstrate, "[w]hat needs to be magnified are things that are already potentially disturbing and disgusting" (Carroll 50). In a similar vein, the hybrid creatures that inhabit films including *Q*, *Tremors*, *The Relic*, and *Deep Rising* (1998) combine magnification with what Carroll terms fusion: namely "the construction of creatures that transgress categorical distinctions" (43) and therefore represent the "impure and repulsive" (45).

The historical and cultural connotations of magnification are also explored in Bakhtin's writing. In his study of Rabelais, Bakhtin "explicitly connects giants to carnivalesque folk culture" (Schmidt 58). Bakhtin links the grotesque body of the giant with "all that is excessive and superabundant in culture" (303). For Bakhtin the giant's size is an embodiment of the level of excess they represent, and their huge scale a representation of the level of a culture's desire for subversion of the prevailing order: "they encode the transgressive, often heterodox longings of popular culture" (Schmidt 59) In embodying these subversive desires; the giant threatens hegemonic power, reflected in the giant monster movie's recurrent depictions of a creature being brought into the midst of civilisation only to break free and run amok. There is, as Susan Stewart notes in her cultural work on the gigantic, an inherent fascination in witnessing such an encounter: "The appearance of the gigantic within the context of the city must be linked as well to the creation of *public* spectacle" (84). The recent *Jurassic World: Fallen Kingdom* (2018) depicts this conflict on a national (and global) scale. The film ends with its dinosaurs being freed and franchise stalwart Dr Ian Malcolm declaring the start of "a new era" as the film cuts to various scenes in which the liberated dinosaurs are shown (re)claiming

different parts of the USA. The 'fallen kingdom' of the title refers not just to the end of the titular theme park but rather more ominously to the final stages of humanity's dominion over the planet; as Malcolm puts it, these monsters have the potential to permanently alter our way of life: "humans and dinosaurs are going to be forced to coexist. These creatures were here before us, and if we're not careful they're going to be here after."

From *King Kong* onwards, a subset of the US giant monster movie has situated its monsters as an embodiment of an 'uncivilised' Nature, what Paul Bullock calls the "green world", which is set against the "grey world" (24–29) of mankind. While I will explore the environmental concerns of the US giant monster movie in more detail in Chapter 3, suffice to say at this point that the positioning of the monster as a foreign and primordial Other has more recently allowed for the depiction of another kind of spectacle: large-scale "spectacular vistas" (King 2006, 339). *Godzilla vs Kong* takes full advantage of this, featuring sequences filmed in the real-world locales of Australia, Hong Kong, New York, and Hawaii as well as those created through studio sets and CGI. Described as offering audiences "a staggeringly well-built and extensive universe to explore" (Benjamin Lee) this "globetrotting royal rumble" (Robert Daniels) was praised for its use of expansive panoramic sequences, particularly a fight between the two titans that takes place in the skyscraper-filled streets of Hong Kong's downtown metropolis, which "takes palpable joy in the way Hong Kong's neon skyline catches the jagged edges of Godzilla's silhouette in pinks and yellows" (David Crow).

Godzilla vs Kong makes copious use of CGI to augment its real-world shooting locations and to help create further fictional environments. This is most evident in the Hollow Earth sequences. In the film the Hollow Earth is the original home of Kong's species. The scenes set there seem designed to showcase the spectacular appeal of artificially created vistas. Long before we see Hollow Earth it is introduced in the narrative as an 'impossible' environment, writing about which has seen Dr Nathan Lind dismissed as "a sci-fi quack, trading in fringe physics". Size here is linked to the promise of an inconceivable spectacle and, as things turns out, Hollow Earth is an environment of such magnitude that it once housed an epic war between Kong and Godzilla's ancestors, the gargantuan remains of which litter its vast landscape. The look of Hollow Earth fuses previous pop culture vistas (*King Kong*, Frank Frazetta, Harryhausen films, *Star Wars* (1977–), *Avatar* (2009)) to create an aesthetic that is "ecstatically dreamy kitsch, in the vein of a '70s sword-and-sorcery paperback book jacket, or a '70s-'80s psychedelic sci-fi or fantasy picture" (Seitz). While it is fair to suggest that the

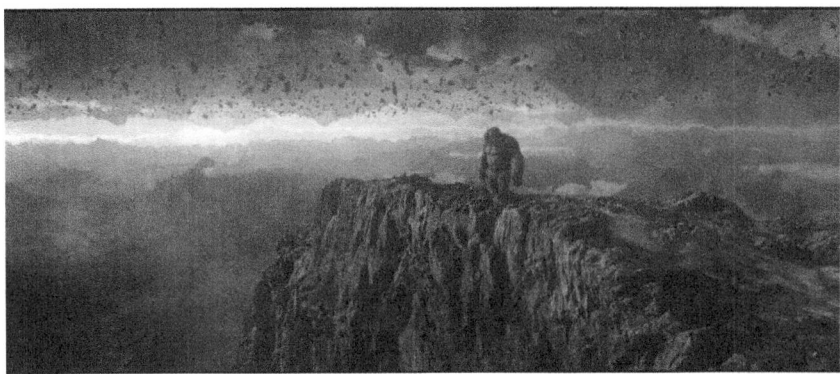

Figure 0.2 King Kong gazes in wonder at the Hollow Earth's sky.
Source Legendary Pictures, 2021

film's appeal relies on the spectacle inherent in the promise of its two monsters being brought together in combat, the inclusion of expansive digital landscapes like Hollow Earth reminds us that "spectacular vistas are one of the continuing sources of the appeal of the specifically theatrical/cinematic experience" (King 2006, 334).

As the financial success of *Godzilla vs Kong* demonstrates, the giant monster movie continues to be popular with audiences, if not also with critics. Part of the genre's continuing appeal to the studios that make such films is the genre's "lesser dependence on issues of cultural or verbal translation" (King 2006, 342), creating "as few as possible barriers to viewer comprehension" (347). Now, more than ever, these are valuable factors in appealing to an overseas market "which has become increasingly important to Hollywood in recent decades" (342). The consequences of the growing importance of international audiences are evident in *Pacific Rim* (2013–). Like *Godzilla vs Kong*, *Pacific Rim* sets some of its key action sequences in countries outside the USA and includes an ethnically diverse cast of characters. While Guillermo Del Toro's "special-effects behemoth" (Quinn) infamously underperformed at the US box office, it went on to enjoy substantial success in markets including China and Japan, where it broke records at the time for a US-produced film. While critics have since attempted to explain *Pacific Rim*'s success by reading it as intentionally campy (Bollinger) and surprisingly feminist (Romano), Barr's proposal that "[m]any of the issues found in *kaiju* films – colonial powers, pollution, military ineptitude – are broad enough to be recognizable to a wide array of fans

throughout the world" (16) seems to better explain the film's ability to cross international borders.

While such discussions might suggest that the giant monster movie is the harbinger of a completely spectacle-oriented future for Hollywood cinema it is important to remember that "spectacle is rendered meaningful through context" (King 2006, 343). This study argues that one of the recurrent contexts for the giant monster is as a representative of something that usually lies outside or is repressed by the hegemonic order; as Walter Stephens notes in his study of giants, "throughout history the Giant has most often signified the Other, the enemy, whether that enemy be another culture or Nature itself" (31). In such a reading the disruptive actions of the genre's monsters become a carnivalesque unleashing of "all that is marginalized and excluded" (Stam 86), enacting a "symbolic, anticipatory overthrow of oppressive social structures [...] pulling grotesque monarchs off their thrones and installing comic lords of misrule in their place" (173). At their most extreme such actions can create a sense of "epistemological crisis or vertigo" (Weinstock 3) as the monster challenges the criteria we use to understand the world around us, collapsing conventional distinctions between the normal and the monstrous.

Rob Cohen's 2002 film *Reign of Fire* foregrounds its exploration of such distinctions by featuring the German philosopher Friedrich Nietzsche's cautionary aphorism – "whoever fights monsters should see to it that in the process he does not become a monster" (86) – in its prologue. Set in a dystopian future in which fire-breathing dragons have replaced humanity as the dominant species, the film's opening, voice-over narration reveals that humanity's ironically futile attempts to fight fire with fire – by using nuclear weapons to attack the dragons – only served to "help them" by destroying the natural environment and creating a climate more amenable to the creatures' needs. Into this now blasted landscape comes the Ahab-like figure of Denton Van Zan, "a cigar-gnawing, apocalyptic badass dragon slayer" (McConaughey 186). Van Zan leads the Kentucky Irregulars, a group of militarily trained dragon killers who arrive at just the right moment to help the pacifist Quinn and his increasingly fractured community of farmers fight back against the monsters that are attacking them. From his first appearance onwards, the film draws parallels between Van Zan and the dragons; both are seen as a threat to the community, with one of Quinn's friends joking that the only thing worse than the dragons are the Americans. Both Van Zan and the dragons are aggressive and seem to actively court the enemy. Where Quinn's commune has tried to maintain a sense of humanity and compassion, in contrast the Irregulars have become

hardened by their murderous experiences, with the shaven-headed and scarred Van Zan boasting that he has taken down numerous dragons. Indeed, the Irregulars seem to relish the act of killing dragons. Rather than follow Quinn's plan and hide out underground until the creatures starve, Van Zan wants to take the fight directly to the dragons. Perhaps unsurprisingly, given Nietzsche's warning, as the film progresses Van Zan is exposed as a monster himself, the reckless and dangerous yin to Quinn's more methodical and cautious yang. Where Quinn's studiousness distinguishes him from the impulsive dragons, Van Zan's behaviour apes their instinctual and violent inclinations. When Van Zan forcibly 'drafts' some of the others to help him in attacking the dragons his actions result in several members of the community being needlessly killed. Though Van Zan is partly redeemed at the end of the film through his admission that Quinn's more cautious approach was the correct one, the character's sacrificial death suggests that his obsession with killing has no place in the new, more diplomatic, post-dragon future that we see hinted at in the film's final scene.

Given the huge number of films that might fall within my remit I have had to place some limits on what I cover. Though some might argue that dragons do not count as giant monsters, I have aimed for a broad approach, discussing examples that have exerted a significant influence alongside those that are lesser known. Constraints of time and space have meant I have been very selective when it comes to covering direct sequels to previously covered giant monster movies. A few have snuck in where there is something interesting to say about them (such as *Anacondas: Hunt for the Blood Orchid* in this introduction), but generally if they get a mention at all it is for contextual reasons or to demonstrate a trend in the wider genre. Equally, I have not been able to go into much detail about the sort of straight-to-television movies, often produced by and for The SyFy Channel, that have recently grown exponentially in number. I do discuss the work of The Asylum in Chapter 5, analysing *Mega Shark versus Giant Octopus* (2009), but this is the extent to which I cover this interesting subgenre in the field.

This book, and the chapters that follow, seek to validate the US giant monster movie as an object worthy of study. Cohen suggests that "[m]onsters must be examined within the intricate matrix of relations (social, cultural, and literary-historical) that generate them" (39) and consequently each chapter will focus on key films from a particular period, examining the developments that take place to better explicate the genre and its appeal. Underpinning much of this discussion will be a critical exploration of the tensions that arise because of the giant monster movie's position as a vehicle for Hollywood to demonstrate

its representational prowess – primarily through state-of-the-art special effects – while, at the same time, it is often ideologically and culturally subversive; offering audiences portrayals in which those in power are frequently challenged and brought low. To facilitate this sometimes difficult analysis, Bakhtin's theories of the carnivalesque will be employed, helping to shed light on the roles that humour and self-reflexivity play in the genre.

Chapter 1 focuses on five key films in the early development and popularisation of the US giant monster movie: *The Lost World, King Kong, Son of Kong* (1933), *Mighty Joe Young*, and *The Beast from 20,000 Fathoms*. While there is an increasing amount of scholarship on *King Kong*, this chapter will argue that it is useful to look at the iconic film in a broader context, to see how it can be viewed alongside a series of pioneering examples (referred to as the *Kong* cycle) that helped establish many of the tropes and conventions of the genre. In particular, the discussion will use Bakhtin's ideas of the carnivalesque to look at how these films encourage audiences to take pleasure in the destructive actions of their monsters. The chapter will examine these subversive elements, exploring how they complemented and conflicted with the films' positioning as vehicles to demonstrate Hollywood's technical and storytelling prowess. The chapter then moves on to explore the carnivalesque deflation of the monster movie found in the later entries in the *Kong* cycle, *Son of Kong* and *Mighty Joe Young*. Both films introduce aspects of comedy into the giant monster movie, often in the form of overt self-reflexivity, a feature that goes on to form a significant part of the genre. The chapter ends with a discussion of the ways in which *The Beast from 20,000 Fathoms* provided a more financially feasible formula for the US giant monster movie as it entered the 1950s.

Chapter 2 focuses on the wealth of giant monster movies released during the 1950s, many of which take nuclear power as their proverbial bogeyman. The chapter examines how films including *Them!, It Came From Beneath The Sea*, and *Tarantula* used the sensationalist concept of creatures being enlarged by the power of the bomb to draw in thrill-seeking audiences while also encouraging them to question aspects of prevailing ideology. As the decade progressed the number of lower-budgeted examples of the US giant monster movie, sometimes produced outside the Hollywood studio system, also began to grow. Accordingly, the chapter looks at a number of independently produced films such as *The Amazing Colossal Man* (1957), *The Giant Claw* (1957), *Attack of the 50 Foot Woman*, and *Attack of the Crab Monsters* (1957), alongside their bigger-budgeted stablemates, in order to effectively chart the development of the genre. In particular, Chapter 2 examines

the ways in which lower-budgeted films often made explicit the self-reflexive strain of the genre through carnivalesque processes such as satire, parody, and pastiche, offering an interesting alternative to Hollywood's more spectacle-oriented output.

Chapter 3 covers a period of transition for the giant monster movie, first through the 1960s when the genre sought to recover from the exhaustion of the 1950s big bug cycle, and then, following in the wake of *Jaws*, as the eco-horror film established itself as the dominant trend. The chapter begins by looking at some of the more peculiar films that preceded *Jaws*, before shifting focus to Spielberg's blockbuster. The chapter provides an analysis of *Jaws*, its influence on the genre, and some of the many films that sought to emulate its commercial success. Though *Jaws* sought to bring a level of respectability to the giant monster movie that was unsuited to the carnivalesque, more subversive elements quickly crept back into the genre through the film's many imitators. Consequently, the discussion at this point turns to explore how some of the 'nature attacks' films released just after *Jaws*, including *The Giant Spider Invasion* (1975), *Grizzly* (1976), and *The Food of the Gods* (1976), embody a carnivalesque upending of conventional hierarchical relations through their presentation of the natural world fighting back, tooth and claw. The chapter also considers why some of the bigger-budgeted examples of the 'nature attacks' subgenre failed to capture *Jaws*' success. High-profile flops such as *King Kong* (1976) and *Prophecy* (1979) were so disastrous that they saw the US giant monster movie shy away from the blockbuster format for the next decade. Chapter 3 finishes by analysing four lower-budgeted films emblematic of a new turn towards 'blue-collar' experience in the genre during the 1980s. Centring on the types of character that might not have previously appeared, the chapter examines how these films reformulated the genre's carnivalesque appeal in directly critiquing those in power.

While some of the films released during the 1970s seemed hamstrung by the limitations of their special effects, Chapter 4 looks at the re-energising impact that CGI had on the giant monster movie during the 1990s. The chapter charts the emergence and subsequent development of this technology, comparing some of the different uses of computer-aided visual effects throughout the decade and the consequences these had for the subversive pleasures of the genre. Starting with *Jurassic Park* (1993) and ending with *Eight Legged Freaks* (2002), the chapter argues that the commercial success of Spielberg's film, and its emphasis on perceptual realism, steered the use of CGI in a direction that others sought to follow to the exclusion of everything else. While films that focused on using CGI to try to achieve a type of photorealism could still provide

the carnivalesque appeal of monsters overturning the hegemony, it took nearly a decade until film makers employed the technology in any other sort of way. The chapter ends by considering some of the more overtly self-reflexive examples from the era including *Deep Rising*, *Deep Blue Sea* (1999), and of course *Eight Legged Freaks*; a film that is significant for its use of CGI in a deliberately anti-illusionist manner.

The final chapter of the book brings the focus up to the 2000s. In an era defined by cross-media franchises and shared universes, the giant monster movie has continued to be successful by effectively adapting to these contemporary film-making trends. The chapter explores how selected examples including *King Kong* (2005), *Monsters vs Aliens* (2009), *Cloverfield*, and *Pacific Rim* often draw upon the long history of the US giant monster movie in the service of creating something new. In the levels of intertextuality on display some of these films border on parody; a mode that seems to have become increasingly commonplace in the genre. To reflect this expansion the chapter also examines the paracinematic, low-budget, giant monster movie, focusing on *Mega Shark versus Giant Octopus* as a representative example of the self-reflexive and anti-realist aesthetic commonplace in such films. Given its status as Hollywood's most recent "holy grail" (Caranicas 11) the second half of the chapter is devoted to examining Legendary Pictures' ongoing attempts to construct a giant-monster-movie shared universe in the form of their self-titled Monsterverse. *Godzilla* (2014), *Kong: Skull Island*, and *Godzilla: King of the Monsters* (2019) are all analysed for what they can tell us about this venture. The chapter ends by reflecting upon the demands of franchise film-making more generally and what the implications of this practice might be for the genre's carnivalesque elements.

1

"The Whole World Will Pay to See This!": The *Kong* Cycle and the Origins of the US Giant Monster Movie

This chapter focuses on five of the earliest and most influential US giant monster movies: *The Lost World* (1925), *King Kong* (1933), *Son of Kong* (1933), *Mighty Joe Young* (1949), and *The Beast from 20,000 Fathoms* (1953), while also discussing a few other interesting examples from the 1930s and 1940s. While these films span more than two decades, and found varying levels of success with audiences, what they all share is an interest in the struggle between the primitive and the modern. Significantly, Merian C. Cooper, director of the most famous of these films, *King Kong*, envisaged it as a "story of the primitive doomed by modern civilization" (Behlmer 8). This chapter suggests that this conflict can be read as an expression of a carnivalesque impulse, which desires to see the hegemonic order disrupted: "In carnival, all that is marginalized and excluded [...] takes over the center in a liberating explosion of otherness" (Stam 86). The monsters in these films embody the forces that threaten the safe and ordered nature of civilisation, and their climactic attacks on recognisable urban locales provide audiences with an opportunity to vicariously enjoy the spectacle of the powerful temporarily brought low.

The origins of these films' depiction of a struggle between the modern and the primitive can be traced back to the turn-of-the-twentieth-century novels of authors including Jules Verne, Sir Arthur Conan Doyle, and Edgar Rice Burroughs, in which "the confrontation of Anglo-Saxon ideals with other races is envisioned in terms of the survival of the fittest" (Carroll 220). Each of these five films examines the consequences of 'modern' human beings encountering a primitive giant creature, presenting audiences with stories in which characters must prove their capacity to control, repel, or defeat monsters that threaten to destabilise contemporary power structures in which humanity is at

the top of the food chain. In his cultural history of the figure, *Giants in Those Days: Ancient History and Nationalism* (1989) Walter Stephens suggests this motif can be traced back even further than the Victorian period, representing a narrative structure that is mythic in origin:

> The folkloric Giant represents the perils that had to be overcome in order for that culture to be born and thrive [...] Through most of its history in Western thought, the Giant was not only defined as Other, that is, from a differing and threatening culture, but he was often also conceptualized as inhuman. (31–32)

While each of the five films discussed in this chapter alters the particulars, they all follow the basic structure outlined by Stephens. In each example the giant creature must be overcome for the cultural status quo to be returned. The enlarged size of each of the monster/s in these films represents the extent of the threat posed to civilisation and its ideals. Cooper wrote to David O. Selznick that the key to *King Kong* was to "not only use the prehistoric animals for their novelty value, but also to take them out of their present character of just big beasts running around, and make them into a ferocious menace" (Cooper quoted in Behlmer 10). The director's comments suggest one of the key appeals of these movies: the opportunity they give audiences to enjoy witnessing the peril posed to civilisation by these monsters realised on screen. For, as much as these films work as Darwinist parables in which humanity (eventually) proves its superiority over what preceded it, part of the attraction is undoubtedly getting to see contemporary civilisation put at risk. Allen A. Debus notes at the start of his book *Prehistoric Monsters* (2010) that "[m]odernity and the prehistoric are, in a sense, like matter and anti-matter. To avoid catastrophe, they should never come together" (5). It is significant how all but one of these early examples of the genre build to a climax in which the creature wreaks havoc amidst a recognisable urban environment, their actions functioning as "a redemptive assault on manifestations of 'decadence'" (King 2000, 144). This chapter will consider how the spectacle of seeing major cities like New York or London thrown into a state of chaos by the presence of a giant monster speaks to a subversive, carnivalesque, narrative impulse in such films that evidently appealed to those who turned up to watch them. While such destruction can indeed be perceived as horrifying, when placed in narratives that are often incredibly self-reflexive the effect is that the audience is positioned to see such destruction as a form of self-consciously cinematic spectacle. Geoff King calls this technique "impressive spectacular realism" (2006, 338), and discusses it

as an approach that "combines spectacle that draws attention to Itself as spectacle, something to be 'wowed' by, with a 'realism' (self-effacing, in that the 'joints cannot be seen') usually understood as seeking to draw us into fictional world of the film" (338–9). Further demonstrating these films' emphasis upon spectacle is the fact that all five examples use what were, at the time, innovative stop-motion special effects, created first by Willis O'Brien and then by his protégé Ray Harryhausen. Each of the five films develop this technique, in the process establishing a link between the realisation of primitive giant creatures on screen and stop-motion animation that would have an indelible result on the genre for years to come.

These stop-motion effects are one of the key attractions in Harry O'Hoyt's *The Lost World*. Selected for preservation as "culturally, historically, or aesthetically significant" by the United States National Film Registry in 1998, *The Lost World* represents the first feature-length film to include stop-motion effects by genre pioneer O'Brien (Higgins 88) to bring its dinosaurs to life. Though his models were only 18 inches high, O'Brien, following the early work of Polish Russian puppeteer Ladislav Starevitch, created the illusion of life in *The Lost World* by shooting them in "stationary positions that are photographed between incremental adjustments [...] projected at so many frames per second to generate a moving image" (Webber 2). So convincing was O'Brien's early footage for the film that the anecdote goes that many test audience members were left "uncertain about whether the film showed actual dinosaurs" (Wilmington 7).

Though *King Kong* has attracted much more analysis to date it is *The Lost World* that introduced many of the conventions of the US giant monster movie that will be explored throughout this book. Effectively birthing a cinematic genre – Steffen Hantke suggests that Conan Doyle's novel "cements in the public imagination the link between dinosaurs in particular and giant creatures in general" (35–36) – the film tells the story of a group led by Professor Challenger who venture into a remote part of the Amazonian rainforest to prove the existence of living dinosaurs. Challenger has already seen the creatures first-hand but the only evidence he has of what he has witnessed are sketches contained in the journal of Maple White, a fellow explorer who is now lost in the jungle, thought dead. The inclusion of White's journal and the dramatic sketches of the dinosaurs contained therein (a plot device taken from Conan Doyle's novel), position the giant creatures as a form of aesthetic spectacle. Challenger's desire to prove the existence of the dinosaurs by taking others to see them (and then bringing one of the creatures back to be displayed as proof to an even larger audience), mirrors the

cinema audience's own desire to witness O'Brien's models 'brought to life' on screen in a manner previously unheard of in Hollywood film. In this manner, the film foregrounds the appeal of its own special effects, encouraging the cinema audience to share in the anticipation that Challenger's crew experience during the narrative of the film.

It is safe to say that *The Lost World* represented a deliberate attempt to create a "big-budget extravaganza" (Eagan 96), a movie 'event' "unlike any other feature widely marketed at the time" (Taves). Producer Watterson R. Rothacker held the motion picture rights to Doyle's novels and joined forces with Willis O'Brien to create what they hoped would be a "box office bonanza" (Rovin 13). As Jeff Rovin suggests, "[o]ne of Rothacker's first commitments was to spend over $1 million on the picture, money that would be lavished on sets, quality players, and special effects" (16). These lofty expectations are also evident in the film's marketing, with posters for the film exclaiming it to be "[w]ithout doubt the biggest motion picture achievement" (Taves), before prominently mentioning Conan Doyle's name (significantly, positioned above those of any of the cast). This hyperbolic strategy seems to have paid off with the film becoming "one of the top ten films of 1925" (Eagan 97), creating an "avalanche of box-office revenue: receipts in just the premiere week at one New York theatre totalled $13,416" (Rovin 18), and going on to augur Hollywood's belief in the giant monster movie as a consistently commercially successful genre.

The emphasis on size apparent in *The Lost World*'s marketing is reflected in the film itself. Before we see any of the dinosaurs, the narrative emphasises their most significant characteristics. Maple White's daughter (who managed to escape with Challenger) notes the creatures were tremendous in their "size and ferocity". Furthermore, each of White's dinosaur sketches includes drawings of human figures for scale, effectively demonstrating how large they are.

The first dinosaur we see, identified as a pterodactyl, is shown flying above and then landing on a plateau where it feasts upon another dinosaur. The short pterodactyl scene is the first of a series of sequences in which special effects are foregrounded. Challenger's crew next encounter the brontosaurus that they will later transport back to London at the film's climax. The audience have previously been shown the creature in long shots, in which it has been difficult to get a sense of scale, but at this point in the narrative Challenger and his companions encounter the dinosaur up close. The brontosaurus clearly looms over the group as it uproots entire trees to feed on their leaves. In what will become a staple technique of the US giant monster movie, the awe of the human characters is conveyed using close-ups of the emotion on

Figure 1.1 Reverse shot of Professor Challenger and a travelling companion looking in awe at a brontosaurus [off-screen].
Source First National Pictures, 1925

their faces, signalling to the cinema audience that they should respond in kind to the special effects on display.

The vastness of the brontosaurus is emphasised through the repeated use of a long shot of the dinosaur eating, in which it dwarfs the group of human characters in the bottom right-hand corner of the frame.[1] The size of the brontosaurus positions it as carnivalesque; its actions disrupt any sense that the human characters may still hold of being in control. Challenger comments that the brontosaurus is harmless "unless it happens to step on us", and Roxton exclaims that in light of the dinosaur's size "my elephant gun might as well be a bean-shooter!" While the dinosaur does not go on to attack the group directly, it does take a liking to a huge tree that the group had previously used to cross

[1] It is interesting that this type of shot was a necessity born out of the difficulties in showing actors interacting with stop-motion models, yet it works so effectively in conveying a sense of scale, of the creatures in relation to their human counterparts.

from a nearby hill to the isolated plateau. The brontosaurus dislodges the tree with ease, causing it to fall down a ravine and leaving the crew adrift with no obvious means of returning to their base camp and civilisation.

Rather more dangerous to the human characters is the appearance of an allosaurus, which first dispatches an unfortunate trachodon and then attempts to attack a mother triceratops and its baby (a sequence likely inspired by the illustrations of Charles R. Knight's iconic 1906 painting *Rex vs Tops*).[2] These scenes are intercut with shots of the amazed Challenger and the other characters as they are shown to be overwhelmed by what they are watching. Indeed, it is notable that rather than attempt to run away, the human characters on screen are seemingly immobilised by the spectacle they are witnessing, much as the cinema audience are also encouraged to marvel at the actions being depicted. After being deterred by the triceratops, the vicious allosaurus turns its attentions to a night-time assault on Challenger's camp before then going on to battle, and lose its life to, an agathaumus, which is then, in turn, attacked and killed by a tyrannosaurus.

While *The Lost World* is a relatively faithful adaptation of Conan Doyle's novel, the changes that were made in translating the original to the screen are instructive, demonstrating the importance of the carnivalesque to the US giant monster movie from its very beginnings. Ian Duncan writes that Doyle's novel establishes "the dinosaur in the metropolis [as] a catastrophic emblem of urban life" (vii), yet the novel's *dénouement* – with a baby pterodactyl escaping its confines before being seen in various London locations as it flies back to its South American home – seems tame when compared to the film's climax. O'Hoyt's movie increases the sense of threat substantially, replacing the diminutive pterodactyl with a towering brontosaurus. This alteration exemplifies the greater emphasis placed on size and spectacle in the film adaptation. While the novel's pterodactyl is described as "like a huge moth" with "ten-foot wings" (Conan Doyle 184) it can still be contained in "a large square packing-case" (183). In contrast the brontosaurus of O'Hoyt's film is "110 feet long". At the climax of *The Lost World* this brontosaurus, captured and brought to London by Challenger and the Brazilian Geodetic Survey, runs amok in the city. Here the subversive potential of the dinosaur as carnivalesque is evident as the film builds a sense of anticipation in the audience, encouraging us to look forward to witnessing the chaotic spectacle that is to follow. Suspense is created as we are privy to a dramatic phone conversation with the dinosaur's captors: as they reveal that there has

[2] For more details see Debus 179–180.

been a terrible accident, a title card exclaims "[t]he fall smashed the cage – and it got out! It's running wild – the streets are in uproar!" The film ends with the out-of-control dinosaur causing havoc in central London before destroying Tower Bridge and falling into the Thames. This scene of urban devastation (along with an earlier sequence in which a volcano erupts on the Amazonian plateau, causing the dinosaurs to stampede *en masse*) also highlights the giant monster movie's connection to the disaster genre. Tellingly, both sequences are inventions of the film makers who presumably felt that they should add further opportunities for spectacle over and above those found in the original novel. In adding these spectacular scenes of destruction, *The Lost World* imbues the novel's narrative with a greater sense of the cinematic, and effectively visualises the carnivalesque appeal inherent in Conan Doyle's story. The critical response to the film, with many seeing it as "still the most rewarding" (Newman 2000b) adaptation of Conan Doyle's text, seem to indicate that these additions were successful.

Duncan notes that Conan Doyle's story "can be read as a sort of playful homage to the late-Victorian and Edwardian Romance or 'Boy's Own' adventure". Indeed, while Doyle was a "convinced imperialist" (xii) the narrative of *The Lost World* "is a witty and often hilarious performance" (xiii). This humour is reflected in the now deeply problematic racial stereotypes that the film employs, but also, more interestingly, in the film's surprisingly subversive critique of imperialism. Professor Challenger, as played by Wallace Beery, is depicted as a tempestuous man "with the temper – of a gorilla". The comparison is apt because while *The Lost World* does not go as far as explicitly critiquing the conventional binary between the 'civilised' West and the 'barbarism' of the non-Western Other, it does examine the basis for some of these long-held distinctions. It is not by accident that Beery, better known for playing villains, was selected to play Challenger. The film links Challenger to the creatures he encounters in some interesting ways. One of the first actions we witness Challenger perform is to violently pursue the character of Edward M. Malone when he finds out his wannabe fellow traveller is, in fact, a reporter for the *London Record-Journal*. Challenger is depicted tracking down his prey in a fashion similar to that used by the monsters that hunt the Professor and his crew later in the film. These parallels are further emphasised when Challenger attacks Malone on the steps of his house, with the victim's torn clothes and bruised face foreshadowing, albeit in comic form, the violence that will be threatened by the dinosaurs later in the narrative.

Further emphasising the carnivalesque nature of *The Lost World*, the film's climax can be read as a subversive rebuttal of the nationalist

accoutrements of the previous part of the narrative. Where an early scene has the Union Jack hanging prominently behind Challenger at the Zoological institute as he makes his speech about needing to return to the Amazon, triumphalist tones playing on the soundtrack, by the end of the film a brontosaurus is let loose in London, the heart of the British Empire. Significantly, the dinosaur's rampage involves toppling the Duke of Wellington's statue and destroying Tower Bridge. When these actions are combined with the scene where Malone returns to find that the motivation for his adventure, his beloved Gladys, has married an insipid clerk, the film seems to skewer the grandiloquent pretensions of the Imperial Romance. The film's closing shot of Challenger as he falls to his knees, distraught at the devastation he has brought about, seems to confirm the view that *The Lost World* offers a carnivalesque burlesquing of the genre.

There is a great deal of overlap between *The Lost World* and *King Kong*. This is not surprising given that the former film, and Conan Doyle's novel, were a direct source of inspiration for the latter. Such was the degree of influence that, as Cynthia Erb explains,

> [a]t one point, *King Kong* was to be promoted with credits identifying it as "based on a story by" Wallace and Cooper, "adapted from Sir Arthur Conan Doyle's *The Lost World*," scripted by Creelman and Rose, and directed by Cooper and Schoedsack (39).

However, whereas *The Lost World* introduced many of the conventions of the US giant monster movie, it is *King Kong* that forges them into what Noel Carroll calls "one of the miracles of cinema" (1984, 215). This success means that while *King Kong* was not the first US giant monster movie it nevertheless remains the *ur*-text for the genre. The reasons for this enduring status are numerous but central to *King Kong*'s success is the extent to which its narrative emphasises size and spectacle, in the process creating a template that others have been emulating ever since. Carroll has described *King Kong* as:

> the quintessential American film – its image is so enormous [...] It is a swaggering, arrogant film that spends much of its time telling us how great it is, yet its blustering, gigantic view of itself is not off-putting; somehow it accords with the circus-exaggerated energy that is its most distinctive quality (1984, 228).

While hyperbolic in its claims, Carroll's interpretation is difficult to argue with. The wealth of material that has been written about the film

would seem to testify to its ongoing appeal. Of the examples discussed in this book, it is *King Kong* that has attracted the greatest amount of analysis, most notably in Ray Morton's detailed history, *King Kong: The History of a Movie Icon, From Fay Wray to Peter Jackson* (2005), and Cynthia Erb's comprehensive study of the cultural afterlives of the titular figure, *Tracking King Kong: A Hollywood Icon in World Culture* (1998; 2009). While it is not my intention to replicate what others have already effectively covered, given the stated aims of this study it is worth considering the myriad ways in which Merian C. Cooper and Ernest B. Schoedsack's film builds upon the tensions in *The Lost World*. For, like its predecessor, *King Kong* also wavers between a straightforward celebration of size and spectacle, and more subversive and self-reflexive elements that seem to critique this ideological stance.

Bigness is intrinsic to *King Kong*. Before viewers at Grauman's Chinese Theatre got to watch the film upon its initial release, they were confronted with a "forecourt decorated with a Skull Island jungle setting: ferns, tropical plants, live pink flamingos and a full-size moving bust of Kong himself" (Harryhausen and Dalton 17). This sense of presentational theatricality emphasised the scale of the film, and included "front of house stills showing a huge creature towering over a city [...] and a live seventeen-act show" (17). As Ray Harryhausen recollects, of his 13-year-old self's awed response to such epic razzamatazz, "I just sat there mesmerized by the sheer grandeur of it all" (17). This emphasis on spectacle is not surprising given director Cooper's "bigger than life [...] showmanship" (Harryhausen quoted in Behlmer 22). The adult Harryhausen would recount seeing "an original cartoon made for Cooper during the *King Kong* production that [...] showed Cooper jumping up and down screaming 'Make it bigger, make it bigger!' That's what Cooper always said: 'Make it bigger, *make it bigger!*'" (quoted in Behlmer 22).

The film itself opens with a set of imposing titles, proclaiming the last of the film's players as "King Kong (The Eighth Wonder of the World)", accompanied by Max Steiner's grandiose music: "one of the landmark scores in Hollywood history" (Morton 77). Though space limitations do not permit a comprehensive account of the long-running debate concerning just how pioneering Steiner's score for the film was,[3] it is adequate to note that Steiner's approach to *King Kong* was to create

[3] For a comprehensive discussion of this debate see "Reassessing *King Kong*; or, The Hollywood Film Score, 1933–1934" in Slowik, Michael. *After the Silents: Hollywood Film Music in the Early Sound Era, 1926–1934*. New York: Columbia University Press, 2014. 230–265.

a "thundering score" (Erb 108) in which music is used to "create feelings of excitement and nervous anticipation" (MacDonald 33).

This sense of the film operating on an epic scale continues into the story. The opening part of the narrative uses the suggestion of excess to build suspense for the audience. We find out that the crew that film maker Carl Denham has hired for his journey to the mysterious Skull Island is "three times more than the ship needs"; and that Denham is taking "enough ammunition to blow up the harbour", including several gas bombs, one of which would be "enough to knock out an elephant". Once they are nearing the island that houses Kong, Denham reveals to the ship's captain, Englehorn, and first mate, Jack Driscoll, that they will have to navigate a sheer precipice "hundreds of feet high" in order to reach a colossal wall that shields the island's tribespeople from Kong, who is himself a creature of fearsome magnitude: "something monstrous, all powerful".

After the crew get to Skull Island things remain larger than life. First the crew encounter a ceremony in which the massed indigenous population are preparing a woman to become the bride of Kong. Then, following the kidnapping of aspiring actress Ann Darrow by the tribespeople, Denham's crew return to the island and encounter Kong for the first time in the famous sacrifice scene. Here the film demonstrates its prowess as a vehicle for Hollywood's ability to mount large-scale productions, combining grand sets with big casts and cutting-edge special effects. We watch Ann escorted by baying crowds of tribespeople through the massive doors that keep Kong enclosed before she is tied to the sacrificial altar. The huge gate, which was originally constructed for the Biblical epic *The King of Kings* (1927), is impressively used in the sequence, with long shots giving a sense of scale as hundreds of villagers dance across its top (actually a soundstage), and its immense size implying just how large Kong might be in comparison. Repeating a technique used in *The Lost World*, the arrival of Kong is signalled by a series of reverse shots focused on the tribespeople's awed faces before the camera switches to Ann's horrified, upturned visage as the giant creature emerges through the tree line. Kong separates the trees with relative ease, Murray Spivack's striking sound design of the trees creaking as they topple to the ground further emphasising the giant ape's strength and power.

Denham, Driscoll, and some other members of the crew set off to try to rescue Ann, only to discover that Kong is not the only giant creature inhabiting the island. The group first encounter a lumbering stegosaurus in a sequence that illustrates the size-as-spectacle motif that permeates so much of the film. Shot using rear projection techniques, initially the

group spy the dinosaur in the middle distance before it charges at them, getting larger and larger on screen as it approaches the front of the rear projection frame. After shooting the dinosaur and making sure it is incapacitated, the group then walk the entire length of the stegosaurus's body, from its head to its tail, in a scene that is very obviously intended to foreground the spectacular size of the creature for the audience: as Denham exclaims, "just look at the length of that brute!"

One of the film's most iconic special effects sequences comes about an hour into the narrative, when Kong fights an allosaurus. The thinking behind the scene seems to be that the spectacle provided by the presence of one giant creature can only be surpassed by the introduction of a second giant creature. For, while it might be argued that Kong's willingness to fight the allosaurus demonstrates his protectiveness towards Ann, at this point in the story it is not clear what Kong's designs are regarding her and it seems more likely that the film makers intended the sequence to function as a showcase for O'Brien's stop-motion special effects. During the fight, Ann is trapped atop the remains of a tree in the foreground of the scene, operating as both an audience surrogate (she watches in what seems to be a combination of awed fascination and terror) and a means of underlining the scale of the combatants, who are presented using rear projection. Kong and the allosaurus face off, trading blows until eventually Kong manages to overpower his adversary and kill the dinosaur, breaking its jaws apart in what has become an iconic moment of grisly spectacle.

Mark McGurl writes of *King Kong* as a "fantasy of increased scale" (440), proposing that "the identity of the film is deeply imbricated in the technology of enlargement" (440). Building upon the techniques pioneered in *The Lost World*, where scaled-down, stop-motion models were animated against miniature sets, Willis O'Brien and the special effects artists that worked on *King Kong* constructed two 18-inch models to simulate the 18-feet-tall Kong (alongside another, 24-inch model, and 'life size' models of Kong's head and upper body, and right arm and hand). Originally, the plan had been for Kong to be about ten feet tall but during the development process the appeal of having Kong fight model dinosaurs (already built for the uncompleted film *Creation*) led to the giant ape's size being doubled. As Morton notes, "[i]ncreasing the size of the creature increased the possibilities for mayhem it could create" (22). Kong is not only much larger than a normal ape in the film's narrative but as a cinematic artefact Kong disturbs conventional spatial relations, speaking to Hollywood's interest in creating 'larger than life' spectacle through a variety of special effects techniques impossible outside the studio system. Cooper has explained that he "continually

shifted [Kong's] height to fit settings and illusions. He was different in practically every shot" (quoted in Behlmer 21). Scenes such as the stegosaurus charge and the allosaurus fight have become "treasured by the film's fans" and are still seen as representing some of "the greatest achievements in stop-motion animation" (Erb 116). RKO's largesse in facilitating such time-consuming and expensive filming techniques were due to *King Kong*'s positioning as an example of event cinema, showcasing Hollywood's "representational prowess" (Hovet quoted in Hall and Neale 36) in mounting large-scale productions which only the financial strength of the Hollywood system could facilitate. The film's negative cost, the money spent on producing and shooting the picture, was $672,254 at a time when RKO's average budget for an 'A' picture was said to be $225,000. Though *King Kong* did not initially perform as well as financially expected, it went on to become RKO's biggest hit of the 1932/33 season, making over $1.8 million in worldwide rentals.

King Kong builds upon the carnivalesque aspects of *The Lost World* in several important ways. Most notably, *King Kong* is a more explicitly self-reflexive film. Where the actions of the characters in *The Lost World* encourage the audience to view the dinosaurs in a similarly awestruck fashion, Carroll suggests that "[t]hrough the conceit of the film-within-a-film, Kong constantly informs us about how we are to take it. Kong, more or less, writes its own reviews, telling us what to think about it as it goes along" (228). Part of this commentary involves depicting making movies as a disruptive yet revolutionary force. At the start of the film Denham is described as a "crazy fella" with a "reputation for recklessness", who is willing to put his life in danger to get the perfect footage for his films: "if he wants a picture of a lion he just goes up to him and tells him to look pleasant". The actions of the film are set in motion by Denham's "search for spectacular photographic footage" (McGurl 418), the director exclaiming that he wants to show the public "something that nobody's ever seen or heard of", something that "no white man has ever seen". One of the reasons cinema is dangerous is because it enables audiences to see things that they otherwise would not be able to see; what Telotte refers to as "a 'shadow' aspect of reality" (391). This revelatory potential mirrors the "temporary liberation from the prevailing truth and from the established order" offered by the carnival. Both carnival and cinema have the power to change the way we view ourselves and the world we live in; as Bahktin writes, "[c]arnival was [...] the feast of becoming, change, and renewal" (7).

This transformative process is embodied by Kong, a figure that "invites one, not merely to see, but to interpret" (McGurl 416), such is his allegorical nature. Telotte suggests of the titular figure's subversive

potential that "Kong threatens to reverse the normal world by casting his shadow over its normal patterns" (390).[4] Kong's category violations: his gigantic size, his fusion of qualities that seem both animal and human, also lend him a carnivalesque quality tied to Bakhtin's notion of the grotesque body. As Peter Stallybrass and Allon White suggest, for Bakhtin the grotesque body is an "image of impure corporeal bulk", a "mobile and hybrid creature, disproportionate, exorbitant, outgrowing all limits", a figure that resists modernity and instead refers to the "collective, ancestral body of all the people" (9). Kong represents these qualities; his body is not the clean and self-contained body of Classical myth but rather a wild and uncontainable site of excess that collapses many of the usual distinctions between inside and outside. The film emphasises the permeability of Kong's body, as Carroll notes: "Kong is strangled, pecked, burnt, gassed, stabbed, slashed, speared and machine-gunned" (1984, 236). The creature's mouth is also repeatedly highlighted: "Kong's glistening white maw is the most striking thing about him in his first close-up" (236–237). This focus on the mouth evidences the monster's corporeality, as does the infamous (and once censored) scene in which the audience watch the "licentious stripping of Ann" (Towlson 93) at the hands of Kong. The giant ape peels off Ann's tattered clothing, "providing a salacious angle from which the audience can view the scene" (94) and further demonstrating Kong's baser instincts.

In facilitating the monster's passage to New York, ostensibly for exhibition as "The Eighth Wonder of the World", Denham enables the casting of that revelatory shadow that Telotte identifies. The final sequence of the film, with Kong running around unfettered in New York city, represents a spectacular culmination of the parallels that have been drawn between the supposedly civilised environment of New York and the allegedly uncivilised, remote, jungle location of Skull Island:

> Almost point by point, we find, the events on the island match those back in civilization: the native sacrifice and Denham's show; Kong's fight with the snake and his destruction of a train; the ship's crew trapped on a tree trunk and the passengers trapped on the train; Driscoll hiding in a crevice and Ann and Driscoll hiding in a hotel room; the pterodactyl that attacks Ann and the planes that attack Kong; Kong breaking through the great gate and Kong smashing through the theater wall; Kong throwing a native hut

[4] Not least of these possible readings is that of Kong as racialised Other. For more on this interpretation see James Snead's *White Screens, Black Images: Hollywood from the Dark Side.* New York and London: Routledge, 1994.

into the foreground and Kong tossing a car into the foreground; Skull Mountain and the Empire State Building. (Telotte 396)

In asking the audience to consider "how much [...] the conditions of New York resemble those on Kong's Island [...] that this civilized world [...] only barely disguises a grim struggle for existence every bit as desperate as that encountered on the island" (Telotte 397), *King Kong* encourages a critical response to the film commensurate with Bakhin's reading of carnival as a space in which everything is "topsy-turvy [...] [everything] is mixed, hybrid, ritually degraded and defiled" (Stallybrass and White 8). While Denham believes he can restrict Kong, using the tools of "civilisation" to make him a "captive", the movie's ending suggests that Kong's carnivalesque energy cannot be restrained in so presumptuous a manner. In a more spectacularly realised repeat of *The Lost World*'s final brontosaurus in London scenes, Kong rampages across New York causing chaos wherever he goes and temporarily demonstrating the fallacy of civilisation's control over the Dionysian forces he represents. Significantly, and unlike *The Lost World*, which lacks any conclusive return to the status quo, *King Kong* does provide a sense of narrative closure as the giant ape is ostensibly defeated at the end of the film, falling to his death after being shot from the Empire State Building. However, the inherent appeal that Kong seems to have for audiences, as a kind of carnivalesque threat to the staid control of civilisation, would see the figure return again and again in a variety of forms.

Interestingly, for Carroll, one of the attractions of *King Kong* is the way it embodied the carnival spirit present in pre-Second World War America at large, capturing

> that quality or feeling of an admixture of hokum and enthusiasm, superficiality and profound energy, that the movie and show business motifs serve to project. The show business razzamatazz and self-advertising serve to incarnate the *geist* of unsophisticated American dynamism. (230)

Perhaps hoping to capitalise on some of this élan the rushed sequel to *King Kong, Son of Kong* (the film was made in eight months), suggests this energy had been significantly redirected to more diminutive ends. Morton notes that *Son of Kong* "lacks the original's mythic undertones, as well as its spectacularly conceived set-pieces and terrific narrative drive" (110) and it does seem that a great deal of the original film's grandeur has been replaced with a decidedly more comedic attitude to proceedings; scriptwriter Ruth Rose apparently claimed "[i]f you

can't make it bigger, make it funnier" (Fiscus 36). Yet this change in approach also has positive implications for the US giant monster movie, introducing a shift towards the overtly parodic that is in keeping with the self-reflexivity of both *The Lost World* and *King Kong*, but which starts to free the genre from the self-important grandeur central to those two films.

Son of Kong's opening scene, in which a close-up of Kong's monstrous face is revealed to be a poster rather than the 'real' giant ape, seems to set the tone for much of what is to follow. The defining mood of *Son of Kong* is bathos. The film offers viewers a reprise of many of *King Kong*'s most iconic elements, only this time in a noticeably less grandiose form: the "Gustave Doré influence was [...] abandoned [...] resulting in settings that lacked the lush, visually dramatic qualities of those in the first film" (Morton 102). The effect of this process of reduction is that *Son of Kong* often seems to be parodying the 'big is better' motif of its predecessor; the Denham we meet in this film, while still played by actor Robert Armstrong, is depicted as a deflated figure – living in run-down flop houses, dodging debt collectors who are looking to collect on the destruction caused by Kong in the first movie. Where the opening journey in *King Kong* is on the impressive steam liner *The Venture*, in *Son of Kong* the first trip Denham takes is on a rag and bone man's horse and cart with a bag ignominiously over his head. In seeking to escape from his New York debts, with Captain Englehorn from the first film, it is not long before Denham finds himself in the decidedly more exotic locale of Dakang, east Asia, "17,053 miles from Skull Island". In Dakang Denham witnesses an unusual show, "Petersen's Musical Monkeys", which consists of four exotically attired monkeys. The comedic musical routine they perform seems to function as a deliberate call back to and caricature of Denham's grandiose exhibition of Kong as the "Eighth Wonder of the World" in *King Kong*. However, whereas the allure of Kong packed out a Broadway theatre, this down-at-heel show plays to a small crowd of about 30 islanders, and is compèred by an aging ringmaster in a threadbare suit. The initial comedy of this routine is further undercut when we later find out that the ringmaster of the show used to be with "Worldwide, the biggest circus in the East" but is now an alcoholic, struggling to make ends meet, and that his adult daughter Helene used to be a ballet dancer before being reduced to playing vaudeville songs in the middle of nowhere because of her father's drinking.

Son of Kong's interest in the often-depressing realities behind the epic spectacle of the first film also surfaces in the mutiny that takes place on the ship in the second half of the narrative. Stirred up by the dishonest Helstrom, one of the crew of *The Venture* accuses Denham of

exploiting them: "because you pay us your dirty money, you think you own us. You sweat and drive us but you don't give us a living wage for our blood and sweat." While Denham refutes these claims, and the cinema audience are encouraged to side with Denham and Englehorn, the fact that the film stays with the rebellious crew as they then proceed to throw Helstrom overboard because they no longer want "any captains" raises interesting questions about the human cost of the spectacles so beloved by the "blasted bourgeois". This critique of the consequences of the Hollywood spectacle-making process that drove the plot of the first film continues in the next scene of *Son of Kong*, when Denham and his small crew, now thrown off *The Venture*, encounter the tribespeople from *King Kong* who criticise them for letting Kong through the wall and thereby contributing to the destruction of their village. The message (albeit briefly made) seems to be that the spectacle offered by Denham and his ilk is built upon the back of working-class labour and the exploitation of indigenous people, groups who get to see little, if any, of the profit that is being made.

Where *King Kong*'s set-pieces involved epic confrontations between creatures 50 feet tall, and Kong rampaging through the heart of New York City, *Son of Kong* replaces these examples of spectacle with less grandiose stop-motion scenes; we get to see the smaller Kiko (tellingly referred to as "little Kong" by the human characters) stuck in quicksand; a brief but effective attack by a styracosaurus, and son of Kong knocking down a bunch of coconuts. *Son of Kong*'s most spectacular sequence is probably the titular character's tussle with a large cave bear. Designed to replicate *King Kong*'s iconic allosaurus fight, this scene shows the tonal differences between the two films quite clearly. Rather than the thundering display of aggression we get in *King Kong*, which ends with Kong brutally separating the dinosaur's jawbones before thumping his chest and letting out a bellowing cry, here we get "little Kong" rolling around with the bear, intercut with comedic music as he gets knocked on the head and must temporarily (re)compose himself before continuing on with the tussle. Tellingly, the fight ends, not with the death of the bear, but with its being driven away before Kiko licks his wounds and receives medical aid from the watching Denham and Hilda, who seem to act as surrogate parents to the vulnerable creature.

In critical parlance, *Son of Kong* seems to demonstrate the law of diminishing returns. At a final cost of $269,262 the film had roughly half the production budget of the original *King Kong* and was afforded little in the way of the huge promotional spend that its predecessor had been given, though as Morton notes "[i]t didn't really need any – *King Kong* was still fresh in the public's mind" (109). Originally intended as

something "bigger and more elaborate than the first" (Morton 93) *Son of Kong* ended up being only 71 minutes in length. The final film did not include many of the special effects sequences that it had originally been planned to feature (including several jungle scenes and an exciting dinosaur stampede) and ended up reusing "salvaged remnants" from *King Kong* (quoted in Morton 109). The film did well at the US box office and was "a smash hit overseas, especially in Asia" (Morton 111) but its successes paled in comparison to those of its predecessor. Reflecting the criticism made by one of the characters in the film that the son of Kong is "not a patch on your old man", the critical response to the film was somewhat tepid – *The New York Times* called the film "a low melodrama" while *Variety* suggested *Son of Kong* should be viewed as "a wash up of the King Kong theme" (quoted in Morton 109).

However, in its satirising of the spectacular pretensions of *King Kong*, *Son of Kong* might be considered as an early ancestor of the overtly comedic US giant monster movies that were to follow. Its relative lack of commercial and critical success indicates that audiences were not yet ready for its carnivalesque parodying of the genre. Though the film's often glib handling of the giant monster motif seemed to discredit it in the eyes of many contemporary reviewers *Son of Kong* leverages the comedic potential of the genre more explicitly than either *The Lost World* or *King Kong* had done before it. When "little Kong" tests whether his latest dinosaur foe has been defeated by taking its head in his hands and waving it from side to side in the film's final fight scene, the audience is obviously meant to recognise his actions as a repetition of those of Kong at the end of the allosaurus fight in *King Kong*. When the same scene in *Son of Kong* has the dinosaur temporarily revive, eliciting a further flurry of punches from "little Kong" followed by a humorous exclamation direct to camera, it seems clear we are meant to be in on the suggestion that none of this should be taken seriously.

The high bar set by *The Lost World* and *King Kong*, coupled with the muted success of *Son of Kong*, may have made smaller studios wary of tackling similar subject matter. Consequently, very few films featuring giant monsters were made following *Son of Kong*'s release. Producer Hal Roach's *One Million B.C.* (1940) was released seven years after *Son of Kong*. Roach's film proved to be a box office success and was nominated for two Academy Awards. The film, which involved legendary filmmaker D. W. Griffith in the early stages of its production, aims at something slightly different from the type of giant monster movie exemplified by *King Kong*. *One Million B.C.* is less of a straightforward adventure narrative and more of a romance with pretensions to realism when it comes to recreating the prehistoric era (though it is questionable how

realistic a film that has dinosaurs and humans existing in the same period can hope to be). Despite this the film does occasionally feature oversized creatures who terrorise the human, cavemen characters, albeit these monsters are created using different techniques from those in *The Lost World*, *King Kong*, and *Son of Kong*. Instead of models animated through stop-motion *One Million B.C.* contains dressed-up elephants, a pig placed in a baby triceratops costume, optically enlarged lizards, and a man in a tyrannosaurus suit (Webber 111). The film's desire to match the spectacle of *King Kong* is most evident in its emulation of the famous Kong versus allosaurus fight. In *One Million B.C.* a magnified baby alligator and a Tegu lizard fight each other, as the central human characters Tumak and Loana watch. The scene does not quite measure up to the equivalent tussle in *King Kong*, partly because the sense of scale is less convincing, though when Tumak then walks the entire length of the felled Tegu, rear-projected in a facsimile of *King Kong*'s dying stegosaurus scene, the film demonstrates just how shameless its plagiarism is. Ultimately, *One Million B.C.*'s deviance from the established template of the giant monster movie leaves it as an unsatisfying hybrid. Its attempts to emulate the spectacle of its genre stablemates through claims to quasi-historical verisimilitude now leave it seeming rather turgid.

Another eight years passed before Film Classics' *Unknown Island* (1948) hit cinemas. Often featured on lists of worst dinosaur movies ever made, *Unknown Island* appeared to act as a catalyst for a brief flurry of low-budget dinosaur films including *Two Lost Worlds* (1950) and *Lost Continent* (1951). While *Unknown Island* and *Lost Continent* rehash elements of the plots of *The Lost World* and *King Kong* (right down to repeating key scenes), the main failing of these films is that their makers lacked the resources of the major Hollywood studios, and therefore could not effectively realise the sense of scale so central to the appeal of those bigger-budgeted examples. Neither did they attempt the sort of knowing self-reflexivity of *Son of Kong*. *Unknown Island* is probably the most competent of these low-budget examples, though with a budget of $450,000 the film makers had to resort to a combination of model work and actors in rubber suits to realise the film's monsters. The advertising hyperbole that proclaimed that *Unknown Island* was "so spectacular – it took one year to produce!" seems more telling than intended. The film is noticeably limited by its budget; studio stages are disguised by the frequent use of medium close-ups, and the claims made by the character, adventurer Ted Osborne, that we will get to see "the last specimens of gigantic creatures that roamed the earth before man came into existence" turns out to be somewhat disappointing when said

monsters appear to be "[a] sorry menagerie of drunken wobblysaurs" who "ineffectually bash against each other in what are supposed to be fights and stagger around as if they've been on a heavy drinking binge" (Lyons).

The "lighter touch" (Harryhausen 33) evident in *Son of Kong* continued in the next film that Willis O'Brien was involved with, *Mighty Joe Young*. While the film was afforded a bigger production budget than *Son of Kong*, the $1.5 million allocated to *Mighty Joe Young* still paled in comparison to *King Kong*'s budget when adjusted for inflation. When the film went on to lose an estimated $675,000 it proved to be a disappointment for all involved,[5] including RKO who would never release another new giant monster movie, and O'Brien, who would never work on another major studio film. As Webber notes, *Mighty Joe Young* ended up being "the last 'grandiose' stop-motion production" (42), as the film's failure led subsequent film makers to be "wary of the [stop-motion] procedure" (42). In retrospect, *Mighty Joe Young* represents a significant staging post in the development of the US giant monster movie, as Erb proposes that "*Mighty Joe Young* [...] offers a clear example of an effort to reformulate the King Kong story for a postwar context, this time through an emphatic appeal to a young family audience" (129). The film makers' attempts to achieve this difficult goal – balancing genre expectations with their desire to domesticate the monster and thus make him suitable for a younger audience – results in an "internally conflicted" film (Erb 131) that is as interesting as it is flawed.

While all three of the films that Snead refers to as the "Kong" trilogy (34) can be read as self-reflexive, *Mighty Joe Young* is the most sustained in its examination of the consequences of the spectacle-making process and the most explicit in linking the spectacle of its giant ape to the objectification and exploitation of non-Western cultures and their peoples. Consequently, Joe's actions in the film can be read in a carnivalesque manner, with the giant African ape's eventual overthrowing of his Western captors suggesting a desire to overturn established (colonial) hierarchies.

The film opens in "Africa" as the 8-year-old Jill Young bargains with two African tribespeople to try to buy the orphaned baby ape they are

[5] There is some disagreement about just how great a failure the film was in financial terms. While the loss quoted comes from Richard B. Jewell's *Slow Fade to Black: The Decline of RKO Radio Pictures*. Berkeley: University of California Press, 2016 (104), Morton suggests "*Mighty Joe Young* did well at the box office but not well enough to earn back the $2.5 million it cost to produce" (295). Roy P. Webber puts this production cost down to "studio padding of expenses and overhead" (42).

carrying to their camp. Immediately, the sense of 'exotic' spectacle offered by Joe, who is initially hidden from the cinema audience in a basket, is positioned as attractive to the white American Jill; she is willing to trade many of her possessions (and those of her father) to successfully gain possession of Joe. Twelve years later and the film introduces us to Max O'Hara, a Hollywood nightclub owner who is "looking for a new angle" for the opening of his new venue. While the audience is made aware that lions can be purchased in California relatively easily, O'Hara hits upon the idea of travelling to "deepest, darkest" Africa to ensure the lions that appear in his club will be more of a spectacle. When the film moves back to Africa to show us the authentically African lions O'Hara has purchased, he claims he has generated "a million dollars' worth of publicity" for his club; the film connects the objectification of the exotic with the spectacular. This connection is further emphasised when the camp is "attacked" by the adult Joe in the film's first action sequence. Interestingly, while Joe seems to act aggressively towards the caged lion that he attacks, his actions end up freeing the beast, and thus the animal is presumably saved from becoming a spectacle in O'Hara's New York show.

Mighty Joe Young takes the process of reducing the size of its titular ape even further than *Son of Kong*. Partly because of the film's smaller budget, and partly due to the tighter shooting schedule, which necessitated changes in the special effects process, Joe Young is only 12 feet tall in the film. The stop-motion models were "designed to be smaller than the Kong models" (Harryhausen and Dalton 34) to facilitate the use of smaller and therefore less grainy rear-projection images. The results achieve a sense of perceptual realism comparable to that found in its bigger budgeted predecessors. Though he is much smaller than Kong (or indeed the son of Kong) Joe's interactions with the human performers successfully create the impression that they are frequently occupying the same space. This is demonstrated in the next part of the film when O'Hara's crew attempt to lasso Joe. In an exciting scene Joe plucks O'Hara off his horse and carries him to the top of a nearby cliff. He then holds O'Hara aloft, threatening to throw him to his death, only for the showman to be saved when the adult Jill turns up and commands Joe to let O'Hara down safely.

Consequently, O'Hara convinces Jill to be a part of his show as a way of also obtaining the involvement of Joe: "all I want you to do is walk out on the stage, you, and Joe." The scene, though brief, exemplifies the film's contradictory attitude towards spectacle; criticising the amorality of O'Hara's commercially driven desire to create the world's biggest spectacle while simultaneously operating as a piece of cinema that relies

on the special effects spectacle of Joe to meet audience expectations. While even O'Hara's associates, including Jill's future love interest Gregg, urge her to refuse O'Hara's promises of "music, glamour, the bright lights, Hollywood", Jill eventually agrees to the club owner's deal.

The show that O'Hara puts on back in New York is the embodiment of what Donald John Cosentino terms "'Afrokitsch' – mass-produced spectacle based on imitation and appropriation of art forms crafted by local ethnic groups in Africa" (quoted in Erb 133). First, O'Hara's guests are greeted by dark-skinned individuals dressed in clichéd African tribal wear, then they walk through a foyer decked out in jungle paraphernalia, before taking their seats to watch an 'authentically' African musical prelude to the main event, the appearance of Joe and Jill on stage. The artificial nature of this display is emphasised for the cinema audience. The camera shows us that the musical performance is being augmented by a classical orchestra (hidden behind tribal ornamentation); a group of expensively attired guests debate how badly they are equipped to judge the authenticity of the decoration; and O'Hara, in his role as compère, wears a colonial safari hunter's outfit with a pith helmet that looks about two sizes too large for his head. Indeed, as numerous scholars have noted, this scene plays like a recreation of the 'real life' showmanship employed in selected cinemas before screenings of *King Kong*. Just as the young Harryhausen noted how impressive this grandeur was, so a sense of creating something epic is also crucial to the spectacle O'Hara sells to the patrons of his club. We find out that the club owner has promoted the lions that are trapped behind glass in his club's bar as "the biggest lions in the world", and Joe first appears holding Jill above his head as she plays a grand piano, emphasising his strength and size. This emphasis on scale continues in the second part of the show that O'Hara has constructed when Joe plays tug of war with the ten strongest men in the world, competing against their "brawny arms [and] those massive chests" to prove that he is "powerful enough to overcome that combination" by himself.

By the "tenth massive week" of their run, Jill and Joe are depicted as increasingly unhappy. Jill is shown being constantly harassed by fans wherever she goes, and Joe is becoming severely depressed after being kept in a cage between performances. The film's message that Joe's fame is in fact a form of exploitation is made explicit in a scene in which members of the club's audience are instructed to throw huge novelty coins at Joe to try to win free champagne. We are then forced to watch these customers fling oversized money at Joe, the ape's cries of pain contrasting starkly with the close-ups of the patrons' grotesquely laughing faces. Interestingly, the power dynamic found in

King Kong is reversed here and it is the representatives of civilisation that demonstrate their ability to overpower and dominate the giant ape. Joe's size counts for little against the combined actions of the baying crowd: as a dejected Jill puts it, he has become "a target, a clown for all those awful people". That the film condemns this effective mastery of Joe is significant for it points towards an acknowledgement that the appeal of the giant monster movie lies in vicariously experiencing the energies of the monster, not in its taming. Indeed, the carnivalesque pleasures of the US giant monster movie are soon to be liberated. In the very next scene, Joe's destructive potential is unleashed when, following an attempt to get him drunk, the ape breaks the bars of his cage and runs amok in the club, destroying much of the Afrokitsch adornment in a symbolic rejection of his positioning as an exotic spectacle. As he smashes up O'Hara's club we are encouraged to empathise with Joe's anger and frustration at being exploited and view him as a victim of the spectacle-making process rather than as a rampaging monster to be feared.

While Erb concludes her discussion of the film by suggesting that *Mighty Joe Young* favours the domestication of spectacle in favour of family-friendly melodrama, it is possible to argue that parts of the film's narrative foreshadow the ecocritical concerns of the giant monster movies of the 1970s, discussed further in Chapter 3. The film suggests that Joe is "too big" for confinement in New York, his natural but unsophisticated vitality being intrinsically tied to the freedoms that only the less civilised Africa can give him. Africa is positioned as an unspoilt idyll in contrast to the vulgarity of O'Hara's club and, by extension, New York. It is important, then, that Joe gets an opportunity to destroy the accoutrements of O'Hara's showmanship, highlighting their oppressive artificiality, as recreations rather than authentic instances of the 'natural' world. It is only by returning to a bucolic version of Africa free of the perversions of Hollywood, as he does in the final scene of the film, that Joe can be happy again.

O'Hara's complete change of heart in the penultimate part of the film, his admission to Joe that "I should have left you in Africa where you belong", and his helping to orchestrate Jill and Joe's escape, provide an uplifting finale to *Mighty Joe Young* yet also threaten to undermine much of the film's criticism of the tawdriness of the Hollywood system. It is unclear whether the audience are really meant to overlook O'Hara's exploitative behaviour in tricking Jill and imprisoning Joe just because the character belatedly realises this is not a moral way to go about doing things. In extradiegetic terms, Armstrong's appearances playing similar showman roles in *King Kong, Son of Kong*, and *Mighty Joe Young* suggest

an intentional continuity that encourages a reading of O'Hara's actions in this third film as a form of redemption, giving the character, and (perhaps more importantly) the actor, a noble send-off. Nevertheless, such volatility in O'Hara's character serves to sidestep the issue of just how much harm Hollywood's drive for ever bigger forms of spectacle should be allowed to cause before those responsible are punished.

This equivocation also manifests in the film's climactic sequence when the escaping Jill and Joe intervene to help save a burning orphanage. The sequence provides the film with one last chance for spectacle, as, under Jill's instruction, Joe rescues several children while the burning building they are trapped in dramatically collapses. Erb suggests the scene connects "Joe's actions [...] with a child's terror and anxieties about homelessness" (141) and is therefore designed to "cancel the forcefulness of Joe's earlier outbreak and rebellion in the club" (141). Certainly, Joe's domestication seems complete when he peels the banana that is thrown to him in the reel of home-shot film Jill and Gregg send O'Hara at the end of the film. Yet O'Hara's exclamation when Joe walks into frame – "Yikes!" – seems to acknowledge, even if only parodically, the threat that Joe still potentially embodies. The ambiguity at the centre of *Mighty Joe Young* reflects the impermanence of the carnival. Much as Bakhtin suggests that the carnival is a temporary break from the established order, so the film seems happy to highlight the exploitation involved in the spectacle-making process but ultimately refrains from condemning it outright.

The "defanged" apes (Snead 33) of *Son of Kong* and *Mighty Joe Young* proved less popular with audiences, meaning that studios, in turn, were less inclined to spend substantial amounts of money on making more giant monster movies. Moreover, the carnivalesque pleasures of seeing destruction writ large necessitated huge budgets and lengthy production times. One possible answer to this problem would be found with the next feature-length film Harryhausen was to work on, *The Beast from 20,000 Fathoms* (hereafter *Beast*). While Kim Newman notes that *Beast* was a direct result of the unexpected success of the rereleased *King Kong*, which in 1952 "earned four times as much as it had done during its original depression run" (2000, 79), *Beast* was to prove "revolutionary" (86) for the genre. Whereas *Mighty Joe Young* had suffered from studio padding, escalating the costs associated with the film to the point where its ability to make a profit was severely curtailed, *Beast* was made on a much smaller budget of around $210,000 yet went on to become the fourth-highest-grossing movie of 1953. The film proved "the surprise hit of the year" (Rovin 75), earning "about $5 million at the box office", and was viewed as "a triumph of quality moviemaking

on a shoestring budget" (Webber 77), in the process establishing a cost-efficient model that would quickly become a template (overused) for future giant monster movies in the USA.

Rovin writes that one of the strengths of *Beast* is the way in which Harryhausen was able to create effects comparable to *King Kong* on a much smaller budget and over a considerably shorter period than previous examples of stop-motion had required. Harryhausen achieved these results by working alone and by coming up with ways to give the impression of a grand scope that were cheaper than miniature settings and glass paintings. Foremost among these techniques was the "reality sandwich", which involved the shooting of the live action elements of a sequence, with the actors pretending that the monster is present, then projecting a miniaturized version of this footage across a miniature stage and animating the creature against it:

> Ray's innovation was to matte out those elements which he wanted in the foreground [...] and then matte them *back into* the negative containing the miniature-projected stop-motion footage [...] Ray's trick, which could be accomplished in an optical printer, was both slick, less expensive, and more realistic than these other methods of superimposition. (Rovin 83–84)

Because of Harryhausen's pioneering work *Beast* managed to reinstate the epic kind of spectacle achieved in *King Kong*. The sense of size being important to the film starts with the central monster, alluded to in the film's title. The rhedosaurus was specifically designed as a composite of several dinosaurs that had existed because, as Harryhausen suggested, "[w]e felt that a real dinosaur would have been too small for our purposes" (quoted in Webber 50). The rhedosaurus is revealed to weigh about "500 tons at least" and measures approximately "200 feet from nose to the tip of the tail" (Webber 50). Consequently, the creature's spectacular qualities are doubled as it is an example of both magnification and fusion; being larger than any known single species of dinosaur while also combining qualities from several known to have existed.

The rhedosaurus is awakened from its enforced hibernation by the controlled explosion of an atom bomb in the Arctic Circle. The film immediately demonstrates the spectacular consequences of this experiment. The explosion of the bomb is followed by several exciting shots (drawn from stock footage) that illustrate its power: collapsing ice shelves, cracking glaciers, and repeated images of a huge nuclear mushroom cloud. Colonel Jack Evans and Professor Tom Nesbitt, two

of the characters involved with the experiments, further reinforce the vastness of the force being dealt with, Nesbitt ominously noting "when energy of that magnitude is released it's never over; what the cumulative effects of all these atomic explosions and tests will be, only time will tell". Given the rapid pace of the early part of the film, not much time passes before the audience get a sense of what one of these effects will be. The rhedosaurus first appears in the middle of an Arctic blizzard, the film using a brief glimpse of the creature, combined with its shadow and guttural roar, to suggest its size, before the dinosaur reveals itself atop a snowy precipice, causing one of Nesbitt's fellow scientists to fall down a nearby ravine in sheer amazement. The incredulity continues when the rhedosaurus reappears at the top of the ravine, its size triggering an avalanche that leaves Nesbitt as the only person alive to have seen the creature.

As a result of the professor's injuries, he is taken to receive medical care in New York. Psychiatrists there believe that Nesbitt's claims of a monster are the result of trauma brought on by the shock of seeing his friend killed. This motif of the singular witness who tries to warn others of the existence of the monster would become a recurrent feature of the US giant monster movie after *Beast*, helping to build tension for cinema audiences while also underlining the spectacular nature of the creature – no-one believes the witness because the existence of the monster is too incredible to comprehend without seeing it for yourself.

Beast then cuts to two fishermen whose boat is attacked by the rhedosaurus. The creature appears to play with the boat bobbing in the water, before finally sinking it. While Harryhausen had previously worked under O'Brien on *Mighty Joe Young*, *Beast* was the first feature-length film in which he had taken charge of technical effects. Webber notes the "wonderful characterization" (61) of the rhedosaurus, ascribing this sense of personality to Harryhausen's animation techniques, which work to imbue the creature with "familiar animal mannerisms [...] he clearly based much of its behaviour upon that seen in a dog" (61). The consequences of this approach to animating the rhedosaurus are that it often appears that the film is encouraging the audience to sympathise with the creature, even as it goes about destroying much of New York in the latter part of the story. Though we learn that the rhedosaurus is responsible for "180 known dead, 1,500 injured, damage estimates $300 million" Webber states its characterisation is such that killing the dinosaur "brings with it a touch of pathos" (62). The carnivalesque aspect of the film, the enjoyment an audience can take in watching the monster's destructive actions, is most apparent in *Beast*'s climactic scenes. Surfacing at the Manhattan docks, where its elongated head and

neck tower over the assorted packing containers, the monster swiftly exits the river and proceeds to terrorise the city. Cue many sequences of crowds running away from the off-screen monster, and an unintentionally humorous scene in which an overly courageous cop seems to think he can defeat the gigantic creature with a pistol, only for the rhedosaurus to lift him into the air and eat him whole. While much of the final part of *Beast* is a repeat of the ending of *King Kong*, the film attempts to outdo Kong by having the rhedosaurus' rampage go on for much longer. After the initial attack on Manhattan we are shown a news presenter who reports that "New York is like a city besieged, a state of emergency has been declared". If Kong was dispatched relatively swiftly from atop the Empire State Building, *Beast* seems to want us to know that it is not so easy to defeat the rhedosaurus. Indeed, it takes the combined might of the police force "put on 24-hour duty, civilian forces fully mobilised" and "the national guard [...] fully armed" to deal with the monster: as the reporter suggests, "this is full-scale war against a terrible enemy such as modern man has never before faced".

The fact that the creature cannot be killed quickly means that the audience also gets the chance to see even more of the monster. In an exciting night-time sequence, the rhedosaurus is held back by an electric barricade before the army try to deter it by shooting it with a bazooka. Unfortunately, this is not a viable approach to defeating the monster as the characters find out that the creature's blood has the potential to infect those who come into contact with it. Luckily for mankind, "a method of destroying the awesome creature" is eventually discovered: shooting a radioactive isotope into an open wound on its neck. The rhedosaurus is cornered at the amusement area of Manhattan beach. The scene making explicit the position of the monster as carnivalesque spectacle, it is trapped between the undulating tracks of a rollercoaster and Nesbitt and the army sharpshooter must ride the coaster to its highest point to get a clear shot at the dinosaur's neck. The setting is an apt one as *Beast* offers pleasures similar to the rollercoaster; as Angela Ndalianis notes, "the overlaps between the two media are deeply connected on a systemic level" (14). Much as the structure of a stereotypical rollercoaster places an emphasis on thrills, so in *Beast* there is a recognition that the audience has less interest in narrative than in the visceral, affective pleasures of its special effects sequences.

In terms of the future development of the US giant monster movie, *Beast's* return to an explicit emphasis on size as spectacle would be emulated *ad nauseam* in monster movies of the 1950s. *Beast* also pointed the way forward in introducing a shift in the symbolism of the monster: "In retrospect, *Beast* was the first motion picture

Figure 1.2 The beast from 20,000 fathoms attacks a rollercoaster.
Source Mutual Pictures of California, 1953

linking radioactivity together with gigantic (and usually ill-natured) creatures, inventing an entire subgenre" (Webber 76). Whereas many of the other films in this chapter had used their monsters to explore the threat posed to the contemporary (Western) world by a carnivalesque eruption of the primitive into its midst, *Beast* combined this threat with a warning about the dangers posed by nuclear power. It is not too much of a stretch to read this element of *Beast* as a response to the series of above-ground atom bomb tests carried out in Nevada in the 1950s. In a conversation between Nesbitt and Dr Thurgood Elson *Beast* suggests a causal relationship between the 'modern' process of nuclear testing and the unleashing of the primitive energies represented by the rhedosaurus. The two characters discuss how the dinosaur is over "a hundred million years old" but has been awoken from its frozen "state of hibernation" by the "heat generated" as a result of the explosion of the atom bomb, which "melted the ice" in a way that nothing could previously have done. While so many of the films discussed in this chapter evoke pleasure in the carnivalesque spectacle of the monster as primitive Other challenging the hegemony of modern civilisation,

the 1950s would see the genre update this formula to explore both the desires and the anxieties of the nuclear age. It is to some of the more interesting films from this era that we turn in Chapter 2.

2

Atomic Terror! Big Bug Movies and the 1950s' Giant Monster Movie Boom

In his insightful re-evaluation of genre films of the 1950s, Mark Jancovich argues that the decade's horror films have been wrongly positioned as "represent[ing] the genre's 'reactionary' wing'" (1). Instead of seeing the defining trait of such films as being "a conservative, Cold War politics" (2), Jancovich proposes that "[t]hese texts often display an anxiety about humanity's role within the cosmos" (27), exploring contemporary fears about the amount of control we have over our everyday lives: "Science may save us at times, but it also creates a world which we can no longer recognise, a world in which giant ants or man-eating plants threaten to overwhelm us" (27). That Jancovich should include several of the better-known giant monster movies in his discussion of 1950s genre fiction is not surprising given just how many examples of the genre were released during the decade. Indeed, the giant monster movie became so prevalent in the USA during the 1950s that it would be impossible to cover all the films that were released. Instead, this chapter will explore a range of key examples of the US giant monster movie, examining the significant changes that took place in the genre during this era following the earlier success of the *Kong* cycle of films (and their associated spin offs and imitators).

Despite claims that the "American film seemed to have a crisis of proportion" during the 1950s (Pomerance 179), the number of giant monster movies released during the decade seems to indicate that many film makers still felt confident that the type of spectacle promised by the genre could appeal to audiences. However, while "'Bigness' set the agenda for the relevance and financial viability of Hollywood in the 1950s" (Acland 167), as we will see in this chapter, the fact that the once lavish production budgets of the *Kong* era were often no longer available to help facilitate this spectacle would have significant consequences for the genre, even if other parts of the US film industry were flourishing.

In the first half of the 1950s, examples including *Them!* (1954), *It Came From Beneath The Sea* (1955), and *Tarantula* (1955) took up the baton from *The Beast from 20,000 Fathoms* (from here on, *Beast*), seeking to replicate its successful ratio (low production cost to high profit). Such films sought to emulate *Beast*'s suspense-laden structure that conveniently kept the monster off-screen for a considerable amount of its runtime. Where *King Kong* had been designed as a big-budget studio epic, evidence of Hollywood's "representational prowess" (quoted in Hall and Neale 36), *Beast* and many of the films that followed it were intended to be low-budget, 'B' pictures from the outset. Following the Paramount Consent Decree in 1948 and the breaking up of the major studios' stranglehold on exhibition that followed, studios increasingly needed inexpensive yet marketable concepts to help minimise costs and maximise profits. *Beast*'s relatively low budget; its proven commercial success; and its ability to play to a range of different audiences (including the important, emerging teen demographic) meant that Columbia and Universal would soon join Warner Brothers in producing films heavily indebted to its formula. Noel Carroll calls this the "complex discovery plot" and suggests that it has four stages: "onset, discovery, confirmation, and confrontation" (1990, 99). In the giant monster movie this manifests as a series of seemingly unexplainable events taking place (*onset*); a group of professionals coming together and eventually working out what is going on; the giant creature being revealed at about the half-hour mark (preferably later for the sake of the production budget) (*discovery*); more investigation ensuing, then several scenes of destruction (*confirmation*); before the group, often in conjunction with the armed forces, help to defeat the monster at the film's end (*confrontation*). This basic plot structure would be repeated *ad nauseam* before the decade's end.

This formula had implications for the carnivalesque elements of the genre, too. By delaying the emergence of the monster, the films that followed in the wake of *Beast* often limit the number of scenes of destruction they contain. Yet, while this constraint might suggest a concurrent decline in the subversive pleasures on offer, the use of an escalating plot in which the expected outcome (a spectacular confrontation between the creature/s and a recognisable city or landmark) is repeatedly suggested yet deferred arguably heightens the pleasures on offer.

In criticising nuclear power, the 'big bug' cycle of movies, perhaps the "best-known form of American atomic age monster movie" (Bogue 115) can also be seen as inherently subversive. The repeated plot device in which the monster is frequently the result of an unnatural growth

spurt caused by some form of nuclear radiation suggests a rejection of the military–industrial complex; the forces, be they governmental, military, or scientific, that are responsible for unleashing such power in the first place. This trend would spread further than just those films featuring giant insects (or arachnids) that became a recognisable trope of the genre – "an overarching metaphor or master-narrative for the era as a whole" (Jones et al. 9), though it must be noted that as carnivalesque as this trope might seem, often it is also representatives of officialdom (soldiers, doctors, scientists) that help save the day in such films.

Perhaps unsurprisingly, given they were responsible for releasing the film, Warner Brothers were among the first of the major studios to attempt to capitalise on the success of *Beast* with their next genre entry, Gordon Douglas' *Them!*. The film's title, which obfuscates the true nature of the creatures at the centre of the narrative, epitomises the sense of suspense that is built effectively in the opening section. The techniques successfully employed in *Beast* to build anticipation are honed further still in *Them!*, to the extent that the narrative becomes, as one character self-reflexively notes, a means of playing "footsie" with an expectant audience.

Them! opens *in medias res* as a search party find a catatonic young girl wandering the New Mexico desert. We quickly discover that the girl has narrowly escaped a mysterious attack on a nearby trailer that has been left in a state of disrepair. The protagonists, police Sergeant Ben Peterson and Trooper Ed Blackburn, then hear an eerie noise emanating from out in the desert landscape but cannot come up with an answer that "adds up", to help explain what has happened. They subsequently discover a murdered store owner in his ransacked shop. Once again Blackburn hears the eerie noise from the desert and this time he goes to investigate. He is then attacked by something that violently kills him off-screen.

Much as with *Beast*, a small team of experts are rapidly assembled, including FBI agent Robert Graham and doctors Harold and (his daughter) Pat Medved. Like *Beast*, the team in *Them!* have scant evidence to indicate who, or what, has killed Blackburn. This time round there are no eyewitnesses, only a repeated, eerie noise; the presence of sugar at the crime scenes; and a series of "gigantic" prints left in the sand. The explanation of what is happening is delayed even further in *Them!* than it is in *Beast* as Medved Snr chooses not to reveal to either Peterson and Graham, or the audience, his theory that the culprits are *Camponotus vicinus* – North American ants, "over eight feet" long – until he can be "positive" this is the case. At one point the doctor tells an impatient Graham "please believe me, I am not being coy with you. If I'm wrong,

no harm has been done. But if I'm correct... then something incredible has happened in this desert. In which case, none of us will risk revealing it because... none of us can risk a nationwide panic." The opening part of the film offers those watching just enough clues to suggest that something "monstrous" is indeed involved but effectively prolongs the moment before the titular creatures are revealed. This use of suspense reduces the potential size of the visual effects budget as it is not until the 28-minute mark (a third of the film's total running time) that any special effects are needed on screen.

Them! has become perhaps the most iconic of the US nuclear 'big bug' movies; Mike Bogue calls it "the most successful example of its class, the finest 'big bug' movie ever made" (127) and Kim Newman suggests that *Them!* is a "more successful film than" *Beast* (2000, 80). In ideological terms, the film certainly expands upon *Beast*'s exploration of the possible consequences of the (mis)use of nuclear power. Medved Snr reveals that the giant ants have been created by "lingering radiation from the first atomic bomb", linking the evolution of the film's monsters to the real-world Trinity test, part of the Manhattan Project's attempts to develop new types of weapons. Scientific progress, as represented by the bomb, has created giant mutations that threaten to spread across the USA and overthrow humanity's position as the dominant species, within as little as a year. Rather than celebrate atomic experimentation, *Them!* "implies that the scientific pursuit of progress is actually in danger of simply destroying the world rather than improving it. It is in danger of hurtling humanity back into prehistory rather than forward into a brave new world" (Jancovich 54). In this sense the film updates the pleasures of the *Kong* cycle of films, transferring the carnivalesque forces of the primitive giant ape to the freakishly enlarged insects that it eventually shows us.

The film's iconic status undoubtedly hinges on the film makers' choice of creature. Ants as insects "tap into entomophobic associations of rapid breeding cycles that threaten to overwhelm; of insidious infiltration into man's domestic and personal spaces; of uncontrollability" (Butcher and Leaf 7). Yet where the *Kong* films and their reliance upon simian creatures arguably present audiences with giants that are in some measure relatable to humans, the insects of the 'big bug' cycle represent a more distinctly alien version of "Humanity's Other" (Brown xi). The giant ant models created for *Them!* stress the creatures' insectoid features. The models' spiky antennae, their compound eyes, and their exoskeletal bodies all foreground their alterity, their strangeness and distance from what we recognise in ourselves. While the ants in the film are much enlarged over their naturally sized brethren, the other

significant threat they pose to humanity is their growing numbers. Indeed, *Them!* alters the formula of the US giant monster movie by introducing the threat of multiple giant creatures working together.[6] Whereas the *Kong* cycle and *Beast* both focused on a single, often isolated creature, the danger in *Them!* is that "a single queen can lay thousands of eggs" and therefore there may be anywhere from "several hundred to several thousand" giant ants in existence. The threat of being overwhelmed by the ants, with the ending of the film concerning a race to prevent breeding colonies being propagated across the rest of the USA and the world, suggests that *Them!* may also be interested in exploring post-war attitudes to identity and conformity. We learn from Medved that the ants are a particularly functional and unfeeling species: before the film's climax he shows the other characters an informative film which seems designed to demonstrate the ants' aggressive yet utilitarian approach to life: "Males are unequipped for survival beyond the mating and die soon after." Medved suggests that each ant is part of a collective, lacking the agency and subjectivity that defines humanity; as Jancovich proposes, "the ants [...] are used as a metaphor for a social order in which the populace are little more than standardised, conformist and interchangeable subjects who simply exist to fulfil the needs of the state" (61). This critique of conformity can be seen in the film's handling of the Lodge family. The father is killed and his body mutilated by the giant ants, but rather than give up the rest of the family for dead (as the ants would do), the US forces combine their search and destroy mission with an extensive manhunt for the two missing Lodge children. The efforts to which those in power go in saving the otherwise ordinary Lodge children helps demonstrate how much they care about every US citizen, a marked contrast to the ants who, as Medved tells us, "have an instinct and talent for [...] savagery".

While *Them!* locates its action on the outskirts of Los Angeles and thereby downplays the carnivalesque appeal of seeing its giant ants destroying the markers of civilisation, *It Came From Beneath the Sea* more closely emulates *Beast* in foregrounding monsters rampaging in and around cityscapes and their recognisable landmarks. The film is perhaps best remembered for its giant creature's destruction of San Francisco's Golden Gate Bridge, an iconic image that was critical in

[6] Indeed, in his insightful unpublished doctoral thesis on the killer bug film, Liam Hathaway reads *Them!* in terms of post-war fears concerning overpopulation, with the "overbreeding species" reflecting "the booming US population and the contemporaneous environmental problems this caused" (97).

getting it made; as Ray Harryhausen recounts, the producer, Charles H Schneer, had a singular desire: "he wanted to make a picture of a giant octopus pulling down the Golden Gate Bridge" (quoted in Rovin 87). The rest of *It Came From Beneath the Sea* is perhaps not as memorable as this scene and offers only the slightest variation on what was rapidly becoming the standard formula for the 1950s' giant monster movie. In this case H-bomb tests have irradiated a giant cephalopod meaning it can no longer catch its natural prey and instead must rise to the surface in search of an alternative food source, attacking San Francisco before it is eventually vanquished.

It Came From Beneath The Sea does help to demonstrate the continuing emphasis on spectacle in even relatively low-budgeted examples of the genre. While the film features no major stars and the human characters are sketchily drawn, Harryhausen's stop-motion effects provide an impressive monster and he manages to imbue the titular creature with a surprisingly large amount of personality. *It Came From Beneath The Sea* had a smaller budget than *Beast* (believed to have been between $100,000 and $150,000 compared to *Beast*'s $210,000 (Webber 79). That just over a quarter of the film's budget went to Harryhausen and the film's visual effects (Harryhausen and Dalton 70) suggests an understanding that these elements were of primary importance to the genre. Nevertheless, this smaller budget meant that Harryhausen notoriously had to reduce the planned octopus' tentacles by two (creating, as the animator put it, cinema's first sextopus). The pressing financial limitations of the film (it was designed to be a 'B' picture, released as a double feature with *Creature with the Atom Brain*) also show in its employment of stock footage (some of which is cribbed, tellingly, from *Beast*), and its use of location shooting in and around the San Francisco Navy shipyard (which was cheaper than building sets). Given the iconic nature of the creature's attack on the Golden Gate Bridge in the film, it is ironic that the film makers were denied permission to shoot on the real bridge and instead resorted to guerrilla shooting methods to get their footage: "the necessary footage was shot on the sly, from the back of a bread truck and other clandestine locations" (Rovin 94).

Despite these budgetary restrictions, the creature's demolition of large parts of the San Francisco Bay area, including the Oakland Ferry building and the Market Street clock tower, provides a visually striking, albeit brief, set of climactic scenes to end the film. This finale once again speaks to the carnivalesque and subversive nature of the genre: *It Came From Beneath The Sea* relies almost wholly on the spectacle offered by the partial destruction of civilisation for its appeal. The

promotional material for the film notably placed the sextopus' attacks on San Francisco's landmarks front and centre, using repeated images of the "dangerously radioactive" creature destroying the city to sell the film to audiences. Even with its relatively limited budget, *It Came From Beneath The Sea* went on to make $1.7 million on release, leading to more collaborations between producer Schneer and Harryhausen and pointing the way to the many formulaic takes on the giant monster movie that would fill cinemas towards the end of the decade.

Universal hoped to get into the giant monster movie business with *Tarantula*. Fortuitously, they chose Jack Arnold to direct the film. Arnold has been described as "one of the best Sci Fi directors of the 1950s" (Andrews quoted in Jancovich 170) and as "a striking, often brilliant fantasy director" (Hardy 139), responsible for many of the decade's best remembered science fiction films. Like *It Came From Beneath The Sea*, *Tarantula* manages to distil the key components of the atomic era US giant monster movie into an effective if unoriginal whole. Bartlomiej Paszylk comments that *Tarantula* "remains one of the best films of its kind" (58) due to the "the unrelenting atmosphere of mystery [...] and the ingenious special effects" (60). These special effects involved the use of a real tarantula filmed against miniature sets and enlarged through trick photography.

Like many examples of the genre, size is central to *Tarantula*'s narrative. Arnold has suggested that the film's genesis came from contemporary developments in agricultural science: "I tried to use the scientific discoveries the botanists were making in growing larger vegetables, the work of Burbank, just taking it one or two steps further, using it on living animals" (quoted in Kelley 21). The nature of these origins might help to explain the critique of science that we find in the film. Where *Beast* and *It Came From Beneath The Sea* both blamed the atom bomb for triggering their respective creatures' disruptive emergence and behaviour, and *Them!* suggested that its ants had been mutated by radioactive fallout, *Tarantula*'s spider is the result of direct, albeit careless, scientific experimentation.

The plot follows good Dr Matt Hastings, as he uncovers the horrifying consequences of Dr Gerald Deemer's unthinking experimentation on enlarging animals. The audience first see Deemer in his laboratory, checking in on an abnormally large rat and guinea pig that he has created. Deemer then moves over to a tarantula in a terrarium on his desk before a much bigger, approximately dog-sized, tarantula suddenly looms into shot behind him. This tarantula is another of Deemer's test subjects. The foreboding music that is used in this scene and the spider's threatening behaviour as it rears up, scratching against the

glass of its cage, signpost the recklessness of the scientist's experiments. The lack of any sort of emotional reaction to the enlarged tarantula suggests Deemer's scientific detachment from his evidently monstrous creation. Inevitably, given the sense of foreboding, it is not long before a deformed and disgruntled former lab assistant turns up to attack Deemer, accidentally setting the laboratory on fire in the process and freeing the tarantula, which ominously creeps out of the open lab door and into the desert landscape.

Popular upon its original December 1955 release – "*Tarantula* paid for itself and much *much* more" (Weaver et al. 386) – the film is proof of the continuing commercial appeal of the US giant monster movie. However, it differed from many of the films that had come before it as the titular creature was not a created special effect (an animated model or a puppet). Therefore, any characterisation of the tarantula had to be achieved through other means. While music, sound effects, and the careful framing of the 'natural' behaviour of the real tarantulas that were used on the film all play a part, Niklas Salmose notes that "arachnids are generally associated with negative qualities" (146); the tarantula's enlarged size becomes central in conveying a sense of its personality.

The audience for the film quickly finds out that the tarantula's rapid growth is a result of Deemer's work developing an advanced yet inexpensive nutrient supplement, which he hopes can be used to combat "the disease of hunger". Deemer plans for his supplement to be used to grow significantly larger livestock than is naturally possible and, in the process, create greater quantities of food for the world's ever-increasing population. As well as experimenting on tarantulas (which are not traditionally part of most American diets) the fatal flaw in Deemer's work seems to be that he has been using the "radioactive isotope, ammoniac" as a binding agent. This isotope turns out be dangerously unstable, leading the tarantula to behave unnaturally aggressively. Through this plot device the narrative links enlargement to instability, imbuing the creature with carnivalesque properties; as Robert Stam suggests "the aleatory" (86) is central to the carnival's energy and its ability to disrupt the status quo. That which is large, like the spider, cannot be trusted to behave in a rational manner; as the local sheriff exclaims, "I don't know where to start thinking". Once the spider is bigger than normal and displaced from its natural environment, it becomes "something that's fiercer, more cruel and deadly than anything than anything that ever walked the Earth". The giant tarantula starts a rock fall that nearly kills Hastings and his love interest Stephanie Clayton; it kills and feeds upon a local farmer's cattle; goes on to attack

Figure 2.1 The giant tarantula's face peers menacingly into the window of Deemer's isolated house.
Source Universal International Pictures, 1955

a horse ranch; and throws the rancher's pickup truck 30 feet across a nearby field.

In the climax of the film the now gigantic tarantula terrorises Deemer and Clayton in Deemer's isolated homestead. We watch as the spider's huge eyes get closer and closer to the window of the unsuspecting Clayton's bedroom (echoing a similar scene in *King Kong*), before it clambers over the roof, destroying the building with its weight, and crushing Deemer in the debris.

Luckily Hastings arrives to rescue the imperilled Stephanie, driving them off at high speed in his car. After a failed attempt to blow the tarantula up with dynamite, the creature is eventually killed by napalm just as it nears the local town.

Like *It Came From Beneath The Sea*, *Tarantula* testifies to the increasingly spectacle-oriented nature of the genre at this point in its development, the burning remains of the giant, flailing spider making for a spectacular ending to the film. While it is true that special effects had been of paramount importance to earlier examples of the genre including *The Lost World* and *King Kong* their narratives also provided

memorable characters such as Professor Challenger, Ann Darrow, and Carl Denham. In contrast, Dr Deemer, who might conceivably have been fashioned into a Dr Frankenstein or Moreau-like figure, is drawn superficially. Indeed, a reading of the genre's pleasures as primarily carnivalesque might suggest that human characters are unimportant, for "[c]arnivalesque art [...] sees its characters not as flesh-and-blood people but as abstract puppetlike figures" (Stam 137) whose main role is to be threatened, maimed, or killed by the giant monster. *Tarantula* does not go quite this far but it does propose that, in keeping with the 'big bug' formula, ultimately atomic power, not the scientists who attempt to wield it, is the real evil. Consequently, Deemer is depicted as someone who had the best of intentions but made a tragic mistake in using radioactive materials in his experiments; "the film implies that even nuclear knowledge used for good nevertheless goes awry" (Bogue 138).

The year 1956 saw the American release of a heavily recut and mistranslated version of Toho Studios' *Gojira* (1954), renamed *Godzilla: King of the Monsters*. While, technically, the central creature is not an enlarged version of anything – Godzilla has always been as big as he appears in this version of the story – the influence of the film on the giant monster movie genre has been so immense that it would seem wrong to discount it on those grounds. Several critics have noted the damage done to the original tone of the film by the US re-edit. Chief among these is William Tsutsui, who has criticised the recut for jettisoning "many of the meatiest and stimulating scenes in *Gojira* [...] sapping the film of its gravity and its message" (40–41), and Danny Peary, who suggests that the American version of *Gojira* deliberately tries to excise any references to the damage done by the A-bomb (quoted in Ryfle 56). Because of these cuts *Godzilla: King of the Monsters* is arguably less subversive than the Japanese original. Where *Gojira* tries to ask challenging questions of those in power, the US version "does nothing to jar the status quo" (Tsutsui 41) and carries little sense of a moral message. Put out by Embassy Pictures, the film went on to earn over $1 million in theatrical rentals and was responsible for bringing the iconic monster to an international audience.

The Supreme Court's 1948 decision to force the five major Hollywood studios to sell off their cinemas (the "Paramount Consent Decree") opened the market for the growth of a host of independent production studios during the 1950s, most notably American International Pictures. Like many independent studios AIP targeted their films at niche audiences, and relied upon them for the films' success. While the tendency for expensive spectacle in the giant monster movie might suggest that independent film makers would avoid it, encouraged by

the success of studio films such as *It Came From Beneath The Sea* and *Tarantula* the decade witnessed several attempts to reformulate the genre within the constraints of an extremely low budget. Critics, such as Jancovich, have suggested the limits within which independent film makers worked sometimes led to more interesting approaches: "these films were not necessarily of poor quality; indeed, in different ways, many were formally innovative" (198). Certainly, films such as *The Amazing Colossal Man* (1957), *Attack of the Crab Monsters* (1957), and *The Blob* (1958) had to find ways to appeal to an audience that did not rely upon expansive visual effects budgets. Central to many of these films was an acknowledgement that they could not hope to achieve the levels of perceptual realism possible within the Hollywood system. Instead, and often looking more towards the model set by *Son of Kong* than *King Kong*, self-deprecatory comedy bumped shoulders with self-reflexive commentary, creating an eclectic mix that further opened the genre to the playfulness of the carnivalesque.

Away from the 'big bug' cycle of movies, there was a second series of giant monster movies during the 1950s that moved in quite the opposite direction. Independently made films, including *The Cyclops* (1957), *The Amazing Colossal Man*, and *Attack of the 50 Foot Woman* (1958) featured giant humans. In part this approach was undoubtedly adopted by film makers because it was much cheaper and easier to realise a giant human character on screen than nearly any other type of animal. Where a huge creature might require models and puppets to be built and skilfully animated to appear convincing, an enormous human could be achieved through the clever use of forced perspective and trick photography. However, while this approach may have been driven by commercial considerations, instead of emphasising the monster's alterity as the 'big bug' movies did – tapping into widely held fears and phobias around insects and similar animals – the giant humans were often depicted, at least in part, as relatable and sympathetic victims.

Nicknamed "Mr B.I.G." by Forrest J. Ackerman, Bert I. Gordon could reasonably be called the first directorial auteur of the US giant monster movie, even if many of the films he directed featuring oversized humans are remembered more for their "heart and passion" (Gambin 124) than the quality of their special effects, plots, or characterisation. Indeed, such was Gordon's appetite for the genre that in the same year as *The Cyclops* and *The Amazing Colossal Man* were released he also managed to direct and produce *Beginning of the End* starring a giant locust, before going on to work on even more giant monster movies in the 1960s and 1970s including *Village of the Giants* (1965) and *Empire of the Ants* (1977).

Gordon wrote, directed, and produced *The Cyclops*. The film is most interesting for its attempts to fuse aspects of the colonial adventure narratives offered in the *Kong* cycle with a sprinkling of the atomic era anxieties of the 1950s. The plot follows four central characters – pilot Lee Brand, courageous scientist Russ Bradford, Martin 'Marty' Melville, a mining expert played by Lon Chaney Jnr, and Barton's girlfriend Susan Winter – as they explore the uncharted jungles of Mexico in search of missing test pilot Bruce Barton. Though they are warned against flying into the area by officials, the characters proceed regardless. As they search the jungle, the group encounter several "strange animals" including a huge lizard, a giant hawk, a giant mouse, and an oversized tarantula. These creatures are realised on screen with inconsistent matting techniques, rear projection, and close-ups, yet it is worth noting that, in comparison to many other giant monster movies of the time, *The Cyclops* does not force the audience to wait long to see some of its headline attractions. After taking a sample of skin tissue from a giant iguana, Bradford works out that the creatures in the jungle have grown so large because they have been affected by radioactivity that stimulates their "pituitary gland" and means they "never stop growing". In a rather bitter turn of events, the animals are not the only things to mutate after exposure to the radioactivity. When the group finally catch up with Barton they discover he has also grown "25 feet tall" and become horribly mutated, losing the sight in one of his eyes and his ability to speak. That Barton turns out to be the cyclops of the film's title is a surprisingly dark narrative twist in what might otherwise have been a rather run of the mill genre entry. The sense of tragedy that surrounds the pitiful character – as Susan suggests, "there's something about that giant that makes me terribly sad" – would recur in an expanded form in Gordon's next, more successful film, and go on to become one of the defining traits of the enlarged humanoid strain of the 1950s giant monster movie.

The Amazing Colossal Man tells the story of the heroic Lieutenant Colonel Glenn Manning after he is exposed to radiation and grows to more than 60 feet tall. The film signals that we are meant to see Manning as heroic when, in the opening scenes, he risks his life to try to save a civilian pilot who accidentally crash-lands at the site of the first plutonium bomb test seconds before the bomb is due to explode. Somewhat inevitably Manning is caught in the radioactive blast from the bomb and miraculously survives the explosion, though he suffers disfiguring burns across most of his body. In the scenes that follow, Manning's anxious fiancée Carol Forrest stresses that he is a "wonderful man" and exclaims that he "doesn't deserve a break like this; why

did this have to happen to him?" A difficult question, to which the accompanying soldier replies, not entirely reassuringly, "things like this just happen, there doesn't have to be a reason".

The seemingly lackadaisical nature of the soldier's comments takes on a broadly existential bent when considered alongside the rest of the film's narrative. In the morning following the accident, the attendant medical professionals, Dr Paul Linstrom and Dr Eric Coulter, are stunned to see that Manning's burns have completely healed. It turns out that the explosion has given the test pilot incredibly strong regenerative abilities that could be of great use to medical science; however, he is also growing at the staggering rate of eight to ten feet a day. Rather than present Manning as empowered *The Amazing Colossal Man* depicts this accelerated rate of growth as an illness: "the process is out of balance [...] new cells are growing at an accelerated or speeded-up rate while at the same time the old cells are refusing to die". The scientists go on to note with some alarm that unless they can work out a cure, "Glenn Manning will continue to grow until he dies". This is because unfortunately his heart is not growing at the same rate as the rest of his body and so eventually it "won't be able to carry the load" and will simply "explode". Sensationalism aside, the influence of director Jack Arnold's recently successful *The Incredible Shrinking Man* (1957) on Gordon's film is clear here. In Arnold's movie the protagonist Scott Carey "begins to shrink, a process which causes him to feel increasingly isolated and estranged from the normal world" (Jancovich 1996, 192). Similarly, *The Amazing Colossal Man* charts Manning's changing status, not just in terms of his rapid physical growth, but also by exploring the psychological consequences of this unnatural growth process.

Though Jancovich describes *The Amazing Colossal Man* as "generally inept" (1996, 202) and notes its "appalling special effects" (1996, 201), the film still manages to provide what is a surprisingly thoughtful (though, it must be admitted, inconsistent) exploration of the psychological consequences of its central dramatic conceit. That the film "tries to say something" (Bogue 40) is perhaps commendable when judged against major studio films like *Tarantula* which were made with significantly larger budgets and which often seem content to rely almost entirely on (carefully rationed) instances of spectacle for their appeal.

Rather than gain a sense of carnivalesque enjoyment from his increased size, Manning's growth takes a heavy toll on his mental well-being. *The Amazing Colossal Man* explores the effects that being so large have on his ability to relate to the world around him. In an early scene in the film, Carol visits her fiancé, currently 22 feet tall, pleading with Manning to keep his spirits up, but he is depicted as

being distraught irrespective of what she says. Despite her reassurances, Manning is unable to share Carol's optimism, crying "what sin could a man commit in a single lifetime to bring this upon himself?" Later in the story Carol and Manning meet again, this time on a secluded hillside, in what is intended to be an excursion intended to remind Manning of happier times the two lovers shared together. But, in reflecting upon what has happened to him, Manning admits that "time has lost all perspective" since he started growing. He now views the period before the explosion as "another world, another life" and, in a particularly poignant stylistic trick, Carol's further verbal reassurances are muffled on the film's soundtrack, exposing how distant she is becoming to him, both literally and metaphorically. Embodying his condition as "sick in body and mind" Manning refuses Carol's requests and instead self-consciously acknowledges his status as a "monster", recollecting, with a mordant sense of humour, the prophetic comments made about him in his college yearbook, where he was voted "the man most likely to reach the top".

Much as the *Kong* cycle of films commented upon the effects of the spectacle-making process on their headlining creatures, so *The Amazing Colossal Man* suggests that Manning's increasingly destructive actions are a direct result of his (re)positioning as a spectacle rather than an autonomous subject: "this 'insanity' is the result of his growing recognition that he has become an object of fascination and curiosity for other humans" (Jancovich 1996, 202). The depiction of Manning as a form of spectacle begins with his heroic actions trying to save the downed pilot at the start of the film. As the narrative progresses we find out that scientists had fitted the test site with several cameras. Because of this they can rewatch footage of Manning as he runs out on to the site and is caught in the blast, over and over again. Similarly, following the accident the test pilot is forever being looked at and studied, not least by the scientists who are trying to find a cure for his condition. In this way Manning's growth initially disempowers him, making him a subject for others' gazes. Indeed, several critics have noted how Manning is made to look like a "big baby, an idea highlighted by his constant rages and crying fits" (Hendershot 81), further underlining how, as the pilot gets bigger, his levels of autonomy and agency decrease.

Signifying the film's inversion of the genre's carnivalesque impulses, Manning ends up confined to living in a circus tent. He is not the giant as embodiment of transgressive liberation (Schmidt 59) but rather becomes increasingly frustrated with his magnitude and the way it positions him as something to be looked at by those who are 'normally'

sized. Manning tells one orderly "I'm a circus freak" and, in a self-conscious nod to the film's melodramatic title, asks the man to "make me up a sign, see the amazing colossal man!"

Eventually the scientists do find a possible cure, one that should not only stop Manning from growing but return him to his normal size, prior to the blast's effects. Unfortunately, by this point in the story Manning has left his temporary home in the circus tent. Unable to bear living forever with his tremendous size, the hysterical giant has crossed the Nevada desert, eventually reaching Las Vegas. It is at this juncture that the film returns to the conventionally carnivalesque pleasures of the genre as we get to witness the now 50-foot man run amok in Vegas' many casino districts. Manning first contemplates the giant sultan statue atop the Dunes casino before eyeing up a bathing woman through one of the windows of the Riviera Hotel. Capitalising on the city's many recognisable landmarks, he lifts the giant model crown from The Royal Nevada and then the shoe from The Silver Slipper. The character's interactions position him as a spectacle both within the narrative (a local news broadcaster turns the camera on him) and extradiegetically. After trashing a few more Vegas landmarks, Manning is finally killed by the army, though not before he has spared Carol in what is presumably meant to be evidence of his remaining humanity.[7]

In its intermittent exploration of the psychological effects of gigantism on its central character Nancy Archer, *Attack of the 50 Foot Woman* can be viewed as a companion of sorts to *The Amazing Colossal Man*. Like Gordon's film, *Attack of the 50 Foot Woman* was also independently produced, in this case by the short-lived Woolner Bros. Pictures, and was made on a very low budget (reportedly under $100,000). The film, which

[7] Or maybe not killed: the film's sequel, *War of the Colossal Beast* (1958), spends decidedly less time exploring the emotional and psychological impact of gigantism. Indeed, by this point Manning seems to have completed his transition from subject to object. We find out that he has suffered brain damage and that he has now lost the ability to talk so it is difficult for anyone to understand what he is thinking (a development that also helps disguise the fact that the character is now played by a different actor). While Manning, who is now partially disfigured because of the attack and fall that ended the first film, is described as a "colossal freak" by his sister, there is none of the self-reflexivity or carnivalesque celebration of his destructive potential that elevated *The Amazing Colossal Man*. At one point we do get a comedically scored sequence that depicts a series of state officials who are all incredibly eager to deny any responsibility for dealing with the giant Manning, but overall *War of the Colossal Beast* lacks its predecessor's (occasionally) thoughtful engagement with the emotional and psychological effects of growing larger than is naturally possible.

has been gradually re-evaluated as "one of the all-time camp classics" (Bogue 45), differs from many other films of the era as it features very little in the way of commentary on the dangers of nuclear power. Instead of anxieties about atom bombs, *Attack of the 50 Foot Woman* seems more interested in tackling "gender issues of the day" (Bogue 47), most notably in its placing of a female character in a central, rather than a supporting, role, even if this does mean that ostensibly the said character is the film's 'monster'. Indeed, *Attack of the 50 Foot Woman* might be read as a gender-swapped version of *The Incredible Shrinking Man*. Where successful advertising executive Scott Carey shrank and found an increased need to "assert his authority and superiority [...] in order to affirm a sense of his own masculinity" (Jancovich 1996, 193), Nancy's growth could be interpreted as a response to her frustrations at being ill-treated by a patriarchal society: "the repressed returns in the form of Nancy's gigantic size" (Williams 1985, 270).

In the film Alison Hayes plays Archer, a wealthy heiress who grows to a gigantic size following an encounter with a similarly giant alien, but the implication is that the real monsters are the men in Nancy's life, in particular her adulterous husband Harry. We first meet Harry *in flagrante* with his latest conquest Honey Parker, who breaks off their passionate on-screen embrace by sarcastically exclaiming "what'll your wife say?" We quickly find out that Harry continues to live with his wife Nancy for one reason: to try to acquire her fortune. The conniving Honey suggests they might finally be able to get Nancy's money if they were to exploit her already fragile mental state, tipping her over the edge so that Harry can get her permanently committed to a sanatorium and inherit her riches.

When we meet Nancy, she is depicted as a tragic figure. She drinks heavily because her marriage is loveless and has already spent some time receiving treatment for depression in a mental hospital. When she turns up at the local bar following her encounter with the giant alien at the start of the film, no-one believes her. Tony Williams notes that "[a]ll the males attempt to supress her [...] so that the status quo remains" (1985, 267). The sheriff and his deputy reluctantly go with Nancy to check out her story (it is suggested that they do so only because they know she's wealthy) but conclude that she is "off her rocker". The sheriff goes so far as to propose that Nancy may be to blame for the attack because she was wearing a highly valuable diamond necklace, the 'Star of India'. All of this suggests that Nancy has very little agency in her life. Rather than her wealth empowering her, she is trapped in an abusive situation for which she is encouraged to blame herself, though "she is clearly presented as the wronged party" (Jancovich 1996, 207).

One of the central principles of Bakhtin's reading of carnival is the idea of the "world standing on its head" (150); this often involves a subversion of standard patriarchal gender roles. As Barbara Creed notes "a well-known reversal practised during carnival was 'woman on top'. In this enactment the man lies on the bottom and a woman sits astride him; her position and pose indicate her power" (130). This carnivalesque turnaround is embodied in the film by a woman who grows to have control over all the men in her life. Though Jancovich suggests that "the film is rarely coherent enough to justify the argument that it is a proto feminist revenge fantasy" (1996, 205), as Nancy grows bigger and bigger she gains the power to do whatever she wants to those who have previously wronged her. In a striking contrast to the debilitating psychological effects becoming gigantic have on the male central character of *The Amazing Colossal Man*, Nancy's growth transforms her from a self-loathing and downtrodden wife to a powerful giantess, emerging from, and in the process destroying, the house in which she has been kept sedated. She breaks the chains that are actually placed on her by the male Doctor von Loeb, then strides across the Californian desert to find and get revenge on her husband and his lover. Nancy's destructive path takes her to the local town, where she first targets the hotel before discovering that Harry and Honey are celebrating in the local bar. The enraged 50-foot Nancy proceeds to destroy the bar, and kills the cowering Honey by dropping heavy wooden timbers on her from a great height. Nancy then picks up Harry and, being shot at, and in a seemingly disorientated state, she walks into a nearby electricity pylon, killing them both outright.

Much like the carnivalesque practice of woman on top, Nancy's position of power in the film is only temporary, yet it does offer a break from the cinematic conventions of the time. Whether the character is meant to be interpreted as a symbol of male paranoia about empowered women, or as a pre-feminist figure, threatening the patriarchy, it is significant that the final scenes in the film offer audiences an opportunity to see a female character causing the sort of cinematic destruction that has remained largely the preserve of giant men, or creatures coded as male (Kong, Godzilla). While Williams reads this in political terms – "the film functions as a patriarchal nightmare about the female threat" (265) – whatever the audience's leanings might be, there is still something quite radical in the idea of seeing Nancy rampaging across California, even though the film's budgetary limitations meant that this spectacle was most effectively realised on the film's memorable poster by Reynold Brown. Such an iconic image of an empowered woman stands in clear opposition to the "reaffirmation

of domestic ideology" (Higashi 66) that took place during the 1950s even if the makeshift bikini that the giant Nancy ends up wearing seems to exemplify the objectification of women that was widespread in US cinema of the era.

In comparison to the more interesting aspects of *The Amazing Colossal Man* and *Attack of the 50 Foot Woman*, during the second half of the 1950s the major studios continued to churn out rote reproductions of *Beast* and *Them!* Films such as *The Monster that Challenged the World* (1957), *The Black Scorpion* (1957), *The Deadly Mantis* (1957), and *The Giant Claw* (1957) show just how entrenched the formula for making a low-budget giant monster movie in the USA had become. Each of these films had a budget of less than half (sometimes a quarter) of the standard cost of an 'A' picture and sought to keep production costs to a minimum through utilising cost-cutting techniques including a lack of big-name stars; employing stock footage where possible; very basic special effects; and a suspenseful narrative structure that often allowed for only brief scenes involving the monster until the climactic showdown.

In an opening with distinct echoes of the earlier *Beast*, *The Deadly Mantis* begins with a volcanic explosion that causes icebergs in the Arctic to shift, exposing the giant insect of the title. The giant mantis, like the frozen rhedosaurus in *Beast*, is of prehistoric origin. In the opening part of the film we see an outpost attacked by an off-screen force that emits a buzzing sound a lot like the ants in *Them!* Then, like *Beast*, *The Deadly Mantis* follows the attempts of a small group of professionals to find out what is responsible for this attack. They find evidence that something huge has been involved (large skid marks in the snow; wreckage of a downed plane, the bodies of the crew missing; part of a huge, unidentifiable, living creature) but the answer ultimately remains out of reach until the mantis itself emerges to directly threaten civilisation. In this case the creature first appears at about the halfway point of the film, when it menaces the protagonists at a Canadian military base. The oversized mantis then goes on to attack a boat, a train, and a bus before reaching Washington DC. Once in the capital, the monster lands on the Washington Monument before the air force attempt to drive it towards the sea where they hope to kill it. The film ends with a sequence that is reminiscent of the defeat of the ants in the LA storm drains at the end of *Them!* Here, the mantis is killed in the Manhattan Tunnel with chemical bombs. The only significant deviation from genre clichés that *The Deadly Mantis* provides is that, in being awakened by a natural disaster rather than an atomic one, the film lacks any of the more interesting anti-nuclear critique contained in some of its cinematic predecessors.

Whether such low-budget, formulaic instances of the genre can be considered carnivalesque does raise interesting questions about the nature of genre. The fact that films like *The Deadly Mantis* came at a time when genre "plots had become highly ritualized" (Bogue 163) might indicate that the key appeal for audiences was not in narrative or characterisation but the expectation they would get to see more of the spectacular destruction that they had witnessed in previous films. Such a reading aligns the giant monsters' destructive actions with the song and dance numbers in musicals or the murders in slasher movies: as "sequences of heightened spectacle and emotion [...] capitalizing on the power of cinema to produce visual and aural spectacle of beauty or stunning power" (Freeland 256–257). The most memorable parts of these otherwise generic giant monster movies are most often the scenes where the monster attacks; sequences in which spectacle supersedes narrative in providing pleasure for the viewer. Yet in their attempts to closely mimic the carnivalesque pleasures of their predecessors, films like *The Deadly Mantis* and *The Black Scorpion* risk ossifying the subversive energies of the US giant monster movie, depriving it of its "anarchizing vitality" (Stam 3).

Despite its formulaic plot *The Black Scorpion* contains several effective special effects sequences. The initial appearance of one of the giant scorpions is impressive, with the animation of the creature as it launches a surprise attack on a bunch of isolated telephone repairmen, before terrorising a nearby village, conveying a real sense of the threat. Unfortunately, the interspersed close-ups of the scorpion's head and body are much less effective, largely because of the unconvincing mechanical prop that is used for these shots. The film also provides an exciting fight sequence between a "30-foot" worm and a scorpion, a giant trapdoor spider chasing a small child, and a scorpion's attack on a crane. The highlight of the film's special effects work is a memorable night-time assault on a train by multiple scorpions. Scenes of the scorpions swarming over the train wreckage as its former passengers flee for their lives are suitably nightmarish and help demonstrate the strengths of stop-motion animation. Where the mechanical prop head and body that is used in some parts of the film can only move rather slowly and unconvincingly backwards and forwards or from side to side, stop-motion animation can successfully integrate different elements into the same special effects sequence – skittering scorpions, the upended train carriages, a passenger who is picked up and killed by one of the creatures – creating a level of "graphic intensity" (Schoell 48) otherwise missing.

A comparison of *The Black Scorpion* to *The Giant Claw* demonstrates how important convincing spectacle is to the genre, even in relatively

low-budgeted examples. While both films are largely unsuccessful in providing an original plot or examples of compelling or interesting characterisation, Willis O'Brien's work on *The Black Scorpion* (he supervised animator Peter Peterson) has led many critics to look more favourably on it. Bogue describes *The Black Scorpion* as "brimming with wonderful stop-motion animation effects" (163), while William Schoell suggests that the film benefits immensely from O'Brien's "expertly designed scorpions", which "rivet attention" (48). In contrast to these plaudits *The Giant Claw* has been widely condemned, in large part for its "ludicrous" colossal bird beast (Bogue 163), which Schoell suggests has a "hare-brained appearance" (93) and plays a central part in "sabotaging its own movie" (11).

Tellingly, producer Sam Katzman had originally planned for the *The Giant Claw*'s central creature to be realised using the stop-motion talents of Ray Harryhausen. Katzman had worked before with Harryhausen, on both *It Came from Beneath the Sea* and *Earth vs the Flying Saucers* (1956). Unfortunately, for budgetary reasons, the decision was taken to go with a cheaper special effects studio based in Mexico. The result of this decision is a film that provided audiences with an unintentionally comedic form of spectacle. Inadvertently foreshadowing the mock-busters released by The Asylum (see Chapter 5), the subpar nature of "a bird as big as a battleship" realised through a "horrendously, laughably bad" marionette that looks like "some deformed child's toy" (Kinnard 103) has seen *The Giant Claw* acquire a cult afterlife. The film now finds fans because of its failure to meet the levels of perceptual realism achieved by other, more 'successful' films; as Bill Warren notes, "it has certainly given a great deal of pleasure to many viewers. Not the kind of pleasure intended – tension, terror and excitement – but authentic pleasure, nevertheless" (483).

Irvin Yeaworth's *The Blob* manages to sidestep any issues concerning realising its titular creature by making the monster an amorphous alien entity. While the film follows the basic formula of the 1950s giant monster movie it stands apart from examples such as *The Giant Claw* and *The Deadly Mantis* through its focus on teenage protagonists Steve Andrews and Jane Martin, and its unique monster. The film's producer, Jack H. Harris, claimed that "[t]here's got to be a new and unique type of monster, one that's never been done before" (quoted in Felton 54) and one of the ways in which the film distinguishes itself is that, apart from seeing that the creature comes from outer space, no attempt is made to explain its origins or its motivation: it is "formless, faceless and mindless" (Bogue 89). Echoing anxieties that were touched upon in the earlier *Them!*, the blob "engulfs people and expands as it digests

them. In this way, the film operates in relation to fears about the loss of identity through engulfment by, and absorption into, some larger mass" (Jancovich 63). That the blob gets bigger and more powerful through assimilating people means it works as a metaphor for any number of mid-century fears (containment culture, communism). Given the small-town setting of the film and the fact that its central characters are teenagers it is interesting to read the "larger mass" that Jancovich mentions as adulthood. However, while *The Blob*'s tongue-in-cheek title song and its status as a camp classic are suggestive of something carnivalesque the film itself is surprisingly conservative in its portrayal of responsible teenagers working with adult authorities to defeat the alien invader. The teenagers in the film are depicted as surprisingly mature; Steve cares about what his parents think of him, and Jane is depicted as a sober and responsible individual. At first the authorities do not believe the youngsters who tell them about the monster, and suspect that Steve and Jane might be playing a prank. However, the two protagonists persuade their friends to help them and hatch a plan to alert the whole town to the danger by setting off the town's alarm systems. Following this local police chief Dave Barton comes to believe Steve and puts the townspeople on high alert. Attempts to electrocute the blob fail but eventually it is defeated when Steve works out that the blob is averse to cold, and it is frozen and airlifted to the Arctic.

Taking issue with claims that the special effects in science fiction films of the 1950s were ever meant to be considered realistic, Jancovich and Derek Johnston argue that "it was less a question of whether special effects had the capacity to create an illusion of actuality than whether special effects displayed skill and invention" (100). Such creativity is certainly evident in the "cheap-jack nobility" (Schoell 91) of AIP's *Attack of the Crab Monsters*. The film's "decidedly low-tech" visual effects (Schoell 91) seem to be designed to be the antithesis of the more conventionally "illusory" (Jancovich and Johnston 100) approach taken in more mainstream Hollywood films. Perhaps the most overt evidence of this are the "squinty eyed" (Lindsey) *papier-mâché* crab models, with limbs controlled by piano wire, that hobble around chasing the film's protagonists in an unconvincing manner.

Indeed, it seems closer to the mark to view the mechanical crab props as a bathetic parody of the drive towards perceptual realism underpinning many of Hollywood's bigger-budgeted special effects. In this respect *Attack of the Crab Monsters* can be read as a subversive artefact in and of itself, with director Roger Corman's cheap and cheerful techniques embodying a carnivalesque approach to film making, one that looks to unhinge the rigid hierarchies of the Hollywood system; as

Figure 2.2 Close-up of an unconvincing papier-mâché crab monster.
Source Los Altos Productions, 1957

Corman said, "rules are there to be broken" (quoted in James). Certainly, the film's off-the-wall plot (in which a pair of irradiated, telepathic, giant land crabs set out to conquer the world), its rejection of a cohesive storyline (see the previous parenthesis), and its laughably poor special effects can be read in Bakhtinian terms as "a refusal to accept the certainties, and the seriousness, stipulated by the dominant order" (Mathijs and Sexton 99).

Though not directed by Corman (he was executive producer), *Attack of the Giant Leeches* (1959) shares *Attack of the Crab Monsters'* hybrid approach to genre. While *Attack of the Crab Monsters* mixed horror elements into the giant monster movie, creating a "chilling little film" (Newman 2000, 85), *Attack of the Giant Leeches* introduces a distinctive bayou setting and an adulterous love triangle that suggests the influence of Southern Gothic melodrama; that is, until the giant leeches show up in the local swamp. We find out that the mutated leeches are the result of "atomic energy", radiation spillage from rockets being fired at Cape Canaveral, but this explanation seems like an afterthought, coming, as it does, in the film's closing few minutes. Instead, what the film seems more interested in showing an audience is "leeches consuming their prey in a [...] grisly way" (Hathaway 126). Having grown to about human size the leeches are now routinely dragging the locals down to their underwater cave to ripen the prey up before eating it. However,

the very-low-budget technique used to realise the leeches – "divers in black wetsuits dotted with white 'suckers' of varying sizes" (Schoell 59) – means they are even less impressive than the crab monsters. Indeed, it is difficult not to read the film's use of two men dressed "in black plastic pup tents" to depict the giant leeches (Reamy quoted in Warren 41) as a reflection of the reduced status of the US giant monster movie by the decade's end.

While claims that *Attack of the Giant Leeches* "put an end to the 'big bug' cycle of the 1950s" (Schoell 58) seem to overlook the carnivalesque pleasures associated with 'bad' special effects, it is true that the number of giant monster movies produced in the USA significantly decreased by the 1960s. Most of the giant monster movies of the 1960s were released by Japanese studios, including Toho and Daiei Film, rather than by Hollywood. Given the unprecedented number of giant monster movies released in the USA during the 1950s perhaps it was inevitable that a state of exhaustion would be reached. With no more animals left to enlarge, as Bogue notes, "there wasn't anywhere for the [...] giant American monster genre to go" (215). Diminishing fears of nuclear power, following the Cuban missile crisis, might have also played a part in the decline of the 'big bug' cycle. "The Bomb had become moribund" (Bogue 283) as people became acclimatised to living with the possibility of mutually assured destruction. While the major Hollywood studios shied away from the giant monster movie, equally, the success of the UK-based Hammer Studios' low-budget horror films, and AIP's Edgar Allen Poe adaptations, led many low-budget film makers to turn away from sci-fi excess and towards more Gothic subject matter. The fortunes of the giant monster movie would not change to any significant degree until 1975 when a film featuring an oversized shark with a grudge would prove a runaway commercial success and establish a new direction for the genre to take.

3

Nature Attacks: Politicising the Giant Monster Movie During the 1970s and 1980s

While the 1960s saw a steady stream of giant monster movies being released in southeast Asia (including the popular *Mothra* (1961) and *King Kong vs Godzilla* (1962) the situation was quite different back in the USA. The new wave of Hollywood films of the 1960s and 1970s seemed to reject the epic proportions of their classical forebears, telling smaller, more domestic stories, often on reduced production budgets. In such a changed climate the US giant monster movie's status as a vehicle for big-budget representational prowess looked out of step with the "[a]esthetic experimentation, generic revisionism, European-style auteurism and [...] anti-establishment ethos" (Neale 91) of the New Hollywood film makers. Critics described films such as *Bonnie and Clyde* (1967), *The Graduate* (1967), and *Easy Rider* (1969) as "visually arresting, thematically challenging, and stylistically individualized by their makers" (Cook 69). Yet, as we have seen, the grandeur of the giant monster movie was often accompanied by a subversive set of attractions, more in keeping with the "[n]othing was sacred" (Biskind 14) tone of many 1960s and 1970s films. This chapter will examine how the US giant monster movie tried to keep up with broader changes taking place in the country's cinema following its 1950s heyday. Initially, this resulted in a period of uncertainty as the big Hollywood studios stopped producing giant monster movies and the genre was kept alive by independent film makers, so the chapter begins by considering two of these more offbeat films, *Village of the Giants* (1965) and *Night of the Lepus* (1972). When *Jaws* was released in 1975, the genre would come thundering back to mainstream prominence, its "family adventure movie" take on the formula becoming "the defining Hollywood output" (Kramer 1998, 295) for the next decade. This chapter will examine how *Jaws* largely disregards the genre's carnivalesque appeals, striving for greater psychological depth and a

more earnest form of realism. It will also chart how the carnivalesque crept back into the genre through the host of lower-budgeted *Jaws* imitators that followed in the wake of Spielberg's blockbuster. As the 1970s progressed other big-budget studio movies were released to try to capitalise on the rejuvenation of the genre. Consequently, this chapter will offer analyses of *King Kong* (1976) and *Prophecy* (1979), reading them as more carnivalesque than *Jaws* though both were considered commercial and critical disappointments. The chapter ends with a discussion of an interesting but overlooked set of films which further solidified the genre's carnivalesque elements through a focus on blue-collar characters and their experiences.

Though not released by a major Hollywood studio, Bert I. Gordon's *Village of the Giants* (1965) demonstrates some of the potential problems in retooling the giant monster movie to capitalise on the emergent youth audience. The film, which is very loosely based on H. G. Wells' *Food of the Gods and How It Came to Earth* (1904) is seemingly designed for the drive-in circuit, attempting to bolt together parts of the beach party subgenre with the giant monster movie. In contrast to films like *The Graduate* and *Easy Rider* that said "'fuck you' [...] to a generation of Americans who were on the wrong side of the generation gap" (Biskind 49), *Village of the Giants* appears more interested in reflecting anxieties concerning teenagers. The film opens with a bunch of young people who crash their car and then choose to have an impromptu dance in the rain. Following this, the group of teenagers decide to visit the nearby town of Hainesville to meet up with their friend Nancy. The film then cuts to Nancy, passionately necking with her boyfriend Mike, before her precocious younger brother, nicknamed 'Genius', causes an explosion that interrupts their romantic embraces. It turns out that Genius has created a pink, strawberry, milkshake-like substance he names Goo. However, rather than do the morally responsible thing and tell Nancy's parents about the new, untested substance, Mike and Nancy hatch a plan to get rich quick by feeding Goo to two ducks. That the two, now human-sized, ducks appear in the very next scene in the movie, 'dancing' to the Beatle-esque music of The Beau Brummels, gives a good indication of the tone of the film. Indeed, none of the partying teens depicted in the scene are remotely phased by the appearance of two giant ducks. The film itself seems at least as interested in focusing on the exposed midriffs of the female characters as it is on the giant avian interlopers.

While Mike and Nancy attempt to keep the location of the Goo a secret it is not long before some of the other, 'bad', teenagers have discovered and imbibed it. Significantly, the 'bad' teenagers take the Goo

Figure 3.1 Giant ducks dancing alongside teenagers to the Beatle-esque music of The Beau Brummels.
Source Embassy Pictures, 1965

in a scene that seems to overtly reference fears around peer pressure and recreational drug use, with one of the gang members demanding that "we all take it [...] nobody chickens out" while another boy in the group encourages a reluctant girl to "eat it, don't be scared". Once the teenagers take the Goo and grow to become giants, they realise that they now have the power to assert themselves against the oppressive adult authority figures in their lives. One of the teenagers states "wait until my old man gets tough with me again", while another suggests "we'll turn the tables on them". In a carnivalesque fashion, the Goo promises to overturn established societal hierarchies; as one of the newly giant-sized teenagers explains, "the adults, honey, this isn't their world anymore". However, though such a change in power relations might suggest a carnivalesque viewpoint to the film, *Village of the Giants* instead stresses the naivety of the giant teenagers' attitudes. The remaining, normal-sized teenagers, who include Mike and Nancy, question the giants' subversive thinking, emphasising the parallels between them and the adults: "you're just trying to trade places with them". The recklessness of the giant teenagers is further stressed when they steal the sheriff's young daughter and hold her hostage. The giants use their hostage to enforce their demand that all weapons are handed over to them, effectively neutering the adults and ensuring the teenagers can rule unopposed.

Rather than depict the giant teenagers' actions as a carnivalesque liberation from the staidness of adult authority, *Village of the Giants* portrays the giants' desire to free themselves as immature and immoral, suggesting the film is "grounded in the early sixties establishment's fear of the countercultural rebellion" (Noonan 35). It is significant that when Genius eventually creates a cure that reverses the Goo's effects, it is Mike and his teenaged friends who help Genius to administer the antidote to the others. As 'good' teenagers, the film suggests they recognise that the best way forward is through a return to the status quo. Ultimately, the 'acting out' by the 'bad' teenagers – their hideout is in a disused theatre – is depicted as the result of their naivety, something they need to be cured of by being both metaphorically and literally brought back down to size by their less rebellious, and therefore wiser, peers.

While *Village of Giants* and several of the films that Ray Harryhausen worked on during this period (*Mysterious Island* (1961), *Valley of Gwangi* (1969)) meant that the giant monster movie did not die out completely in the USA during the 1960s, it would take roughly another decade before the genre returned in earnest. Several factors helped signal its re-emergence. Most significantly, by the middle of the 1970s genres closely related to the giant monster movie were experiencing substantial commercial success. In particular, the resurgent popularity of the disaster movie, with examples including *Airport* (1970), *The Poseidon Adventure* (1972), and *The Towering Inferno* (1974) all making huge profits, suggested that there was still an audience interested in big-budget spectacle if it was framed correctly. That other close relative of the monster movie, science fiction, was also experiencing a limited revival in the period, with *2001: A Space Odyssey* (1968) and *Planet of the Apes* (1968) indicating that genre films could appeal to large audiences if they offered innovative spectacle and engaged with contemporary ideological proclivities.

The other factor in ushering the giant monster movie back into popularity may well have been the purchasing of several of the big Hollywood studios, including Paramount, Universal, and United Artists, by multinational conglomerates following "[t]he virtual collapse of Hollywood in the fiscal crisis of 1969–71" (Hall 164). Once the budgetary caps self-imposed on the film-making process had started to ease in the 1970s, these huge corporations often gravitated towards high-profile concepts that could be widely marketed before release to maximise interest, and that might allow a range of ancillary products to be sold prior to, and alongside, the release. In this manner, the blockbuster re-emerged as something of a "safe risk" (Wyatt 77). Though the financial stakes might be higher when making a blockbuster than for an average

film, so were the potential rewards if you managed to have a commercially successful hit.

Of course, not every giant monster movie released in the 1970s was designed to be a blockbuster. Many of the more interesting examples of the form were made on lower budgets. The now notorious giant rabbit movie *Night of the Lepus* is widely regarded as one of the "most ridiculous horror film[s] ever conceived" (Muir 2002, 216), yet it foreshadowed the ideological direction that many giant monster movies would take in the 1970s and 1980s. Initially, *Night of the Lepus* seems like a hangover from the 'big bug' cycle of movies, but it was also one of the first in the genre to emphasise ecological concerns. In fact, so central did environmentalist themes become to the giant monster movie that Stacy Alaimo suggests "[m]onster movies [...] could be the single most significant genre for ecocriticism" (279). These kinds of claim are not surprising given that some of the genre's most influential films, including *King Kong* and *Godzilla,* can be read as stories in which "nature [is] going to take revenge on mankind" (Tsutsui 18), usually for its destructive treatment of the natural world. In Bakhtinian terms, the motif of nature fighting back against humanity reconfigures the genre's carnivalesque upending of conventional hierarchical relations into a specifically contemporaneous format that resonated with emerging anxieties relating to the natural environment: "the paranoid suspicion that the natural world is a chaotic, pitiless place, populated by resentful 'lesser' creatures waiting for an excuse to get their own back" (Murphy 187). In movies such as *Night of the Lepus* the monster becomes a symbol of nature's increasingly justified desire for vengeance, with the monster's immense size representing the level of ecological damage inflicted by mankind and the extent of the change that was needed to redress this destructive behaviour.

The conceit behind *Night of the Lepus* articulates the same sorts of concern that led to the creation of the Environmental Protection Agency in 1970 and the growth of the environmental movement, as people began to recognise their "moral obligation to protect the environment" (Lennard 118). The film opens with a *faux* TV news report that foregrounds the often-combative relationship between humans and the natural world. Against authentic newsreel footage of farms overrun with rabbits, which depicts real invasive rabbit crises of the early twentieth century, the on-screen reporter portentously asks whether "man has the right to defend himself against an enemy that threatens his life and property... and in so doing what does he do to the rest of the animal and insect life necessary to his existence?" This sense of ecological unease is shared by rancher Cole Hillman,

the protagonist of the film, who is suffering from an explosion in the population of rabbits on his land. We know the situation is bad because in the film's opening sequence we see Hillman forced to put down his horse after it accidentally steps in a rabbit hole and breaks its leg. Significantly, we find out that this upsurge in the rabbit population is the direct result of a misguided attempt to control the population of coyotes. The rabbits, freed of this natural predator, are now threatening to take over. Seemingly undeterred by the unforeseen consequences of this previous effort at ecological control, Hillman approaches local college president Elgin Clark for help to deal with the rabbit problem. Clark recommends Hillman seek out the Bennetts, a couple who are "looking for new ways to control insects without killing everything else at the same time".

Night of the Lepus suggests that through meddling with the natural order of things science threatens to upset the ecological balance and put us all in danger. To this end, several of the film's more sympathetic characters express a need for humans to live in greater harmony with the natural environment: Hillman knows that "there's a balance to these things" and seeks to find a solution that will not disrupt this equilibrium; similarly, the Bennetts are scientists who believe in organic, rather than chemical solutions – when we first meet them, husband Rory is working on a method of using bats to control mosquito populations in place of the more traditional bio-chemical approaches.

Disgusted with the established technique of spraying huge swathes of the land with the chemical cyanide, the Bennetts' more ecologically friendly plan to control the rabbit population is to use hormones to interrupt their breeding cycles. Unfortunately, this approach does not seem to work when it is trialled. Out of desperation the Bennetts inject one of the rabbits with a new, experimental serum believed to cause birth defects. Their thinking is that by deliberately introducing these biological flaws into the gene pool they might stop the rabbits from being able to procreate. However, the film suggests that any kind of biological experimentation is wrong because we cannot be sure what the consequences might be; as another scientist spells out to the Bennetts later in the narrative, "it's conceivable that we could have created the seeds for a mutated species". This intervention does indeed have dire consequences, creating aggressive, gigantic rabbits that escape the laboratory and then breed with the wild population, posing a significant threat to the human characters in the film.

While the opening part of *Night of the Lepus* engages with contemporary ecological concerns in a surprisingly interesting and radical fashion – situating it as an early example of what Maurice Yacowar

would term the "natural attack" subgenre – the suggestion that the 'good' Bennetts are ultimately responsible for the creation of the giant rabbits implies, somewhat contradictorily, that the original practice of using cyanide might still have been the best approach to take to pest control.

Though the film's ecological message is somewhat inconsistent *Night of the Lepus* demonstrates the continuing importance of visual effects to the genre. Much like *The Giant Claw* before it, *Night of the Lepus* is now best remembered for its inadvertently poor special effects. While one might argue that rabbits are not the best starting point from which to conjure fearsome monsters – as a radio broadcaster in the film notes, "[r]abbits [...] which seem so cuddly [...] can become a menace" – the film's shambolic mismatching of effects and live action, use of stuntmen in rabbit costumes, and depiction of rabbits in slow motion "lolloping through miniature sets" (Hunter 486), has induced some viewers to take a carnivalesque pleasure in the film's near complete abandonment of perceptual realism.

Despite the increasing centrality of special effects, it is noticeable that many giant monster movies, both blockbusters and lower-budgeted examples, seemed to find it difficult to achieve the "representational prowess" (Hovet quoted in Hall and Neale 36) expected of the 1970s blockbuster. Even many of those films made by major studios during this era were frequently criticised for the disappointing nature of their visual effects. The shark in *Jaws* (1975) was described as "less scary the moment he's visible" (Malcolm); some critics suggested that the giant, life-size, animatronic ape in *King Kong* should have been "cut from the film" altogether (Morton 228); while the hybrid monster in *Prophecy* became notorious, being unfavourably compared to a "giant salami" by William Schoell (168). Part of this perceived failure in visual effects may be due to the move away from stop-motion during the 1970s in favour of a combination of other approaches including trick photography, front and rear projection, model work, and putting actors in monster suits. Stop-motion was increasingly seen by many studios as problematic, both for its associations with older, antiquated film-making processes and because of the time it required. Producer Dino De Laurentiis exemplified these views when he claimed that "stop-motion [does not] look smooth enough and [is] too expensive and time-consuming" (Morton 168). Upon completion of his last film in 1981 even Ray Harryhausen suggested that "it was time to stand aside for others and their new technology to take over" (Harryhausen and Dalton 280–282). However, it would be another two decades before the emergence and wide adoption of CGI. Consequently, during the 1970s even commercially and critically

successful giant monster movies seemed to choose to work around the limitations of their special effects rather than foregrounding them; most famously with the "forced virtual absence" (Audissino 66) of the malfunctioning mechanical shark in Spielberg's *Jaws*. Emilio Audissino notes that "[n]o mechanical creature of such complexity and size had been manufactured before" (66). Yet though the three full-size, animatronic shark models in the film cost a hefty $500,000 to build and were designed by Joe Alvey and Bob Mattey (who had created the giant squid for the commercially successful *20,000 Leagues Under the Sea* (1954), they appear for a total of about four minutes, so frequent were their "constant technical failures" (Audissino 66).

The increasingly high production values of giant monster movies such as *Jaws*, *King Kong*, and *Prophecy*, evident in their often thought-provoking and emotionally resonant scripts; expensive shooting on location; and casting of recognisable actors may have served to make the often subpar special effects in these films even more jarring. While the budgets of some giant monster movies had increased to near-*King Kong* levels the practical limitations of in-camera effects were particularly noticeable when trying to realise gigantic creatures and have them interact with human characters. In this respect the pre-CGI 1970s and 1980s represent a difficult, transitional period in the realisation of the giant monster on screen, one in which the "representational prowess" associated with the genre did not always manifest successfully. As the decade progressed, such substandard visual elements were particularly disappointing when judged against other genre films including *Star Wars*, *Close Encounters of the Third Kind* (1977), and *Alien* (1979), and the rapid and impressive advances they represented in the field of special effects.

Jaws is often described as the first and most influential blockbuster of the 1970s. I include the film in this discussion because it exerted such a colossal influence on the US giant monster movie – Peter Kramer writes that it led to "a resurgence" (2022, 24) – that to exclude it would risk missing out a significant developmental link in the genre.[1] Another reason that the film might not immediately be thought of as a giant monster movie is its generic hybridity, something that would come to play a more prominent part in the blockbuster from this point on. Sheldon Hall suggests "[i]t could be argued that *Jaws*, with its scenes of mass panic, also belongs with the disaster genre[, t]hough it is equally

[1] As the largest (female) great white shark on record was only 20 feet in length, in being an estimated 25 feet long the shark in *Jaws* technically qualifies as a giant.

indebted to the horror film, the sea adventure and the post-Watergate conspiracy thriller" (175). This hybridisation would work both ways, with the figure of the giant monster going on to appear in films throughout the 1970s and 1980s that might not be defined primarily as giant monster movies: examples of such would include the *Star Wars* and *Ghostbusters* series and the *Alien* sequel *Aliens* (1986), to name but a few.

Jaws has also been discussed as an example of the 'trickle up' process that informed many 1970s blockbuster films. The film's basic plot – monstrous shark attacks townsfolk – is the sort of story that had previously been considered the preserve of low-budget exploitation film makers; as director Roger Corman famously observed, "[w]hat is *Jaws* but a big-budget Roger Corman movie?" (xi). Contemporary reviews also made this link, with Stephen Farber in *The Times* describing *Jaws* as "nothing more than a creaky old monster picture" (quoted in Lemkin 277) and Vincent Canby noting the film's rehashing of genre conventions in *The New York Times*: "It opens according to the time-honored tradition with a happy-go-lucky innocent being suddenly ravaged by the mad monster" (quoted in Lemkin 277). More recently, Lee Gambin has suggested that *Jaws* is ultimately a 'B' monster movie in the guise of slick Hollywood blockbuster (19) while Dan Rubey has linked *Jaws* to the nuclear concerns of its 1950s 'big bug' predecessors, arguing that the film's shark can be read as a manifestation of the "guilt and doubts about the justifiability of [US] actions" (11) in dropping atomic bombs on Hiroshima and Nagasaki.

Jaws' position as the most influential giant monster movie of the 1970s – "the movie became a phenomenon, bigger than anyone expected" (Man 149) – undoubtedly makes it an important case study for assessing the genre's carnivalesque status. Yet upon close expectation it is difficult to read the film in this way. Indeed, on further analysis the film seems to run counter to what I have argued is the frequently subversive nature of the giant monster movie. Numerous critics have seen *Jaws* and the blockbuster era that it helped inaugurate as a decisive return to a more ideologically conservative model of film making. Hall talks about the "ideologically and formally conservative work of Steven Spielberg, George Lucas, and their successors and imitators" (180), while Jonathan Lemkin discusses *Jaws* as "a propaganda film for America" (287). The closest that *Jaws* perhaps gets to something carnivalesque is in its critical depiction of the character of Larry Vaughan, the amoral Mayor of Amity Island. In the opening part of the film, Vaughan places economic concerns above the safety of the townsfolk and holiday makers when he refuses to close the island's beaches over the lucrative fourth of July weekend. Vaughan has been interpreted as a personification of the

widespread distrust surrounding politicians during the post-Watergate era. The character is ultimately brought low when he is proven to have made the wrong choices, choices that lead to the violent death of the young boy Alex Kintner. However, even Vaughan is ultimately shown to do the 'right thing' when he acknowledges his mistake and agrees to fund the three heroes to hunt down and kill the shark.

Indeed, one of the strengths of *Jaws* is its inclusion of a trio of relatable, well-drawn, interesting central characters; something that previous genre films had rarely achieved, as Tom Shone suggests: "It was nothing short of revolutionary: you could have finger steepling and scary rubber sharks in *the same movie*" (33). That *Jaws* spends so much of its running time developing these human characters as likeable and establishing their relationships as meaningful seems to indicate where the audience's sympathies are meant to lie. Yet this shift immediately makes it much more difficult for the audience to take any carnivalesque pleasure in the actions of the shark; indeed, as Robert Stam suggests, "[c]arnivalesque art is uninterested in psychological verisimilitude or conventional audience identification with rounded personalities" (109). In contrast to previous genre films, *Jaws* encourages the audience to focus on the seriousness of the monster's actions; the devastating impact they have on the human characters. Conversely, we rally behind the human characters and want them to put an end to the shark's murderous behaviour as quickly as possible. Glenn Man suggests that the film "appealed to the fragile American psyche" of the post-Watergate, post-Vietnam 1970s, purging it of its disillusionment through the "catharsis of the shark's destruction" (154). Where *King Kong* encourages the audience to empathise with its titular creature, *Jaws* refuses to characterise its shark as anything other than a "nearly satanic menace" (Schatz 25), "a perfect engine, an eating machine" as the film's scientist, Matt Hooper, describes it.

The film's use of space and setting also marks it out as different to previous US giant monster movies. The film reverses the conventional dynamics of the genre. Rather than chart the movement of the monster from wilderness to civilisation, *Jaws*' plot depicts an initially unprovoked intrusion by the monster into the seaside resort of Amity Island. That the closest the shark gets to civilisation is the otherwise idyllic, fictional town of Amity makes it difficult to interpret the shark's actions as carnivalesque. For it is much harder to experience vicarious enjoyment from witnessing a giant monster terrorise a small town of families and holiday makers, what Lemkin refers to as "the ideal of simplicity and innocence" (282), than it is to cheer on the sympathetic and displaced Kong wrecking parts of decadent, metropolitan New

York. The second part of the film follows the three protagonists as they venture into the wilderness of the open ocean – the 'home' of the beast – to kill the shark, so that it cannot ever return. Where Kong is taken from his jungle home, and Godzilla is awakened by humanity's scientific transgressions, *Jaws* suggests no causal link between the actions of Amity's residents and the shark's attacks (though scholars have provided a host of reasons); instead, and as Lemkin suggests, "[*Jaws*] reinforces our already preconceived fears of the wilderness and the unknown" (287).

While the film signals that we are meant to take its thrills rather more seriously than those of its predecessors it does still find room to include some of the genre's customary self-reflexivity. Shone writes that the film demonstrates a keen level of self-awareness when depicting the frenzied reactions of Amity's amateur shark hunters in the wake of the announcement of a large bounty for whoever can catch and kill the shark. He reads the scenes of hysteria that follow, with Hooper drily exclaiming "they're all going to die", as foreshadowing the obsession with the film, that became known as *Jawsmania*, during its initial release in the summer of 1975. However, while this sequence can convincingly be read as "an allegory [...] for what was about to happen to Hollywood" (Shone 38), whether this means the film can be seen as encouraging audiences to take pleasure in the upending of conventional hegemonic structures seems more difficult to prove.

The conservative nature of *Jaws*, coupled with its huge commercial success – "the first film to break the $100 million mark" (Shone 27) – created a schism in the US giant monster movie. Following *Jaws* there appeared genre entries that attempted to emulate the film's more earnest approach; "a way to make the story play for a contemporary audience" (Morton 152). These films were often released by major studios which may have felt, with some justification, that appealing to the mainstream audience that *Jaws* had attracted required a similar combination of "special effects with solid dramatic credibility" (Murphy quoted in Morton 226). On the other side of the genre were films, often released by independent or low-budget studios, that emphasised the comedic and ridiculous aspects of the genre. These examples often substituted self-awareness for spectacle, or, at the very least, encouraged the audience to laugh at their attempts at realising a giant monster on screen.

Released later in the same year as *Jaws*, the much lower-budgeted *The Giant Spider Invasion* (1975) falls into the latter of these two camps, coming across as a kind of affectionate combination of *Tarantula* and *The Blob*. While the film itself is unremarkable, its unexpected success,

making somewhere between $15 and $22 million from a budget of $300,000, suggested that audiences were still eager to see carnivalesque instances of the giant monster movie. There is some debate about how intentional the comedic elements of the film are meant to be (the co-scriptwriters Robert Easton and Richard L. Huff apparently fought over the jokiness of the tone). Nevertheless, the film's cast of redneck characters who all seem to be cheating on each other; the often laugh-out-loud dialogue (at one point the town's sheriff knowingly comments "did you ever see the movie *Jaws*? well it makes that shark look like a goldfish!"), and the giant spider realised via a VW beetle "dressed in a furry dark rug and eight giant hairy legs" with "its orb-like eyes [that] pulse with an orange glow resembling taillights" (Stockman), suggest some level of self-awareness on the film makers' part. This is not a film that reaches for the epic or mythic qualities of *Jaws*, instead adopting a more bathetic approach exemplified by the final attack in which the giant spider menaces a bunch of locals at a funfair, sending crowds screaming to the sounds of carousel music. In the light of this it is perhaps not surprising to learn that originally *The Giant Spider Invasion* did not feature huge spiders at all. After becoming aware of a film being made that was due to feature an oversized shark, the film's distributor Brandon L. Chase cannily requested a giant spider be added to the mix to capitalise on a possible resurgence in all things gigantic.

Where *Jaws* attempts to take its subject matter seriously, *The Giant Spider Invasion* embraces the inherent absurdity of the genre. This is perhaps most evident in the scene in which the protagonist's alcoholic wife accidentally blends a tarantula into a smoothie. The camera lingers on the poured drink, building up suspense for the audience. Eventually, the unwitting character guzzles it down only to then recoil in disgust when she realises what she's just done. Such an incident taps directly into the celebration of the grotesque in the Bakhtinian carnival. Bakhtin suggests that during carnival "[l]aughter was [...] related to food and drink" (95), by way of overturning social conventions that might dictate what should be eaten and in what quantity.

So similar is *Grizzly* (1976) to *Jaws* that reviewers, including Vincent Canby in *The New York Times*, accused it of being "a blatant imitation" of Spielberg's film. It is true that *Grizzly* keeps the basic set up of *Jaws* but replaces the shark with a bear, in this case a "15 feet" grizzly "weighing over 2,000 pounds" that turns out to be a throwback to the Pleistocene era. The film makers also seem to have been inspired by *Night of the Lepus* and they include a conservationist aspect in their narrative. *Grizzly* opens with military veteran and tour guide Don Stober telling his passengers that the national forest he is flying over needs to be

protected from further encroachment by tourists. Consequently, when we are shown the large numbers of holiday makers and backpackers arriving at the national park in the Blue Ridge Mountains at the start of the film, we suspect that things are not likely to go well. Sure enough, chief ranger Michael Kelly is worried that the area has "more backpackers pitching tents than raccoons in the woods" and it is not long before we witness two hapless backpackers who stay out later than they should being murdered by a gigantic bear.

Much like Chief Brody in *Jaws*, Kelly in *Grizzly* is depicted as an 'ordinary' man faced with an unlikeable and obstructive authority figure, in this case, park supervisor Charley Kittridge. Kittridge blames Kelly for not effectively moving the bear away from the park ahead of the beginning of the tourist season. Despite his position of authority, Kittridge refuses to take any responsibility for the bear attacks – "I wash my hands of it" – and goes so far as to deny the existence of a grizzly altogether: "there are no grizzlies!" Furthermore, in a move which echoes Mayor Vaughan's refusal to close Amity's beaches in *Jaws*, Kittridge irresponsibly reopens the forest to anyone willing to hunt down the murderous creature. He does not care about the danger this will cause to the holiday makers already spread out across the park. Instead, the film's three 'ordinary' protagonists, Kelly, Stober, and naturalist Arthur Scott must take matters into their own hands, setting out into the forest to try to hunt down and kill the bear.

While *The Giant Spider Invasion* uses comedy to cover the limitations of its low budget, *Grizzly* seems intent on upping the gore quotient in comparison to its bigger-budgeted peer. Over the course of the film the audience gets to see 'a butcher's shop' of viscera, including severed arms, bloodied corpses, and, at one point, a decapitated horse. The effect of all this slaughter is that *Grizzly* resembles a hybrid of the giant monster and slasher movie genres. Indeed, given the prominence of the film's forest setting, and the bear's proclivity for gruesomely murdering nubile young women (shot from the creature's point of view), *Grizzly* seems to foreshadow the later *Friday the 13th* series as much as it emulates other giant monster movies or *Jaws*. Irrespective of the film's derivative nature, and its grislier elements, it went on to be the most commercially successful independently financed film of 1976, leading to a sequel, *Grizzly II: Revenge*, which was filmed in 1983 but not released until 2020.

While there is something unintentionally humorous about hearing a character uttering the words "where did you get those goddamned chickens?" before watching them proceed to fight off a giant bird with a rake, AIP's *The Food of the Gods* (1976) is a rare example of a low-budget 1970s giant monster movie that attempts to take the idea

of oversized animals entirely seriously. In contrast to the self-reflexive goofiness of *Village of the Giants* and *The Giant Spider Invasion*, *The Food of the Gods* shares the pseudo-philosophical elements of director Bert I. Gordon's earlier *The Amazing Colossal Man*. The film refashions Wells' original story to fit the conventions of the 'nature attacks' subgenre that became popular during the 1970s. The film opens on American football player Morgan, who we learn is taking a vacation on an unnamed island to "enjoy some of the open spaces that man hasn't screwed up with his technology". In case the audience does not get the message, Morgan portentously recounts a warning his father used to give him that summarises the film's environmentalist sentiment in even more explicit terms: "one of these days the Earth will get even with man for messing her up with his garbage; just let man continue to pollute the earth the way he is and nature will rebel and it's going to be one hell of a rebellion". It turns out that the rebellion comes in the form of a mysterious white substance that is bubbling out of the ground on the island to which Morgan is travelling. A married couple who live on the island, the Skinners, believing the substance to be a gift from God, have been mixing it into the feed they give to their livestock to increase yields. As a result, in a motif that would be repeated throughout the 1970s, "'Chaos reigns' when humans interfere with natural processes" (Murphy 186). The substance has got into the local food chain causing a series of horrific incidents prior to Morgan's arrival. First, a former baseball pro is stung to death by giant wasps, then Mr Skinner is killed and eaten by giant rats that have fed upon the contaminated foodstuff. This leaves a small group of characters – including Mrs Skinner, Morgan, Morgan's friend Brian, and expectant couple Thomas and Rita – to fight off the oversized creatures on the island as they try to survive, and eventually escape to safety.

The Food of the Gods expands upon *Jaws*' criticism of authority figures who place their own private interests above the welfare of the public. Among the group on the island are Jack Bensington, the owner of a pet food company, and his assistant Lorna. Bensington has come to the island to make a deal to buy the substance from the Skinners and get rich. When we first meet them, Lorna exclaims to Bensington "you're the most selfish man I know" and it soon becomes clear that Bensington represents many of the reasons why the Earth is rebelling. Unaffected by the weird deaths taking place around him, the magnate dismisses the dangerous effects of the substance and refuses to put himself in jeopardy by helping others. The film makes it clear that Bensington is "not a good man"; instead he is an amoral capitalist who is only interested in defending his company's ownership of the

foodstuff. When Morgan and Brian drive off to try to kill the giant rats that are terrorising the group, Bensington calls them "stupid" and stays behind so that he can spend his time collecting as much of the substance as possible. However, the character's greed proves his undoing. At the climax of the film, when the giant rats follow Morgan back to the group's base and the other members of the group run to safety in a nearby cabin, Bensington is gruesomely eaten alive by the creatures because he tries to save substance-filled containers instead of making a quick escape.

The Food of the Gods introduces a trope that would recur throughout the 'nature attacks' subgenre. The film criticises humanity's arrogance in assuming they will remain at the top of the 'food chain' forever. This carnivalesque undermining of an anthropocentric view fits within a broader message that what is needed to rectify the current, precarious, ecological situation is a profound recognition of humanity's interconnectedness with the natural world. That the animals in *The Food of the Gods*, and other 1970s 'nature attacks' films, feel a need to 'fight back' at all indicates the level of resentment concerning the harm being caused by humanity. Following the success of Rachel Carson's hugely influential *Silent Spring* (1962), which "provided a crucial and substantial step in the burgeoning environmentalist movement" (Hathaway 150), the giant monster movie could be an effective format for the dissemination of growing worries "about pollution, toxic waste, and development of wilderness lands" that began to find support with "middle-class Americans [...] and many mainstream organisations" (Schuman 30) during the 1960s and 1970s. For example, Carson's warning that "[o]ne of the most sinister features of DDT and other chemicals is the way they are passed on from one organism to another through all the links of the food-chains" (22) is reflected at the end of *The Food of the Gods* when we watch as leaking containers of the film's harmful substance are first washed down a river into a field with dairy cows in it, and then enter the human food chain when a class of young children are shown drinking the cows' infected milk.

John Guillermin's *King Kong* (1976) was the first of the 1970s big-budget giant monster movies to incorporate the theme of ecological destruction and its consequences in an explicit fashion. Produced by Dino De Laurentiis, the rhetoric around the film deliberately sought to evoke the epic nature of the original *King Kong*, retooling it for the 1970s blockbuster era. To this end the 1976 film was promoted as "the biggest production to hit the town in years" (Bahrenburg 4), "a landmark film in the history of Hollywood" (Bahrenburg 252), and as a movie with "the potential to overtake *Jaws* as the largest grossing film of all time" (Bahrenburg 44).

Paramount, who helped to fund the film, were actively looking for another 'big' picture in the same league as their recent blockbuster successes, *The Godfather* and *The Great Gatsby*. After discussions with De Laurentiis the company felt that a retelling of the Kong story would be a good fit. However, such a self-consciously epic venture, a return to the spectacle of the Golden Age of Hollywood, could not be achieved modestly; as Ray Morton suggests, the new *Kong* "was a much bigger and more elaborate production than the original film" (159). To achieve the requisite spectacle De Laurentiis' opus ended up shooting on location in multiple countries, as well as in and around the newly finished World Trade Center, and on a real military supertanker (the first film to do so). In his authorised book about the making of the film, Bruce Bahrenburg notes that "De Laurentiis' goal was to produce *the* definitive monster movie. This would make [his] *King Kong* one of the most expensive films – if not *the* most expensive" (23). Further adding to the cost would be the film makers' significant decision to build a life-size animatronic model of Kong, 40 feet tall, weighing "six and a half tons" (Bahrenburg 115–116). De Laurentiis claimed of his version of Kong "[h]e will be the most expensive actor in the world. It will cost a million to build him" (quoted in Bahrenburg 9). In fact it eventually ended up costing in the region of $3 million to construct the model, with the film's total budget an estimated $24 million (Bahrenburg 256), making it the most expensive film ever produced at the time of its original release. Despite these astronomical expenses, *King Kong* went on to turn a profit for Paramount. The film received the "biggest simultaneous release in film history" (Morton 226) and ended 1977 as the fifth most commercially successful film at the domestic box office.

In comparison to *Jaws*, the 1976 *King Kong* is a surprisingly political film, with an overt, pro-environmentalist message. Tellingly, the film changes the reasons why the human characters venture to Kong's homeland. Where the original film depicted Carl Denham and his crew going to Skull Island to shoot a movie, Guillermin's *Kong* switches things around so that the venture is led by a big energy company, Petrox, which is seeking to exploit a lucrative oil deposit, "the big one", that they believe will be found below an uncharted island in the Indian Ocean. Such a change seems "[i]nspired by the still-current energy crisis" (Morton 153), when Arab embargos led many US companies to explore drilling in environmentally sensitive areas such as the Arctic. Indeed, in casting Petrox executive Fred Wilson as the film's eco-villain – he is referred to as "an environmental rapist" at one point – the film signals its environmentalist concerns quite clearly. Also travelling with the Petrox workers are stowaway primatologist Jack Prescott and wannabe

actress Dwan, who the crew rescue from a life raft after the yacht she was on exploded in a storm. When the mismatched group eventually get to the island, the native population refuse to grant the Petrox crew access to the oil. While the ecologically minded Prescott pleads with Wilson – "[t]his is no longer the nineteenth century, you can't just walk in and grab their island" – the executive is not fazed by the islanders' steadfast refusals. Instead, in an act of moustache-twirling eco-villainy, Wilson suggests he can easily buy the villagers off, or, failing that, blow them up. Fortunately for the indigenous people, Wilson quickly discovers that the oil deposit is unusable. However, instead of leaving empty-handed, the executive decides to try to capture the 40-foot ape that he has heard lives on the island in order to exploit it as a corporate mascot for the Petrox company.

Guillermin's film tries to interrogate the perceived imperialism of the 1933 *King Kong* by aligning Petrox's exploitation of the natural world with the company's similar mistreatment of Kong. However, the 1933 film's inherently carnivalesque nature – it already encourages us to sympathise with the 'monster' and to see Denham's colonialist actions as doomed to hubristic failure – mean that Guillermin's film can seem ideologically superfluous. The film's camp tone complicates matters further. Cynthia Erb has described the 1976 *King Kong* as "the culmination of a tendency in the 1960s and 1970s to rethink *King Kong* through the lens of mass camp" (165) and the film's screenplay (written by Lorenzo Semple Jnr, of TV's *Batman*) attempts to create humour through direct references to other instances of popular culture, most notably, the 1933 original. While Wilson telling Prescott to "stop spouting ape-shit", or telling his captain, upon landing on Skull Island, "[l]et's not get eaten alive on this island... bring the mosquito spray", reward an audience familiar with previous instances of the story, they also encourage "a campy reading against-the-grain of classic film" (77) that arguably undermines any serious socio-political intent the 1976 *King Kong* might have.

The film's troubled production process, which saw many of De Laurentiis' more grandiose claims needing to be scaled back, has been well documented. Morton notes that because of ongoing budget worries "scenes were combined, and a sequence in which a giant snake attacks the search party was eliminated entirely" (192). Most notably, the life-sized animatronic Kong that De Laurentiis repeatedly referred to in the promotion of the film proved too dangerous to operate on-set, with its immense size limiting, rather than enabling, the film makers. In fact, the huge model was so unwieldy to operate that it features in less than 20 seconds of the film's running time. Instead, Rick Baker in a "hastily

knitted monkey suit so unconvincing that audiences kept looking out for the zipper" (Crook 177), and a series of animatronic models of Kong's face and hands, were employed to help realise the ape on screen, to varying degrees of success.

The film's climactic attack scene atop the twin towers of the World Trade Center exemplifies the problematic nature of the film's visual effects. Unable to use the unwieldy and dangerous animatronic version of Kong, the film makers resorted to employing Rick Baker yet again. This approach fails to evoke a sense of the "representational prowess" so important to (bigger-budgeted examples of) the genre. Instead of the technical virtuosity of the original film's stop-motion Kong, the man in a suit serves to remind the audience of the quotidian nature of the film-making process. Firstly, Kong climbs up the tower in a manner decidedly unlike that of an ape. Where gorillas climb quadrupedally, using their feet as much as their arms and hands, this Kong climbs in a bipedal fashion. Once on top of the tower, Kong stands upright like a human, rather than hunched over like a gorilla (a decision taken by Guillermin, with which Baker disagreed). A group of helicopters then attack Kong, causing him to jump dramatically from the roof of one of the towers to the other, an action that gorillas rarely perform. When the cornered Kong realises his fate and decides to 'save' Dwan by putting her down on the roof of the World Trade Center the film noticeably cuts to a shot using the giant animatronic hands interacting with the actress. These hands are obviously not part of the same body as the man in a suit featured in the rest of the sequence and this disrupts the sense of continuity.

On reflection, perhaps the most significant effect that the 1976 version of *King Kong* had on the giant monster movie was in this emphasising, deliberate or otherwise, of the human-like qualities of the giant ape. Whereas the shark in *Jaws* is depicted as a machine – Hooper tells Brody that all it does is "swim and eat and make little sharks" – "De Laurentiis said that he thought of Kong not as a mean gorilla but as an animal with the powers of a gorilla and the mind of a man" (Bahrenburg 180). Because this version of Kong is actually a man in a suit for much of the film's running time, the giant ape is inevitably more like a human than he is in the original. Where the stop-motion technique used in the 1933 film imbued Kong with a sense of bestial otherness, Rick Baker's performance is that of a creature who walks upright like a human, without using his knuckles to support his weight and for balance. Whether intentional or the result of poor production decisions, the 1976 *Kong* cannot help but demonstrate humanity's kinship with the giant ape because here they are one and the same.

Given its commercial success, Gullermin's film received a sequel in 1986, entitled *King Kong Lives*. This second film tries to make up for its reduced production budget ($10 million versus its precursor's $24 million) by emphasising those elements unlikely to necessitate expensive action sequences. Indeed, *King Kong Lives* might more accurately be (re)named *King Kong Loves*, so interested does the film seem to be in the romantic potential of the original Kong narrative. The film's plot, such as it is, concerns an amorous, "horny" Kong, whose life is saved following his fall at the end of the first film by a mechanical heart transplant and who escapes with a newly discovered female giant ape (nicknamed "Lady Kong") to the aptly named Honeymoon Ridge in rural Georgia. Once there, we get to see the courtship practices of the two giants. The amorous Kong gifts Lady Kong first some vegetation, and then a snake (which is not as gratefully received); then Lady Kong tends to her wooer's wounds; finally, the two giants lovingly embrace one another before the film cuts away as the inevitable culmination of the relationship takes place. The romance is halted, however, when the Kongs are attacked by the army and Lady Kong is captured. Fleeing artillery fire, Kong jumps off a cliff, seemingly to his death. While all seems lost for the love-struck apes, it is not long before we find out that Kong is still alive and set on reuniting with the lovelorn (and now pregnant) Lady Kong, even if that means assaulting the heavily fortified military base where she is imprisoned.

In a repeat of the relationship between the 1933 *King Kong* and its sequel *Son of Kong*, rather than attempt to recreate the epic grandiosity of the original film, *King Kong Lives* aims lower. "Lack[ing] an appropriate sense of size and scope" (Morton 280), *King Kong Lives* leans much more overtly into camp than its predecessor. Scenes in which ill-equipped rednecks attempt to torture Kong by getting him drunk; Kong gets comedically hit on the head with a golf ball; and an ending in which a rapidly expiring Kong lovingly embraces his newly born offspring to a bombastic orchestral score; all seem to acknowledge the film's inherent absurdities. Furthermore, the lack of sympathy given to any of the human characters that attempt to stop the giant lovers from reuniting represents a significant change from previous films in which ultimately the monster always had to be stopped, if not killed outright. Though a financial flop, the substantial expansion of the sympathetic giant monster trope in *King Kong Lives* positions the film as an important entry in the development of a much more overtly carnivalesque approach to the genre.

Before this strain of the genre would come to the fore, John

Frankenheimer's *Prophecy* (1979) would be released. The film shares the ecological concerns of *Night of the Lepus*, *Grizzly*, and the 1976 *King Kong*, commenting specifically on the mistreatment of indigenous peoples and the polluting practices of Big Business. However, its "painfully earnest" (Murphy 188) approach in part demonstrates the ideological limitations of the giant monster movie. After a short prologue in which three loggers are killed by an unseen entity, the film introduces us to upscale couple Maggie and Robert Verne. Maggie is pregnant but is scared to tell her husband because he believes that "the world's in such a mess it's unfair to bring a child into it". As a doctor, Robert has dedicated his life to helping the poor and the needy; we first meet him as he treats the tenants of a downtown ghetto who have been attacked by rats. Through some clunky exposition, we learn that Robert just cares too much; he is pushing himself hard in his current position, trying to combat the "futility" of an exploitative system, and make a positive difference to those in his care. Frustrated by inner city life and looking for something "that's got permanent impact", Robert and Maggie set out to Maine for two weeks to write a report for the Environmental Protection Agency concerning a dispute over land rights between a logging company and the tribespeople living there. Though Robert is given the position because he is "good with people", his obvious environmentalist leanings seem to be shared by the film makers. As the couple fly over the forested landscape on the way to their base, Maggie exclaims "it's beautiful, it's so peaceful" and Robert comments "I'd forgotten the world could look like this". These comments position the Maine forest as a "garden of Eden" and the indigenous people as prelapsarian; tellingly, we later find out that the indigenes refer to themselves as the "OPs", or "original people". Led by a character called John Hawks, the Native Americans feel a close connection to the natural world. They tell Robert and Maggie that "the environment is us, and it's being mangled". The OPs reveal that they are willing to defend their forest home with their lives: "you cut my head off before you cut down these trees!"

As the film progresses the OPs' belief that they need to defend the forest is proved to be justified. The Vernes encounter evidence that confirms the logging operation is contaminating the environment with some significant consequences; Robert witnesses a salmon that is large enough to eat a duck; the couple's cabin is attacked by a crazed raccoon; and the couple encounter a tadpole the size of a small dog. It turns out that the careless logging company is polluting the local river with the outlawed chemical preservative methyl mercury. Much like the substance in *Food of the Gods* this pollutant has found its way into

the human food chain and is now affecting the OPs, many of whom are fishermen and therefore live alongside the waterway. They tell Robert of adults who have been behaving as though they are drunk when they have not consumed any alcohol and of "children born dead, born deformed".

Some of the Native Americans talk of the *katahdin*, a vengeful forest spirit which is "larger than a dragon with the eyes of a cat". The *katahdin* makes its first appearance around halfway through the film when it attacks a family of unsuspecting campers, killing them outright in a frightening night-time assault. The creature has been angered by the logging company's actions and stages a series of nocturnal strikes. After killing the local sheriff, the head of a paper mill, and the elder of the indigenous village, the *katahdin* is defeated by Robert, who, along with Maggie, then use its horribly mutated baby to expose the logging company's actions to the press. Unfortunately, as with several of the films from this period, the special effects used to create the *katahdin* were found disappointing by many reviewers; Schoell proposes that "*Prophecy* is actually a pretty high-class monster movie, with one highly unfortunate exception – the monster itself" (190). Intended to be a "hideous mash-up of every step of evolution, from fish to bird to mammal and all stops along the way" (Kaye 2019) the creature is realised on-screen via a tall actor in a (modified) bear costume. Rather than express the vengeful power of the forest – an epic rejoinder to the scale of man's destructive actions – the *katahdin*'s ineffectuality serves to undermine the earnest message of the film. The spirit's mediocrity suggests, incongruously, that the natural world is ultimately nothing to fear.

Though it was intended as a prestigious production, with a respected director (John Frankenheimer) and a screenplay by writer David Seltzer (responsible for *The Omen* (1976)), *Prophecy*'s biggest legacy might be in showing that the giant monster movie could only carry so much ideological commentary. In place of the usual spectacle and self-reflexivity we find mainly a sombre proselytising that is far removed from the more playful, carnivalesque aspects of the genre. Critics duly rejected the film's serious approach, accusing it of being "essentially an indoctrination course in liberal guilt" which, in its clunky "self-righteousness", "mangle[s] or poison[s] every issue [the film makers] try to call attention to" (Arnold). If *Prophecy* can be judged unsuccessful apogee of bigger-budgeted attempts to combine the giant monster movie formula with contemporary concerns about the environment, then the films that followed it were marked by their coupling of an increasingly political stance to the genre's more visceral scares.

Though 1980s cinema is often associated with an ideological conservativeness, the genre films released during this period go beyond "the highly nostalgic" mode (Negra 43) to critique many of the central tenets of US society. Jennifer Holt suggests that, in 1980s cinema,

> [h]ealthy images of family, community, a multicultural society, a strong national identity, the belief in capitalism, individualism, and freedom [...] crucial to [...] the vision of the American Dream [...] were embattled on the screen. (210)

This is certainly true of the decade's handful of giant monster movies, which retool their monsters into embodiments of "the oppositional culture of the oppressed" with their destructive actions reflecting "the symbolic, anticipatory overthrow of oppressive social structures" (Stam 173). Such films depict the rich elite as the true villains and suggest their corrupt conspiratorial behaviour needs to be exposed by blue-collar protagonists. In this respect the films can be read as a reaction to 'Reaganomics', an economic policy that strengthened some aspects of national finances while simultaneously increasing the country's levels of debt, broadening the income gap between rich and poor, and cutting support for those nearer the bottom of the socio-economic scale.

While it owes an obvious debt to *Jaws*, the film *Alligator* (1980), directed by Lewis Teague and written by John Sayles, exemplifies the blending of "political attitude, splashed with humor and film savvy" (Ryan 42) that came to define the US giant monster movie of the 1980s. Released at "a time when economic issues and their impact on the ordinary working American were at the forefront of the public consciousness amid palpable discontent with the establishment" (Mann 121), Teague's film charts the journey of the titular creature as it eats "its way through an American socioeconomic chain" (Ryan 42). In the opening scenes the alligator, named Ramón, is flushed down a toilet by an irate father wishing to get back at his wife. Ramón survives in the sewers by eating the carcases of discarded pets that have been illegally operated on by Slade Pharmaceutical. The company is developing a new growth formula and the dead pets that Ramón eats cause him to grow much larger than is natural. Twelve years pass, and disgraced police officer David Madison begins to suspect something is wrong in Chicago when the city's sewer workers and other city labourers start to go missing. Madison, and his new partner Jim Kelly, investigate the sewer system only to encounter the now huge, "30 or 40-foot-long" Ramón. Off guard and unable to outrun the creature, Kelly is devoured by the

hungry alligator while Madison barely manages to escape with his life. Subsequently, Madison is put in contact with reptile expert Dr Marisa Kendall and the two of them work together to try to track down and kill Ramón. Meanwhile, Mayor Ledeux, unconvinced by the efficacy of his own police force, hires Colonel Brock, a pompous big game hunter, to try to speed up the process of tracking down the gigantic alligator. However, unlike the hard-working Madison, Brock is arrogant, dismisses Kendall's credentials, and is more interested in giving television interviews than in co-operating with the police.

Alligator's "low-budget, blue-collar" take on the giant monster movie (Ryan 43) is evident throughout the movie. Where previous examples of the genre tended to position their climaxes in high-profile locations, *Alligator* focuses on the workaday parts of the city: a police precinct, a low-rent pet shop, the sewers, hospital wards. Chicago is a particularly apposite setting in this regard, having long been associated with the "sweat and gruff" (Mozzaffar 6) of steelworkers and heavy industry. Several critics have suggested that the film uses its creature as a vehicle for "taking a critical stance toward American society" (Shumway 5). Ramón is a physical manifestation of the corrupt practices that help the city to function and the film an "indictment of the establishment [...] the dishonesty, immorality and potential criminality of government, big business, the press and the social elite" (Mann 121) . A scene later in the film reveals that the head of Slade Pharmaceutical is a major donor to the mayor and that because of this the company can dictate what the civic authorities reveal to the public. Slade tells the mayor that if his company is linked to the alligator's attacks, he will ensure that Ledeux loses his position. Against such corruption the giant alligator takes on carnivalesque properties, with his actions representing "carnivalesque egalitarianism" which pulls "grotesque monarchs off their thrones" (Stam 173). When Ramón is provoked into coming out of the sewers it is noticeable that many of his attacks are directed against representatives of authority: a police officer, Slade, the mayor, and Slade's chief scientist. That the last three are killed by the alligator at an opulent wedding reception being held at Slade's luxurious mansion demonstrates the stark inequalities that exist in the city. The film suggests that the poor struggle to make a living in Chicago's graffiti-strewn ghettoes, while the upper echelons relax in luxury detached from the masses. Ramón's protracted killing of Slade, by repeatedly battering with his tail the luxury car in which the magnate is hiding, seems to indicate a level of retaliation for the crimes in which the pharmaceutical company has been complicit, and an undercutting of Slade's arrogant belief that his wealth will protect him from ever being brought to justice.

Two years after *Alligator*, "subversive" independent director Larry Cohen (Williams 2014, 3) would offer a similarly blue-collar take on the giant monster movie with the idiosyncratic *Q: The Winged Serpent* (1982). Set in New York, the film's story follows low-life criminal Jimmy Quinn and his encounter with the flying monster of the title. Quinn is an aspiring musician but has not worked for eight months. As a result of his hopeless financial situation, he reluctantly agrees to take part in a diamond robbery that goes horribly wrong when Quinn drops the spoils and flees the scene. Alongside Quinn, the film also charts the efforts of detectives Shepard and Powell as they track a bizarre serial killer who is sacrificing his victims to the Aztec god Quetzalcoatl. It turns out that Quetzalcoatl is in fact an ancient, giant, flying lizard that is preying upon the residents of the city. The two plots intersect when Quinn happens across Quetzalcoatl's nest, replete with egg, at the top of the Chrysler Building. Tony Williams writes that Cohen's films show a recurrent concern with "the alienation and oppression of those designated as 'Others' in American society" (2). Quinn's plan to extort a million dollars from the city's authorities in return for the location of the egg is presented partly sympathetically, as the act of a confused and desperate man: "just a little kid from the streets". Quinn sees nothing wrong in capitalising on his situation because he is aware that "a lot of murders and crooked politicians have done that" including "Ford pardoning Nixon for everything". The character's comments seem designed to highlight America's "decaying cultural and social values" (Williams 131). The film criticises an unjust system that leads Quinn to feel he must place his own interests above the common good if he is to achieve anything in life. Significantly, *Q: The Winged Serpent* suggests that Quinn is not the only person in New York city desperate enough to act in an 'irrational' manner. As his investigation continues, Detective Shepard learns that sacrifices to Quetzalcoatl must be made willingly, suggesting that there are numerous people who feel so hopeless that they would choose to die in the name of a higher purpose rather than continue living in misery. Though the monster is defeated at the end, the film finishes on the revelation that there is another giant lizard bird. We watch, in shock, as the camera descends on a ruined skyscraper and a huge egg hatches just before the credits roll. This lack of closure is not surprising if we consider that "Quetzalcoatl is really the ultimate expression of a system based on oppression and violence" (Williams 134). The monstrousness that Quetzalcoatl's (re)appearance represents; the larger cultural and social malaise apparent in the city, have not been eradicated, and so the message seems to be that the creature endures.

Chuck Russell's remake of *The Blob* (1988) is most interesting for the way in which it (re)positions its monster as the embodiment of wider societal failings. In this case the story changes the origins of the titular creature from the original film's alien entity to the result of biological weapon experiments by the military, offering a "post-Watergate anti-authoritarian message" (Bowen) reflective of the cynicism of many genre movies of the decade. Where the original film's teen protagonists were "hypocritically conformist" (Bowen), the remake's teenagers are depicted as more genuinely rebellious. After being introduced to amorous couple Paul Taylor and Meg Penney, we meet long-haired bad boy Brian Flagg, a drinking, smoking, teenage biker who nearly kills himself when his motorcycle malfunctions. In contrast to the conservativeness of the original film, here Flagg is positioned as a sympathetic character whose critical worldview – "I have a problem with authority figures" – is proved to be of value in combating the titular creature. It is not surprising that Flagg eventually becomes the film's (anti-)heroic lead when the 'good guy' Taylor is killed by the blob, given the film's anti-authoritarian ethos.

The 1988 *The Blob* also depicts the town's authority figures as ineffectual and corrupt. The Reverend has unhealthy designs on one of the teen football players, while the local police are intolerant bullies. Indeed, it is the negligence of Arborville's adult population, and the US government before them, that enables the blob to infiltrate the town and kill so many of its residents. The blob's first victim is a local vagrant, symbolic of Arborville's socio-economic failings: it is noticeable that when the three teen protagonists initially take the infected vagrant to the local hospital, the nurse dismisses them because the vagrant does not have medical insurance. The local sheriff does not take Taylor's warnings seriously because he mentions Flagg's name in connection with the incident, and Penney's parents do not take her seriously when she tells them what has really happened, dismissing it out of hand even though their daughter is clearly distressed.

The situation is not improved when the scientists who have been tracking the blob eventually turn up, as they prove to be as foolish as the film's other adult characters. Indeed, the scientists are more concerned with retrieving their experimental creation than saving the townsfolk; as one suggests, "that organism is potentially the greatest breakthrough in weapons research since man split the atom [...] that's far more important than a handful of people in this small town". Consequently, rather than helping the teenagers, the scientists imprison Taylor and Flagg before Flagg breaks out and returns to help save Arborville from both the now massive blob and the immoral scientists

who helped create it. The blob's rapid growth rate suggests the scale at which governmental and scientific misdemeanours can rapidly escalate; to the point where they can quickly threaten the very stability of the nation. As one scientist exclaims, "at this rate by next week there may be no US". It is indicative of the film's denunciation of the adult world that the blob's final appearance is only stopped by the quick thinking of the two teenaged characters, who work out that the creature cannot stand cold and then attack and defeat it with a van full of liquid nitrogen.

Now seen as something of a swan song for the pre-CGI monster movie, *Tremors* (1990), like the 1980s films before it, combines a humorous, knowing tone with a set of down-at-heel characters, in the process creating something akin to a white trash version of *Jaws*. Though initially commercially unsuccessful, *Tremors* has since gone on to accrue a cult following and now regularly attracts plaudits, being praised as a "cult classic" (Kaye 2016), "an affectionate tribute to [...] films such as *It Came from Outer Space* (1953) and *Tarantula* (1955)" (Muir 2011, 134), and "the last great monster movie produced in Hollywood" (Melville xv). Certainly, *Tremors* crystallised a formula for the US giant monster movie that would continue into the 1990s. The film weds the more fully developed characters of *Jaws* with a sardonic vein of humour derived from *Son of Kong* and lower-budgeted films such as *The Giant Spider Invasion* and *Alligator*, allowing the audience a critical distance from which to enjoy the more *outré* elements of its plot. While "the *Tremors* tone" (Steve Wilson quoted in Melville 25) still includes the carnivalesque pleasures of seeing civilisation and its hegemonic representatives under threat, it also incorporates a playful acknowledgement and self-reflexive diminishment of the genre's previous bombast and grandiosity.

Epitomising the film's irreverent take on the genre, the opening shot of *Tremors* depicts handyman Valentine McKee urinating into a huge crevasse. McKee works with his friend Earl Bassett in the ironically named Perfection, a run-down township somewhere in the Nevada Desert. When we first meet the two handymen, they are desperate to find "real employment" away from their current jobs, which involve handling the town's "garbage"; for example, they are tasked with emptying a neighbour's septic tank. Their low-paid and mundane lives position McKee and Bassett in stark contrast to the genre's more traditional scientists, police detectives, and military professionals; they spend their time doing banal jobs, squabbling about trivial issues, and hoping for better things. A great deal of the appeal of *Tremors* is created through the juxtaposition of the quotidian with the genre's more conventionally epic aspects. The desert landscape deliberately

evokes the grandiosity of John Ford westerns, yet the film is peopled with "Nevada hicks" (Cooper 543) who ignore McKee and Bassett's initial warnings because they do not expect anything vaguely exciting to ever happen in their boring little town.

Much of the film's comedy comes from witnessing how the seemingly ill-equipped and unheroic population of Perfection respond to the threat posed by the giant, snake-like creatures, named graboids. Local storeowner Walter Chang's initial reaction to finding part of a graboid attached to the back of McKee and Bassett's truck is to offer them $5 for it. Rather than the townsfolk freaking out about the potentially revolutionary discovery of subterranean monsters, it is not long before Chang is charging eager residents to have their photo taken with "the Snake Monster" in his shop, much to the chagrin of the two handymen, who wish they had thought of the idea first. Later in the film, a fleeing McKee and Bassett only manage to escape the first graboid when it inadvertently chases them headfirst into the concrete side wall of an aqueduct, accidentally smashing its own brains out. This skewering of the genre's narrative conventions persists with the trapped townsfolk making a daring but extremely slow escape to a nearby mountain range, in the town's clapped-out CAT loader. Their inching along, crawling ever so slowly towards safety, parodically inverts the more usual dynamism of the genre.

Alongside its other targets, a case can be made that *Tremors* also interrogates some of the gendered stereotypes prevalent in the US giant monster movie. McKee and Bassett are soon joined in their attempts to defeat the graboids by female graduate student Rhonda LeBeck. Much to McKee's initial dismay, Lebeck does not present the more traditional physical criteria that he is seeking: "long blonde hair, big green eyes, world-class breasts, ass that won't quit". Instead, the depiction of LeBeck shares something with characters such as FBI agent and medical doctor Dana Scully in *The X Files*, who are presented as intelligent, capable professionals irrespective of their gender. While Holly Hassell writes of LeBeck as a "babe scientist" (196), a problematic figure in 1990s cinema, the character is nevertheless shown to be instrumental in defeating the graboids in the film. It is Lebeck who works out that there are multiple graboids, that they hunt through sensing vibrations, and it is LeBeck who devises a successful means of escape (via pole vaulting) when the three protagonists end up stuck on a rocky outcrop at the story's halfway point. *Tremors* also features a survivalist married couple, Burt and Heather Gummer. Though far less central to the narrative than is LeBeck, Heather is a surprisingly progressive figure in genre terms. She is depicted as equal to her husband in military prowess; she is as skilful

as he is in the handling of a wide range of firearms and seems to share his knowledge of survivalist techniques. Furthermore, when a graboid attacks the Gummers' underground bunker, it is Heather who saves her husband from being dragged to his death before the pair work together to kill the creature. Figures such as Terri Flores in *Anaconda*, Dr Margo Green in *The Relic*, and Dr Susan Tyler in *Mimic* (all 1997) can, in part, be traced back to *Tremors*' more progressive refashioning of the genre's conventional female protagonist.

While the film's use of practical effects rather than the nascent CGI reflects co-writer and producer Steve Wilson's love of Ray Harryhausen and classic monster movies (Melville 3, 25), the use of CGI quickly came to dominate the process of blockbuster-film making in Hollywood. This new visual effects technology would help create another significant boom in the US giant monster movie, bringing the genre back to mainstream prominence. Chapter 4 looks at the impact that CGI had on the giant monster movie in the 1990s and considers how the subsequent drive for photorealism saw a shift away from the carnivalesque, which took another decade to return.

4

65 Million Years in the Making: *Jurassic Park* and the Rise of CGI in the US Giant Monster Movie

The widespread adoption of computer graphics technology during the 1990s brought about a renaissance in the giant monster movie that has continued until the present day. If "spectacle tends to be foregrounded especially during periods of innovation" (King 2000, 31) then the emergence of "increasingly sophisticated computer-generated imagery" (Balio 181) in the 1990s led to the revival of the giant monster movie genre, perceived to have reached many of its limits in terms of practical effects by the end of the 1980s. The spectacular nature of the giant monster when realised through CGI functioned as an effective demonstration of Hollywood's "representational prowess" in "the particular blockbuster-centred regime of the Hollywood of the late 1990s" (King 2000, 51). Cutting-edge CGI visual effects technology was the latest tool to remind audiences of "[Hollywood's] largeness [...] its own material presence [...] and unusually abundant resources" (Acland 56). While Steffen Hantke notes that "the advent and affordability of CGI and the visual sophistication it permits are the very reason [the giant monster movie] returned to the screen during the 1990s" (2010, 236), this chapter will explore how the dominance of CGI would have important consequences for the genre that would see it depict ever greater levels of destruction while simultaneously moving further away from anything ideologically and politically carnivalesque.

 One of the earliest and most significant films of the 1990s to use to CGI was Steven Spielberg's *Jurassic Park* (1993). Much like *Jaws* before it, while classifying *Jurassic Park* as a giant monster movie might be considered contentious, numerous critics have noted the film's impact on the genre, particularly its pioneering special effects; Stephen Prince suggests that "digital effects came of age in *Jurassic Park*" (5) while Paul

Bullock writes "Spielberg's film helped change the way [...] monster movies were seen by cinema-going audiences" (91). Despite *Jurassic Park*'s status as a pioneer in the field of visual effects the new technology was eventually only used for six minutes in the film. While this does not seem a substantial amount the importance of these sequences suggests a great deal about the future possibilities of computer-aided advances in special effects; as Prince suggests:

> Compared with the animatronics and the suited performers, the digital dinosaurs are more supple, their movements more complex and nuanced, and they interact with the live actors in more active and spatially convincing ways (5).

Also, like *Jaws*, *Jurassic Park* tries to achieve broad verisimilitude in the giant monster movie, limiting the carnivalesque possibilities of its CGI because of its desire to achieve a photorealistic aesthetic. Spielberg is on record as suggesting that *Jurassic Park* "isn't *Gorgo*, this isn't *Godzilla*. This is a real movie that I think is really happening as I'm watching it" (quoted in Bullock 23), while John Kenneth Muir suggests "[t]here is not an ounce of phoniness in [the dinosaurs'] physicality or presence" (2011, 290). Rather than play up the carnivalesque nature of the genre the film's visual effects aim to achieve a sense of "perceptual realism" (Prince 33): a form of "reality that the viewer will find credible because it follows the same observable laws of physics as the world s/he inhabits" (Prince 32). The ability of CGI to enable film makers to create referentially impossible objects that nevertheless appear perceptually real was to become a defining aesthetic in the development of the giant monster movie through the 1990s. The immense critical and commercial success of *Jurassic Park* led others working with CGI to adopt a similarly realist approach to using the visual effects technology. Indeed, it would not be until nearly a decade had passed that film makers started exploring the more carnivalesque potential of CGI; we will come to this later in this chapter.

One of the successful ways in which *Jurassic Park* creates a sense of immersion is by aligning its cinema-going audience with the characters in the film, in the process achieving "a total symbiosis between the audience and the events on screen" (Bullock 50). The film provides repeated moments where the audience are encouraged to share in the characters' feelings of wonder and amazement. One of the most obvious examples of this technique is in the scene in which the brachiosaur is revealed for the first time. This sequence is the first of only two in *Jurassic Park* that were achieved solely through CGI and it helps

to demonstrate the centrality of this new visual effects technology. Notably, up to this point in the narrative the dinosaurs have been kept largely off-screen, alluded to in sequences that tease their existence, or that otherwise keep them hidden through clever use of editing and lighting. Consequently, and much like the various characters who are being shown around the park, the audience's suspense has been raised to near breaking point by this juncture in the film. Having been persuaded to check out John Hammond's mysterious new "biological preserve", the assembled experts (palaeontologist Alan Grant, palaeobotanist Ellie Sattler, mathematician Dr Ian Malcolm, and attorney Donald Gennaro) are being driven into the park itself with its owner. Cresting a hill, Hammond abruptly stops the pair of jeeps being used to transport the group from the coast to the visitor centre, directing them to pay attention to what he has seen. In his actions here (and elsewhere) the character is compared to a film director, controlling and directing the gazes of the other characters.

The camera makes a point of showing the uninterested faces of the passengers; Gennaro is trying to deal with some paperwork, Sattler is preoccupied with a map of the park's fauna, then we watch as Grant's face slowly takes on a look of wonder. The music on the soundtrack starts to build as Grant first removes his hat and then, somewhat frantically, his sunglasses, so that he can stare unimpeded at something that is still being kept off-screen for the audience. The reveal is delayed even further as we then watch Grant turn Sattler's head to look in the same direction. A slack-jawed Sattler then replicates Grant's actions: she stands and removes her sunglasses to get a better look at something off-screen. Finally, in one of the most iconic reveal shots in contemporary cinema, the soundtrack swells and the camera shows what has so stunned the two characters, a fully grown brachiosaur. Notably, in contrast to previous depictions of dinosaurs on screen, the CGI brachiosaur is shown in close-up, in immense detail, and in broad daylight. As the animal moves ahead of the human characters Grant and Sattler exit their jeep and walk up to the creature, Grant exclaiming in astonishment "it's a dinosaur!" Crucial to the scene's sense of spectacle is the sense of scale made possible through the new technology. The gigantic size of the brachiosaur is emphasised by having human characters stand next to the dinosaur as it rears onto its hind legs to feed on some of the more out-of-the-way tree leaves; as King suggests, "Grant and Sattler end up positioned as small figures in the left-hand lower corner of the frame, looking up [...at...] the giant figure" (2000, 44). The amazed palaeontologist starts describing the dinosaur's actions when Hammond reveals that the brachiosaur is

Figure 4.1 Drs Alan Grant and Ellie Sattler gaze in wonder at herds of dinosaurs in Jurassic Park.
Source Amblin Entertainment, 1993

only one of several species they have in the park. The revelation causes Grant to sit down with excitement. The sequence ends with a sweeping, panoramic shot in which multiple herds of different species of dinosaurs are depicted in the same landscape; something that would have been impossible to achieve through practical effects and further showcases the new possibilities afforded by CGI.

While parts of *Jurassic Park* such as the scene revealing the brachiosaur seem to function as a showcase for CGI, it is important to note that practical effects still played a crucial part in helping the film makers to realise the dinosaurs in the film. *Jurassic Park* saw director Spielberg task renowned special effects expert Stan Winston, and his team, with building several full-size animatronic dinosaurs. Of particular note and demonstrating the significant developments that had taken place in constructing large-scale practical effects since the malfunctioning shark in *Jaws*, Spielberg asked Winston to create a life-size, 20-feet-tall *tyrannosaurus rex* for *Jurassic Park*. The unprecedented size of the *T. rex* model meant it took a team of 10 sculptors 16 weeks to put the creature together, with its construction requiring the creation of an entirely new moulding procedure. Once built, puppeteers then used an adapted telemetry device to control, in real time, the large-scale hydraulics and heavy-duty motion platforms that facilitated the dinosaur's movements on-screen. Where De Laurentiis' attempts to build a life-size Kong for his

1976 film had proven overly ambitious, resulting in the film resorting to a man in a suit, with *Jurassic Park*'s *T. rex* Winston and his team succeeded in creating "the biggest, most director-friendly mechanical actor of all time" (Jody Duncan 182).

In his book-length study of digital effects, Prince details the way in which one of the real successes of *Jurassic Park* is in "conjoin[ing] analog and digital effects technologies" (5), meaning that "most scenes featuring dinosaurs feature a blend of traditional effects elements and digital ones" (26). The effectiveness of this combined approach is apparent in the memorable set-piece in which the *tyrannosaur* appears and attacks two of the park's vehicles and their passengers. The scene seamlessly switches between the animatronic model by Stan Winston, a digital version of the creature, and close-ups of the animatronic head, in a way that had not been possible before. The three technologies work together to convey the size and power of the *T. rex*. The scale of the dinosaur is emphasised throughout the scene in several ways. Not only do its footsteps cause the ground to vibrate, but it also dwarfs the vehicles containing the human characters; when it peers menacingly into the passenger's side window, we see that the dinosaur's eye is nearly the same size as the entire pane of glass. Such is the immensity of the *T. rex* that it easily overturns the entire Jeep with a tap of its giant head, proceeding to toy with the vehicle like a cat might with a mouse.

Whereas previous special effects techniques, including stop-motion, often made it very difficult to create a sense of convincing connection between the live action and visual effects elements on screen, CGI meant much more interaction was feasible. *Jurassic Park*'s other sequence entirely achieved through CGI depicts a herd of ostrich-like *gallimimus* as they appear to run alongside the human actors. The characters – Grant and Hammond's grandchildren Tim and Lex – take refuge behind a felled tree, only to have the fleeing dinosaurs proceed to stampede over the trunk, mere centimetres from where the characters are hiding. Such seemingly tangible interaction between live action elements and visual effects would become an integral part of the genre, with subsequent films that used the technology often emphasising physical interactions between the human characters and the monster, not least, *Jurassic Park*'s own sequel *The Lost World* (1998), which features a spectacular sequence in which a group of human characters drive in and around (and at one point underneath) a stampeding herd of dinosaurs.

While Spielberg's previous big monster movie success, *Jaws*, had largely avoided many of the genre's carnivalesque elements, *Jurassic Park* contains a much more overt critique of those with power. The film

takes specific aim at the misguided conviction held by Hammond and his scientists that they can manipulate the natural world without any negative consequences. Starting from the belief that they can genetically engineer the dinosaur's DNA to stop it reproducing (it is later revealed that the dinosaurs are able to breed in same-sex environments), those who work for Hammond are shown to possess a hubristic arrogance that eventually leads to their own downfall. Indeed, *Jurassic Park*'s depiction of the problems surrounding genetic engineering would prove to be hugely influential on the genre through much of the later 1990s, recurring in several films including *The Relic* (1997), *Mimic* (1997), and *Deep Blue Sea* (1999). Prompted by contemporary developments including the Human Genome Project's mapping of human DNA in 1990 and the creation of Dolly the cloned sheep in 1997, due to *Jurassic Park* genetic engineering quickly replaced nuclear power and environmental destruction as the target *du jour* for the genre, reflecting fears that "gene splicing technology and gene therapy will open up a whole new realm in which scientists can play God" (Muir 2011, 289).

In locating most of its story in a literal theme park, created by the misguided but benevolent Hammond "using all the latest technologies", *Jurassic Park* also emphasises the giant monster movie's more self-reflexive tendencies. Like the *Kong* cycle before it, in *Jurassic Park* humanity's attempts to make the natural world into a spectacle for its own monetary gain are shown to be doomed to failure. Right from its beginning, the film draws attention to the problems inherent in trying to exploit the natural world for the purposes of spectacle. Following the highlight of the brachiosaur sequence, the rest of the guided tour of the park proves disappointing as the group fail to see any of the dinosaurs in their enclosures, provoking Malcolm to ask, sarcastically, "[n]ow, eventually you do plan to have dinosaurs on your dinosaur tour, right?" The dinosaurs' refusal to fill their expected roles as theme park attractions is framed as evidence of their human captors' naivety. Grant suggests the dinosaurs follow their own instinctive patterns of behaviour: "*T. rex* doesn't want to be fed, he wants to hunt. You can't just suppress 65 million years of gut instinct."

When Hammond and Sattler take refuge in the visitor centre after the film's security systems stop working and the dinosaurs escape, Hammond suggests he can correct the mistakes that had been made with this version of the park with a future iteration: "Next time, it'll be flawless." However, while initially overawed, by this point in the story Sattler has realised the problems with trying to manufacture ever greater spectacle through manipulating the natural world and argues that "[y]ou never had control! That's the illusion! Now, I was

overwhelmed by the power of this place. Well, I made a mistake, too. I didn't have enough respect for that power, and it's out now." The "lack of humility" that Malcolm warns Hammond about is finally punished when the dinosaurs break out of their enclosures and start killing the human staff. While it is true that most of the central group of characters escape the island at the end of the film, in keeping with the 'nature attacks' films explored in Chapter 3, the broader narrative points to a carnivalesque overturning of established hierarchies in which humans are penalised for ethical and moral transgressions by no longer occupying the top of the food chain.

Like *Tremors* before it, *Jurassic Park* might also be seen as challenging traditional depictions of women in the US giant monster movie. While never radically deviating from the genre's traditional focus on male characters, the film provides a slightly more progressive approach to its female characters. Although palaeobotanist Ellie Sattler retains many stereotypically feminine qualities – most notably, she is depicted as maternal and interested in starting a family – the character is also shown to be knowledgeable, self-aware, and has real agency in the narrative. Rejecting Hammond's suggestion that it is he who should put his life on the line to reboot the park's power because he is a man, Sattler replies "[w]e can discuss sexism in survival situations when I get back". She is not a 'damsel in distress'; rather, it is she who manages to turn the power back on in the park, fending off a raptor attack in the process, and saving the remaining characters. Similarly, while Hammond's granddaughter Lex spends much of the film in distress because she is not a fan of dinosaurs (in contrast to her younger brother Tim), it is Lex who possesses the necessary 'hacking' skills to finalise the rebooting process and bring the park's computerised systems back online at the film's climax. Her technological knowledge (something traditionally coded as masculine) saves the day when other, male, characters are depicted as helpless. Both Sattler and Lex are shown to be equal to their male counterparts, pointing to a future in which women might play a more significant role in the genre, as Sattler jokily suggests when discussing gender politics: "Dinosaurs eat man. Woman inherits the earth."

The nascent state of CGI technology in the early 1990s meant that it took longer than might have been expected for other studios to mobilise their own competitors to Spielberg's film. Of course, as the narrative of *Jurassic Park* famously suggests, just because you can do something does not necessarily mean that you should. The use of CGI in other films was not always up to the same standard as in Spielberg's film, though this is not to suggest that such films do not hold their own

merits. While *Anaconda* (1997) demonstrates how difficult it is to create convincing CGI effects and integrate them into a credible narrative, the film would prove surprisingly influential, creating a template for the lower-budgeted, often more carnivalesque, end of the CGI giant monster movie marketplace. Establishing a self-reflexively camp formula that would be replicated by other companies including, most noticeably, The Asylum and the Sci-Fi Channel/SyFy, in which a cast of B-grade stars must fight off an oversized creature realised through subpar CGI.

The plot of *Anaconda* sees a crew of US film makers setting off to try and document the long-lost Shirishama tribespeople in a remote part of the Amazon jungle. The film's opening scene exoticises the non-Western as strange and different: an intertitle tells of "tales of monstrous, man-eating [...] giant snakes" worshipped by native tribespeople in the Amazon, which can grow "as long as 40 feet" in length. Like many giant monster movies before it, *Anaconda*'s narrative emphasises the dangerous consequences of transgressing established geographical and ideological borders: from west to east, civilised to wilderness. Indeed, when the US characters in the film blow up a wall that has been constructed across the Amazon River by the indigenous tribespeople part-way through the film, their concerns that they might risk "upsetting the ecological balance of this river" appear well founded. Significantly, the barricade turns out to be made of a "barrier full of snakes". In this sense it is literally and symbolically linked to the giant anacondas in the film. When the wall is destroyed the baby snakes hidden inside the barricade attack the film makers, reflecting the hostility of the natural world towards the outsiders' presence.

In keeping with many lower-budgeted instances of the genre, *Anaconda* frequently seems to verge on parody, though it is difficult to tell whether this parody is intentional or not; Edward Margulies notes that "[n]o single movie in the annals of cheesy aquatic flicks [...] has ever provided more unintentional laughs than *Anaconda*" (quoted in Muir 2011, 485). Still, the film seems to demonstrate some awareness of its own absurdities. While a case could be made that nearly all the characters are deliberately unlikeable, to encourage the audience to take pleasure in their deaths, the character Paul Serone, a "failed priest" turned "snake poacher", seems to primarily exist to caricature the 'great white hunter' figure common to the genre. At first Serone appears to be at home in the jungle; he hand-spears a fish for breakfast and saves two of the group from being attacked by a wild boar. However, the poacher's credentials start to be undermined when one of the members of the group, Dr Steven Cale, points out that the story Serone tells of "a sacred lake [...] protected by warrior snakes" is a legend of the Maku tribe rather

than of the Shirishamas. Where the traditional 'great white hunter' is usually defined by masculine professionalism, Serone is an explicitly licentious character. The film indicates that he has unsavoury designs on Terri Flores; he stares at her lasciviously as she stretches on board the group's boat. Serone's deviancy is further emphasised when he delivers a dramatic monologue (reminiscent of the grizzled shark hunter Quint in *Jaws*) about the creature he has dedicated his life to exterminating. His talk of the anaconda holding "you tighter than your true love... before the power of the embrace causes your veins to explode" seems designed to encourage the audience to question his sexual proclivities instead of recoil in awe or fear. Rather than operating in a realist fashion, Serone represents a self-consciously baroque take on the 'great white hunter' figure, one which pushes many of that character's traits to an extreme to highlight how ridiculous they are. Subsequently, at the end of the film it is not enough for Serone to be eaten alive by the giant anaconda, as Quint is by the shark. Instead, during the climactic action sequence, Serone's half-digested body is regurgitated in front of Flores, to whom he delivers a knowing wink before finally expiring.

Alongside the film's parodying of some of the regressive, quasi-colonialist tropes associated with the genre, *Anaconda* is also one of the first US giant monster movies to feature GEM (Global Ethnic Majority) actors in central roles. The film's protagonist, Terri Flores, is played by Hispanic actor and performer, Jennifer Lopez, while African American Ice-Cube plays camera operator Danny Rich. Given the inefficacy and moral corruption of most of the white characters in the film, the depiction of Flores and Rich as moral, intelligent, and sympathetic suggests a more progressive attitude towards race than is usually found in the genre. As Mary Beltrán suggests, "Lopez's lead role [...] distinctly challenged previous patterns of Latina representation" (190). Significantly, it is Flores and Rich who work together at the end of the film to trap and kill the anaconda, with Rich finally dispatching it with an axe. Furthermore, it is only when Flores and Rich have assumed leadership that the indigenous tribespeople come to the group's rescue and the film finishes on an ambiguously upbeat note.

Though *Anaconda* was received negatively by many reviewers, with its CGI being singled out for criticism, the film nevertheless went on to make $136 million against a relatively modest budget of $45 million. This commercial success has led to four sequels (with a reboot of the original now mooted). Though each of these sequels has had a significantly smaller budget than the first film, in part due to the move to a direct-to-television/home-video release pattern, they have also made a substantial profit. One reason for this success might be

that the *Anaconda* franchise tapped into a growing market for what Jeffrey Sconce calls paracinema. Paracinema is "so histrionic, anachronistic and excessive that it compels even the most casual viewer to engage it ironically" (393). This carnivalesque tendency would become ever more prominent among the lower-budgeted end of the US giant monster movie during the 1990s; films, like those in the *Anaconda* series, representing a deliberate appropriation of a subcultural 'trash' position that distinguishes itself from the slicker, higher-budgeted films produced by larger Hollywood studios, partly in order to mock their perceived self-importance and grandiosity.

It is interesting to consider the extent to which the less carnivalesque approach of *The Relic* contributed to its being less commercially successful than *Anaconda*. Like *Anaconda*, *The Relic* feels "like a response to the *Jurassic Park* phenomenon" (Kelper), offering a monster that is realised through a combination of practical effects and CGI, and a plot that touches upon the issue of genetic experimentation. Like *Anaconda*, *The Relic* opens with a prologue set in a South American jungle environment, replete with chanting indigenous tribespeople taking part in exotic rituals. Observing the ceremony is a white photographer, who drinks a mixture prepared by the natives. The drink leads the photographer to hallucinate that one of the more dramatically attired tribespeople is trying to attack him. The film's narrative then switches to the docks, where we discover that the white photographer from the previous scene is in fact John Whitney, an anthropologist at the Chicago Natural History Museum. A now agitated Whitney warns the ship's captain that the crates he had originally organised to be transported to the USA contain something dangerous and must be offloaded. When the anthropologist is unable to make this happen, he hides among the crates as they are loaded onto the ship. In this opening sequence, *The Relic*, like *Anaconda*, literalises fears around border transgression. Whitney realises too late that what happened in the jungle should stay in the jungle.

The Relic is interesting for the multiple ways hybridisation informs the film. On the level of genre, *The Relic* stands as a hybrid version of the monster movie, incorporating elements from horror cinema (resulting in an R rating for the film in the USA); the detective thriller, "like *Se7en*, popular at the time" (Kelper); science fiction; the siege film; and the disaster picture, "unfolding like an Irwin Allen production" (Shawhan). *The Relic* marries these interrelated genres in a manner reminiscent of the more esoteric 1980s examples of the giant monster movie. Much like *Alligator*, one of *The Relic*'s two protagonists is a police detective, Lieutenant Vincent D'Agosta, and the early part of the film is structured by D'Agosta's investigation into what lies behind the horrific massacre

– the numerous severed heads – that he discovers on the ship that has transported Whitney to Chicago.

The Relic's other protagonist is female, Dr Margot Green, an evolutionary biologist. Green is one of Whitney's colleagues and as such his crates are delivered to her office in his continuing absence. While others dismiss the containers and their content as unimportant, Green's curiosity leads her to test the strange 'eggs' that she finds in the crates, eventually discovering that they are a parasitic fungus. The fungus, which is undocumented by Western science, causes mutations when ingested, including gigantism and increased aggression. Alongside the parasitic fungus is a black stone relic of "the devil god". The Relic's monster, named the "Kothoga", embodies this process of hybridisation, being a chimera, "a combination of creatures that superstitious people view as god or enemy". In its genetic make-up, we find out that the Kothoga is indeed made up of DNA from several different species. In transgressing categorical distinctions, the Kothoga is presented as "impure and repulsive" (Carroll 1990, 45). We also learn that the creature is the result of the Callisto effect: "sudden evolutionary changes that produce a grotesque and short-lived, aberrant species". The Kothoga grows larger by killing and feeding on the hormones drawn from the hypothalamus of its victims. It needs this specific food source because, as is revealed in The Relic's final act, the creature's DNA is also 33 per cent human; more specifically, 33 per cent a mutated version of Whitney. In what is a particularly conservative *dénouement* the Kothoga is revealed as the evidential embodiment of the dangers surrounding the collapsing of boundaries (in this case between the scientist and his object of study) and further reinforces the film's depiction of contact with the non-Western Other as potentially hazardous.

Director Guillermo Del Toro's Mimic continues the 1990s monster movie's focus on hybridisation but takes a rather more progressive approach than is found in The Relic. The film's title sequence apes the gritty, crime-scene aesthetic of contemporary films like Se7en (1995), while the opening scenes follow the conventions of the medical disaster movie: we watch as ill and infected children are housed in makeshift hospital wards. These children are dying due to an unprecedented outbreak of Stricker's disease, a fatal disorder that we learn is spread by the common cockroach. Dr Susan Tyler, an entomologist hired by the Centers for Disease Control (CDC), creates an insect – part mantis, part termite, aptly named the "Judas Breed" – that she believes can help end the disease. The new hybrid releases an enzyme that causes the cockroach's metabolism to accelerate to the point at which it starves to death. That all of this happens in the first five minutes of the film leaves

the way open for a more traditional monster movie narrative. Indeed, it is not long before the film provides a scene that is analogous to the 'informational' video segments so common in 1950s 'big bug' movies. In this case, a confident Tyler lectures the city's gathered press and dignitaries about "how resilient the common cockroach is" and explains that "since it has proven to be virtually immune to chemical control" scientists "had to find a new avenue of attack". When Tyler finally reveals that this innovative approach involved genetic engineering it seems likely that all may not go to plan.

However, three years pass without any recurrence of the disease, and the film's narrative returns to follow the work of Tyler's husband and head of the CDC in New York, Dr Peter Man. Man is called in to investigate an illegal Triad operation that is using slave labour to produce fake clothing. Up to a dozen workers have been kept captive in squalid conditions. The situation is so bad that there is "shit on the ceiling" and the whole place must be quarantined. Nevertheless, the filthy conditions do not surprise either Man, or the on-duty police officers, with the doctor's assistant casually referring to this part of the city as "disease land". It is these conditions, presumably allowed to persist by an ineffectual or uncaring state government, that (we learn) enable the genetically engineered insects to survive in the overlooked and uncared-for parts of the city, eventually returning to pose a threat to everyone that lives there.

The next indication of this threat is when two kids bring Tyler a "weird bug" that they have captured. The insect turns out to be a specimen of the "Judas Breed". This should not be possible, given that all the genetically engineered insects that were released were female and meant to die after six months. However, "evolution has a way of keeping things alive", and it turns out that the hybrid species has rapidly evolved to replicate their creators, developing lungs, which have enabled them to grow and become human-sized. This new "man who's not a man" is now on the verge of making its former predator into its prey. Yet where *The Relic* depicts a similar collapsing of the boundaries between human and animal as a horrific aberration, Hathaway notes that "[*Mimic*] actually considers its monstrous insects with a modicum of commiseration, for they themselves can be viewed as unwitting victims in this situation" (265). Certainly, the creation and then discarding of the Judas Breed by the elite of the city might be seen as reflecting "the 'developed' world's manipulation and consumption of the capacities and resources of those deemed 'inferior'" (McDonald and Clark 67). Mirroring the "beer bottles, body parts, cocaine-filled condoms... and little baby alligators" that one sewer worker in the film suggests re-emerge over time, the threat posed

by the Judas Breed might be seen as a form of poetic justice, their return satiating the anger felt by all "the downtrodden, the outsiders, those forced to survive on the underside and on the margins of dominant human cultures" (Copeland 11).

If the other releases of the 1990s sought to capitalise on the success of *Jurassic Park* by using CGI to help realise their giant creatures, albeit in less obviously mainstream films, Roland Emmerich's *Godzilla* (1998) was a deliberate attempt to create a "big-budget, big-talent, big-profits" (Tsutsui 199) competitor to Spielberg's trailblazing movie. Much like De Laurentiis' 1976 remake of *King Kong* before it, *Godzilla*'s $50 million marketing campaign emphasised the gigantic size of the movie. The film's taglines included "Size Does Matter" and "Something Big is Happening" while one of the teaser trailers featured Godzilla's giant foot crushing a dinosaur statue in a direct attack on the sequel to *Jurassic Park*, *The Lost World*, also released in 1998. Douglas Gomery notes that *Godzilla* was positioned as "one of the biggest blockbuster events ever" (79) and was released to an unprecedented 3,310 screens across the USA. Yet although the film had a production budget of between $130 and $150 million and "a marketing campaign [comparable to] the size of its star" (Gomery 79), *Godzilla* is perceived to have been a commercial failure and received generally poor reviews upon release. Muir described it as "fail[ing] on an epic scale" (Muir 2011, 556), and Solomon called it "one of genre cinema's great mistakes" (quoted in Muir 2011, 551).

Part of the reason for this critical reaction might be the remake's demythologising approach to its monster. The plot switches the origins of the titular figure from a prehistoric creature awakened by nuclear radiation to "an iguana mutated to giant size by more bomb tests" (Newman 2002, 145). This change brings *Godzilla* more into line with broader trends in the US giant monster movie, particularly the 'big bug' movies of the 1950s. Several critics noted the way in which Emmerich's version of the story seems determined to undermine the mythic qualities that Godzilla has in many of the Toho films. When the idea of Godzilla being "some sort of ginormous reptile [...] believed to [have] died out in the Cretaceous period" is raised by one of the characters, this explanation is dismissed as nonsensical. Furthermore, while this Godzilla is still the result of nuclear testing these origins lead the human characters to dismiss him as "only an animal". This consistent undermining of Godzilla's "grandeur, mystery, and saurian nature" (Tsutsui 27) means the giant creature becomes "just a big lizard tearing up jack because ... well ... he's big and unwieldy" (Muir 2011, 556). While jettisoning Godzilla's mythic qualities could be seen as carnivalesque – a deliberate puncturing of the Japanese film's pretensions – by abandoning

the more grandiose aspects of the monster's origin story the remake opened itself to accusations that it was trying to obscure America's own history of nuclear testing and the country's position as the only nation to "ever use atomic bombs against a civilian population" (Muir 2011, 552).

While the 1998 *Godzilla* downplays the creature's mythic qualities, it does keep the Toho original's emphasis on the creature's gigantic size. Much like Emmerich's previous film *Independence Day* (1996), *Godzilla* follows a bunch of supposedly normal characters – "worm guy" Dr Niko Tatopoulos, his ex-girlfriend, wannabe reporter Audrey Timmonds, and her cameraman friend Victor "Animal" Palotti – as they try to survive a world-changing event, in this case the appearance and destructive actions of the 180-foot-tall Godzilla. The opening of the film effectively conveys Godzilla's magnitude through a series of scenes that tease the creature's size. In one sequence, cribbed from the 1954 original, Tatopoulos finds himself standing in a giant footprint left by Godzilla, but such is the immense scale of the footprint that he does not initially realise what it is. Next, Tatopoulos is taken to examine a beached tanker in Jamaica with gigantic claw marks in its side. When Godzilla finally reaches Manhattan, we do not see the entirety of the monster, only glimpses of its feet and head, hearing its bellowing roar as it marches just out of view of the characters and the audience. By not revealing the monster in its entirety the film creates the impression that Godzilla is too large to be seen all at once; Palotti tries to record the monster on camera but only succeeds in capturing some shaky footage of it towering above him.

Where CGI had been used rather sparingly in *Jurassic Park* and often in conjunction with other visual effects techniques, in *Godzilla* "prosthetic and mechanical effects accounted for less than 10 percent of effects shots featuring the monster" (Pierson 148). Perhaps because of this heavy use of CGI *Godzilla*'s giant creature often appears synthetic, failing to achieve the levels of perceptual realism reached in *Jurassic Park*. It is certainly possible that this was a deliberate attempt to create a "low-tech retrovisionist pastiche of B-grade effects" (Pierson 149) designed to emulate the similarly non-realist aesthetic of the Toho films. Nevertheless, the artificial look of the film's CGI, with the audience frequently reminded that Godzilla is a special effect, does contribute to a sense that the film is not as polished as it should be. This lack of perceptual realism is not helped by some odd gaps in logic in the plot. For prolonged parts of the film, the gigantic Godzilla manages to hide in the heavily populated, built-up city of Manhattan. Similarly, while the creature must weigh several hundred tonnes, at various points in the narrative it manages to move around the city

seemingly without creating a sound. However, rather than implying a carnivalesque rejection of a realist aesthetic these inconsistencies position the film and its special effects as a step back from *Jurassic Park*.

While it is difficult to read *Godzilla*'s use of CGI as deliberately carnivalesque, the film does offer the spectacle of Manhattan being destroyed by a rampaging CGI monster. Indeed, the film offers a veritable panoply of urban destruction. The audience are encouraged to take pleasure in seeing a range of recognisable locations being wrecked, including the top of the Chrysler Building exploding, and the film's climax in which Madison Square Garden blows up. However, the subversive, carnivalesque potential of these scenes is somewhat undermined by the film's odd political stance. Emmerich's film ignores the role that the USA has played in using atomic weapons, and instead blames the French; in this version of the story the creature is the result of nuclear testing in French Polynesia. In this respect, while the 1998 *Godzilla* provides some effectively spectacular scenes of urban destruction the film's depiction of the USA as a benign superpower "with a military that is no longer an aggressor, but a savior" (Jones 50) makes it difficult to claim the film as meaningfully subversive.

The remake of *Mighty Joe Young* (1998), directed by *Tremors'* Ron Underwood, is like the 1998 *Godzilla* in its offering of a less subversive take on the giant monster movie. This retelling updates the plot of the 1949 original, emphasising its environmentalist message and removing its more self-reflexive moments. To this end Joe is now the "sacred guardian" of the Edenic jungle environment. At the start of the film, rather than having Joe attack the caged lions as he does in the original version of the film, here he releases a caged leopard and watches, reflectively, as it runs back into the freedom of the undergrowth. The original film's nightclub owner and showman, Max O'Hara, is replaced with wildlife refuge director Greg O'Hara. We learn that O'Hara is a good guy because he works in "animal conservancy in California" and, at the start of the film, convinces Jill Young to let him to take Joe back to a nature reserve in the USA, where the ape will be safe from the poachers who might attempt to trap and kill him in Africa. Working against the conservation efforts of Young and O'Hara is Andrei Strasser, a poacher who kills the mothers of both Jill and Joe at the start of the film and sets about trying to capture Joe. Though Strasser also operates a wildlife sanctuary and professes to have the well-being of his animals at heart, the refuge is a front, and in fact Strasser kills the animals under his care and sells their body parts "piece by piece" to the highest bidder. The film thus sets up a battle over Joe, with conservation pitted against

commerce. While both Jill and Joe initially get on well in the USA, with the giant ape settling into his new home, Strasser sees Joe on a television news report and sets about trying to steal him. The poacher sends his men to unnerve the giant ape, and then capitalises on Jill's worries about her simian friend being used to raise money for the wildlife refuge. This part of the remake's plot echoes the original film's deeper exploration of the spectacle-making process, albeit in a sanitised form. Following an unsuccessful fundraising event at which Joe escapes from his enclosure and wreaks havoc while trying to hunt for Strasser and his men, the poacher manages to persuade Jill to let him take the giant ape back to Africa. While Joe is being transported to the airport, O'Hara and Jill realise who Strasser is and mount an attempt to rescue Joe before he leaves the country.

The 1998 remake of *Mighty Joe Young* offers relatively few of the carnivalesque pleasures of the genre. Perhaps the closest the film gets is in its extended climax, when Joe overturns the vehicle being used to transport him to the airport and runs around downtown Los Angeles. The giant ape first causes a pile-up at Hollywood Boulevard, before climbing Mann's Chinese Theatre, and then appearing at the Hollywood sign. However, in keeping with Disney's family-oriented approach, even here there is little real sense of danger, with the initially frightened crowds quickly realising that Joe poses no threat; one laughing bystander exclaims "that was so cool!" and another wide-eyed child tells her mother that she wants to stay to watch the gorilla. By so decisively eliminating any sense of Joe as a threat the film closes off some of the subversive potential of the genre. Consequently, while at the film's finale Joe finds himself in a carnival on Santa Monica Pier, a space ripe for the sort of self-reflexive commentary found in *King Kong* or *The Amazing Colossal Man*, in this film this is the site in which the monster redeems himself in the eyes of the community. Rather than cause mayhem and destruction Joe places himself in danger to rescue a young boy from a burning Ferris wheel. Such is the ape's heroism that his return to Africa at the end of the film is effectively crowdfunded by the public, who pay for the flight and the construction of a new "Joe Young Reserve" in which he can live safely for the rest of his life.

While big-budget examples such as *Godzilla* and *Mighty Joe Young* represented high-profile attempts to emulate the success of *Jurassic Park*, as the 1990s progressed other films sought to marry CGI technology to a more knowing approach to genre staples. Sconce suggests that paracinema "[produces] a relatively detached textual space in which to consider, if only superficially, the cultural, historical and aesthetic

politics that shape cinematic representation" (393). Such a level of self-reflexivity is apparent in *Deep Rising* (1998), *Deep Blue Sea* (1999), and *Eight Legged Freaks* (2002), which were all promoted as combining their CGI-based creatures with a deliberately camp approach to their subject matter, embracing the 'B'-movie side of the genre to varying degrees of success, as a key part of their appeal.

In his discussion of *Deep Rising*, Muir reads the actions of the "truly grotesque and interesting monster" (2011, 540) that feeds by sucking the fluid out of its human victims as a metaphor for "out-of-control business practices" (540) that similarly sucked the liquidity out of the middle classes during the 1990s. Such an interpretation speaks to the film's carnivalesque bent. *Deep Rising*'s gigantic squid monster attacks the *Argonautica*, a luxury cruise liner depicted as the preserve of the ultra-wealthy. To demonstrate this, in the film's opening scenes we are shown crowds of finely attired VIPs ostentatiously enjoying the ship's on-board casinos. The ship's wealthy owner Simon Canton gives a speech to the assembled guests, stating that he has realised his lifelong dream to "create the greatest, most luxurious, most expensive pleasure ship ever built". Canton toasts to "good times forever!", seemingly oblivious of his hubris. Predictably, it is not long before the *Argonautica*'s "state-of-the-art" computer system is sabotaged; then a huge object rises from the ocean and moves on a direct collision course towards the ship's hull. The impending attack is intercut with shots of the partying guests, to further underscore the message that the two are related to each other. The impact of the mystery object hitting the ship causes the party goers to run for their lives. Yet their behaviour here – they trample over each other in their attempts to escape – suggests that we are not meant to feel much sympathy for their plight. Indeed, when one coiffured, jewellery-clad partier hides in a lavatory only to be ignobly pulled to her death by something that emerges from the toilet bowl, the film seems to encourage laughter as much as it does horror.

Like other lower-budgeted monster movies such as *Alligator* and *Tremors*, the film presents the audience with a set of 'ordinary' characters with whom they are meant to sympathise. In *Deep Rising* this means snarky but honourable Captain John Finnegan and his wisecracking but ultimately tight-knit crew, Joey Pantucci and Leila. While this blue-collar group are depicted as flawed, they are still more principled than the wealthy elite who, it seems, the film's monster is there to punish. Early in the story we are also introduced to Trillian St James, a wanted criminal. Though St James has a shady past, in line with the film's valorisation of the marginalised she is also positioned as something of a Robin Hood figure. The *Argonautica*'s top brass describe St James as "a trollop" and

"no lady", yet her attempted robbery is presented as justified, given the decadence of the passengers on board. After their boat is hired by a group of mercenaries to take them to an undisclosed location in the South China Sea, Finnegan and Pantucci are eventually forced on board the ill-fated *Argonautica*. They find the cruise ship to be mysteriously deserted except for St James (who is locked up) and the ship's top brass (cowards who, it turns out, sealed themselves in the ship's vaults leaving the rest of the passengers to die).

In a further indictment of the rich and powerful, the ship's owner Canton is responsible for hiring mercenaries to sink the *Argonautica*. The huge cost of building the ship, "$487.6 million", and of keeping it operating, turns out to be "a hell of a lot more" than the profit Canton would ever be able to make. As a result of this miscalculation, Canton hoped to claim insurance money rather than "lose [the *Argonautica*] to a bunch of pencil-necked bankers". Consequently, Finnegan and St James spend the second half of the film trying to escape the now rapidly sinking liner, while avoiding the giant squid monster as it hungrily dispatches many of those still on board. Though the CGI that is used to realise the squid creature is often not very convincing, *Deep Rising*'s explicit critique of those at the top of the socio-economic scale makes for a particularly subversive film. *Deep Rising* encourages the audience to take a carnivalesque pleasure in seeing the *Argonautica*'s rich passengers punished for their arrogance, not least Canton, who ultimately pays for his hubris and his scheming with his life. In an instance of poetic justice, the shipowner bungles an attempt to escape by speedboat and instead crashes into the *Argonautica*, blowing up himself and the multimillion-dollar ship for which he is responsible in the process.

The overabundance of what Muir calls "snark" (2011, 632) in Steve Miner's *Lake Placid* (1999) links it to the other lower-budgeted US giant monster movies released as the 1990s ended. Like *Alligator* before it, much of *Lake Placid*'s appeal lies in witnessing a series of ever more violent attacks by its oversized giant reptile, in this case, a 30-feet-long saltwater Asian crocodile that has somehow relocated to a freshwater lake in Maine. In the place of *Alligator*'s world-weary police officer David Madigan, *Lake Placid*'s central character is neurotic palaeontologist Kelly Scott. Unlike the cynical but capable Madigan, Scott is inexperienced and does very little to advance the "cause of feminism in pop culture" (Muir 2011, 631). Instead, at the start of the film she is depicted as shrill, overly emotional, and obsessed with being in a relationship. Scott is also very definitely not a "field person". Faced with the prospect of travelling to Maine to help investigate the violent death of a scuba

diver, she suggests she is "allergic to timber", has "got a thing about mosquitos", and is incapable of "blending in with the natives". Despite her protestations, Scott nevertheless ends up being sent to Maine where she must work together with local sheriff Hank Keough, Fish and Game warden Jack Wells, and "kook mythology professor" Hector Cyr to track down the giant crocodile responsible for the attack.

While often knowing and self-reflective, here comedy is used to provide some interesting commentary upon changing attitudes towards masculinity. Sheriff Keough represents a very traditional stereotype of what it means to be a man; he is stoic and favours action above intellect but struggles to listen to the advice of others and is given to comedic bouts of physical violence. In contrast to the gruff Keough, the effeminate academic Cyr is depicted as a louche, intellectual dandy, who uses his loquacity to manipulate others into doing what he wants, usually trying to get them to sleep with him. This leaves the likeable Wells as an idealised middle ground between the two other versions of masculinity. As a result of his profession Wells has a certain level of power and authority over the other characters but he is also depicted as thoughtful and compassionate. He listens to what others have to say and acts accordingly. Noticeably, it is Wells who mediates the several disagreements that occur between Keough and Cyr over the course of the film, and it is Wells who ends the story in a romantic relationship with Scott. Whether *Lake Placid*'s exploration of masculinity constitutes any substantial overturning of gendered genre conventions is more difficult to assess. Certainly, Wells is a softer, less stereotypically male hero than the genre is used to, even though he does still conform to several genre conventions (he is professional, rational, and brave).

Lake Placid is also notable for realising its giant crocodile predominantly through practical effects. At a time when many US monster movies were switching predominantly to CGI, *Lake Placid*'s more traditional approach imbues the crocodile with a greater sense of perceptual realism than many of its lower-budgeted contemporaries achieved. Indeed, the creature's designer, Richard Landon, has claimed that the 30-foot, full-size animatronic was so realistic that it could in fact swim: "Its head left/right and tail left/right functionalities were enough to make it propel itself through the water" (Jody Duncan 237). This confidence in practical effects was well received by critics. Bryan Senn described the film's "crocodile effects as uniformly excellent" (394), while Andrew Collins commented that "the reptile itself is magnificent". Despite receiving generally negative reviews *Lake Placid*'s box office success, making $57 million on an estimated $35 million budget, has led to six sequels, including the crossover *Lake Placid vs Anaconda* (2015).

The last US giant monster movie released in the 1990s was *Deep Blue Sea*. Responsible for reinvigorating the sharksploitation subgenre, largely because it made an estimated $100 million in profit, the film offers the same sort of broad criticisms of genetic engineering that are evident in its 1990s stablemates *Jurassic Park* and *Mimic*. In *Deep Blue Sea* the driven but arrogant scientist Dr Susan McAlester is attempting to cure Alzheimer's by extracting protein complexes from the brains of sharks. To try to help her experiments McAlester deliberately increases the size of the sharks' brains: "a larger brain means more protein". Unfortunately for the humans based at the research facility where McAlester's work is taking place, her misguided actions mean that the sharks become smarter, turning against their captors as they set about trying to escape back into the wild, the deep blue sea of the title.

The use of CGI in *Deep Blue Sea* enables the film makers to realise the tagline "Bigger. Smarter. Faster. Meaner", creating larger and more mobile sharks than might have otherwise been possible through practical effects (which are notoriously difficult to operate underwater). Indeed, CGI would open up new possibilities for sharksploitation, allowing for new types of spectacle, whether larger sharks (see *The Meg* (2018) or more dynamic, non-realist depictions (such as in the *Sharknado* series (2013–2018). As the first instance of this CGI-fuelled revival of the subgenre, *Deep Blue Sea* chooses to focus on the increased size and intelligence of its genetically manipulated sharks. The first shark we see in the film is noted as larger than normal: "It's a 12-footer!" *Deep Blue Sea* links the physical size of its sharks with their increasing malevolence. Notably, it is the largest, and therefore most intelligent of the three sharks at the facility, a "45-footer", that seems to lead the attacks against the humans. The increased size of the sharks also gives them greater strength and power; one of the characters suggests "given gen. 2's size [...] she could put a couple of tonnes, maybe more into a hit", just as we see said shark break through a steel door. Clearly, the larger the sharks have become the more of a threat they now pose to the human characters. Size and spectacle are further linked in the finale of the film, when the last surviving, and largest, of the sharks is shot with a harpoon and then blown up in an explosion of viscera. Though it is never as overtly carnivalesque as *Deep Rising* or *Eight Legged Freaks*, *Deep Blue Sea* does offer a decidedly more subversive take on the giant shark movie than *Jaws*, replacing that film's realist approach with a more reflexive tone. *Deep Blue Sea* encourages the audience to take subversive pleasure in seeing many of the sketchily drawn characters get dispatched by its CGI monsters, not least in the scene where corporate executive Russell Franklin

delivers a rousing speech only to be shockingly and unceremoniously devoured by one of the escaped sharks.

While the 1990s witnessed a number of new entries in the giant monster genre, the early 2000s were dominated by low-budget sequels to existing giant monster movies (including *Tremors 2: Aftershocks* (1996), *Tremors 3: Back to Perfection* (2001), *Tremors 4: The Legend Begins* (2004), *Anacondas: The Hunt for the Blood Orchid* (2004), *Mimic 2* (2001), and *Mimic 3: Sentinel* (2003). As such, *Eight Legged Freaks* stands out as one of the more 'original' films to be released during this period. Like a self-aware version of *Tarantula*, or a bigger-budgeted *The Giant Spider Invasion*, while *Eight Legged Freaks* is not particularly innovative, it manages to balance comedy with frights, leading some to describe it as "the greatest giant insect movie of all time" (Scott). Of particular interest to this study is the film's status as perhaps the first US giant monster movie to employ its CGI effects in a deliberately non-realist fashion. The film signals its knowing approach to genre conventions from the opening scene, in which an initially unidentified speaker tells us that "[t]his is a story of monsters, creatures, hideous nightmares that crawl in the night". As the narrator continues we find out that he is Harlan Griffith, a conspiracy theorist and radio host on KFRD, Freedom Radio. Griffith exclaims that America needs to "wake up... look to the skies... unless, of course, you're driving". Unfortunately, the truck driver in the next scene is not paying attention to this advice and therefore does not see the rabbit that has crossed onto the highway until the very last minute. In swerving to avoid the defenceless animal, the truck sheds one of the barrels of toxic chemicals it is carrying into a nearby reservoir. To make matters worse, Joshua Swift, a local exotic spider farmer, sources his pet food from this now polluted reservoir. Though Swift's parrot warns him that "I see dead people", Swift doesn't seem overly concerned that the spiders in his care are growing much larger than normal. Following genre conventions, it is not long before Swift's menagerie of giant spiders escape their cages, killing Swift (and his parrot), and going on to threaten the rest of the townsfolk of Prosperity, Arizona.

Like Perfection in *Tremors*, Prosperity seems ironically named. Rather than being an affluent place to live Prosperity is actually "going broke", partly because of the many 'get rich quick' schemes that the corrupt mayor has instigated over the years, including an unsuccessful shopping mall and an unprofitable ostrich farm. When the film opens the mayor is eager for the residents to sell out to the company Viroanol which, it turns out, is keen to take possession of the land so that it can store toxic waste in the mines under the town. Further emphasising

the need to defend the community against the immoral actions of big business is the fact that it is one of Viroanol's barrels of toxic waste that is responsible for infecting the town's reservoir in the film's opening sequence, causing Swift's spiders to grow into giants. Indeed, the film draws direct parallels between the equally predatory behaviour of the spiders and of Viroanol, both of which see Prosperity as a resource to be consumed. Chief among those who lead the fight back is Chris McCormick, who has inherited ownership of the disused mines from his father, and divorcee "trailer-trash sheriff" Samantha Parker. While the mayor is in cahoots with Viroanol's plans to store toxic waste in the mines, McCormick and Parker, along with their two children and DJ Griffith, are forced to take control of the situation, organising the attempt to save Prosperity, something they achieve when McCormick blows up the mines and the local mall, destroying the spiders and putting an end to Viroanol's designs on the town.

Eight Legged Freaks marries its criticism of those in power with a deliberately cartoonish approach to its visual effects. Indeed, the film's use of CGI is noteworthy for marking a deliberate move away from the emphasis on perceptual realism that dominated the genre following the commercial success of *Jurassic Park*. In *Eight Legged Freaks* CGI is used to create a subversive, Looney Tunes aesthetic, reminiscent of 1980s practical effects films: especially *Gremlins* (1984). Highlights include a sequence in which we see "a spider slam a cat so hard against plasterboarding that its face can be seen on the other side in bas relief" (Ebert 2002); a scene where a giant spider grabs a miner and pulls him comedically out of shot, emulating the vaudeville hook routine; an episode in which a dirt biker repels a spider's attack by fly-kicking it in mid-air; and a terrifying yet simultaneously comic assault on a stationary trailer-park caravan by a giant tarantula that consciously homages the famous *T. rex* attack from *Jurassic Park*. Such examples began to demonstrate the wider possibilities of CGI for the giant monster movie, suggesting that, in addition to realising increasingly photorealistic spectacle, the technology could be used to realise more subjective and abstract monsters. There is a great deal of subversive pleasure to be gained from the film's climactic "arach-attack" scenes, in which the spiders assault the town of Prosperity *en masse*. Swarming over the townsfolk, jumping up and down on car bonnets, and generally causing mayhem, the spiders here can be seen as interesting examples of a less realist, more illusionist use of CGI that remarkably few examples of the US giant monster movie have adopted, even up to the present day.

As the 2000s advanced the new possibilities afforded by CGI placed a renewed emphasis on spectacle, a task to which the giant monster

movie has always been especially suited. Developments in visual effects enabled film makers to realise more and different creatures on screen in ways that would have been impossible before. CGI meant that film makers were increasingly freed from the physical constraints of practical effects. If one of the recurrent ideological pleasures of the giant monster movie is getting to see hegemony under threat, then CGI pointed to the potential realisation of what Susan Sontag calls "the particular beauties to be found in wreaking havoc" (39) on an ever-grander scale. The final chapter will examine how this impulse was to shape many of the big-budget films of the next two decades, as well as considering the increasingly inventive and esoteric takes on the genre enabled by the falling costs of CGI.

5

Remakes, Reboots and Shared Universes: The US Giant Monster Movie in the Contemporary Era

The first two decades of the twenty-first century saw the US giant monster movie in rude health. The resurgence of the genre during the 1990s gathered pace as CGI became an increasing part of the media landscape. The noughties saw the further consolidation of many of the practices that had defined Hollywood from the 1970s onwards, including "the entrenchment of the blockbuster" (Fleury et al. 9) and the growth of the multimedia franchise. "Franchising [became] standard operating procedure" (Johnson xiv), with films increasingly positioned as part of a series of interrelated products put out by multinational conglomerates hoping to maximise their profits. These companies sought to mitigate the risks of releasing ever more expensive blockbuster films by establishing their own multimedia properties in the vein of Marvel Studios, or Warner Brothers and the Potterverse; as Winston Dixon suggests, "what Hollywood wants more than anything else is a film that can turn into a long-running, reliable franchise" (10). Creating a commercially successful franchise could facilitate the releasing of products in and across multiple media formats and platforms, providing "a safety net in the case of box office failure" (Fleury et al. 6). Subsequently, while there were films released during this period that were intended to operate as self-contained stories (though often these capitalised on existing intellectual property), many of the bigger-budgeted examples examined in this chapter were designed to help establish successful franchises from which a range of products could be released. The hugeness of the giant monster seems a good fit for such an expansive mindset, lending itself to storytelling on an epic scale through its innate scale and its long-established on-screen history.

In line with Charles Acland's suggestion that "in light of so many entertainment options, the easy choice is to head toward the familiar"

(44) it is perhaps not surprising that the first significant monster movie of the noughties was another retelling of *King Kong*. This new, 2005 version of *King Kong*, directed by Peter Jackson, would be more indebted to the 1933 original than Guillermin's 1976 remake, while building upon the latter's emphasising of Kong as a tragic outsider. Central to Jackson's depiction of "the most sympathetic incarnation of Kong to date" (Lennard 38) are the ways in which the film parallels the suffering of the giant ape with suffering by the human characters in the story. The movie opens with a sequence set in Depression-era New York in which we see numerous animals – monkeys and apes among them – living in dilapidated enclosures in a derelict zoo. The film then cuts to the poverty-stricken residents of a ramshackle camp outside the city. This sequence draws obvious parallels between the suffering of the animals and the destitution of the poor. Comparisons are then drawn by cross-cutting between vaudeville shows and shots of protests and breadlines, raising the idea that there is something potentially manipulative but also reassuring about the manufactured spectacle on offer. Tellingly, given the dire economic situation, the film suggests that even this kind of entertainment is failing. The theatre is soon forced to close, and we are introduced to former chorus girl and aspiring actor, Ann Darrow, as she is left jobless and struggling to keep herself off the streets. Where the original *King Kong*'s Darrow was a fairly one-dimensional damsel in distress, and the 1976 film depicted her as a ditzy starlet, the 2005 remake fleshes out the character considerably. We learn that this version of Darrow has been let down by people throughout her life, leaving her feeling cynical and lost. In a revealing scene with her director Carl Denham, Darrow discusses her take on the character she auditions to play as someone who's "not even sure she believes in love" because "good things never last". After overcoming her initial fright at being abducted by the giant ape, the actress realises that, like her, Kong has been alone for a long time. Darrow explicitly identifies with Kong, who is "the last of his species", and therefore also a lonely and melancholy figure.

In keeping with previous iterations of the *Kong* narrative the 2005 film depicts both the actress and the giant ape as victims of the spectacle-making process. Darrow is continually having to fight against prevailing attitudes that see women as objects for the male gaze; a studio executive in an early scene asks Denham if his film will have "boobies... jigglies, jiblonkas. Bazooms". In contrast to previous iterations of the character this film's more self-aware and politically engaged Darrow is shown as unwilling to compromise herself even if it limits her chances of success. Early in the story she turns down the

opportunity to join a burlesque show though it would provide her with a steady income. Similarly, Darrow refuses to be exploited later in the film, risking angering Kong by refusing to carry on with a slapstick routine: "[n]o, that's all there is, there isn't any more!" Foreshadowed in a passage from Joseph Conrad's novel *Heart of Darkness* that suggests that "a thing monstrous and free" is infinitely preferable to the "shackled form of a conquered monster", Kong learns what it is like to be exploited for others' financial gain when he is captured and transported to the USA. This final section of the 2005 remake stresses Kong as the tragic victim of an amoral, capitalist system. The emphasis placed upon the opulence of the theatre where the ape is exhibited as the "Eighth Wonder of the World", and the wealth of those who pay to come and see him, is sharply contrasted with the poverty of those who occupied the breadlines and soup kitchens at the start of the film. That Kong's rampage begins with the destruction of the luxurious theatre in which he is being exhibited, the giant ape tearing out its plush seats and sending its wealthy patrons fleeing into Times Square before chasing Jack Driscoll down Broadway and around much of New York City's bustling commercial centre, suggests a class-conscious critique in line with carnival's "social, political protest" (Kristeva 36). More so than his predecessors, this version of Kong might be considered a representative of the anger felt by the poor, his immense size reflecting the levels of resentment of those left jobless and homeless in Depression-era America.

While the plot of the 2005 remake might take issue with the spectacle-making process, Jackson's blockbuster retelling simultaneously revels in its own grandiosity, not least in its expansive running time (as is now well known, the narrative takes nearly an hour to take us to Skull Island). Much like other big-budget, blockbuster, US giant monster movies before it (including the 1976 *King Kong*, *Jurassic Park*, and the 1998 *Godzilla*) the film was marketed as an epic event, the importance of which was founded in large part on its budget and visual effects. Yet, while the film's teaser trailer highlighted the remake's extravagant production values, both its elaborate recreation of Depression-era New York and its exciting CGI action sequences, it tempered this celebration of the film's representational prowess by also signalling the remake's adherence to the story beats of the 1933 movie, a film that has been recognised as "culturally, historically and aesthetically significant" by the Library of Congress. This concerted emphasis upon the ways in which modern techniques (such as CGI) fruitfully enhance the original movie seems designed to pre-empt accusations of crass commerciality and suggest that the film makers had some awareness of the incongruity

of using cutting-edge visual effects to retell a story in which the protagonist is exploited as a form of spectacle.[2]

This self-awareness permeates other aspects of the film, not least in the way that the 2005 *King Kong* engages with its own status as a (cinematic) epic being retold. Such reflexivity skirts close to a carnivalesque breaking of the fourth wall, with characters commenting upon the idea that they are fated to act in a pre-determined, scripted manner. This seems especially the case for Darrow. When outlining his screenplay, Denham suggests of Darrow's character that "forces are compelling her down a road from which she cannot draw back". Similarly, when she agrees to take the part in his film, Denham exclaims "that it was always going to be you". The actress seems to know that her journey on the *Venture* will be momentous; the scene in which she pauses in awed reflection before stepping onto the ship while the soundtrack swells to an ominous crescendo suggests she is preternaturally aware of what is going to happen. Such metatextuality acknowledges the audience's familiarity with the basic elements of the *King Kong* narrative and helps suggest the film's status as an enduring story worthy of being retold multiple times. These aspects also enable a carnivalesque reading in which the film highlights its own artificiality as a constructed narrative with stock characters and the like. By drawing attention to the ritualised, mythic nature of the *Kong* narrative the remake blurs the usual distinctions between the world of the audience and the world of the film.

The repetition of many of the familiar special effects sequences of the 1933 *Kong* is also presented as a key part of the 2005 film's appeal. Director Jackson claimed that the reasons for remaking his favourite film centred on recreating the sense of excitement he had experienced for a new generation "who would never sit down and watch a black and white film with jerky animation and creaky, old-fashioned dialogue" (quoted in Sibley 522). Such comments suggest that visual effects technology can be used as a tool to help renovate pre-existing narratives: "refining early popular images that failed to fulfil the visual richness that digital cinema exhibits now" (Constandinides 122). Indeed, much as with the other metatextual elements, characters in the film seem to speak for the film makers; one early scene sees the pompous

[2] This was one of several aspects of the film covered in the production diaries; short videos that were made available online prior to the film's cinematic release. These detailed the making of the 2005 film and, in containing nearly four hours of content, also contribute to the perception of the remake as an important and substantial piece of cinema.

star of Denham's movie, Bruce Baxter, exclaim of the dinosaurs "no one's going to believe these are fake!" Furthermore, the remake uses CGI to restore visual effects sequences planned for but not included in the original, most notably the spider pit section, filmed but then dropped from the 1933 film (and now lost) because it was felt that it interrupted the flow of the plot. The inclusion of the sequence adds a patina of cinematic respectability to the 2005 film, suggesting that visual effects are being used for more than just 'empty' spectacle.

Advances in CGI since *Jurassic Park* meant that the 2005 *King Kong* could also depict much greater levels of interaction between its human characters and giant creatures than had previously been possible. The characters in the film are shown being grabbed, lifted, dropped, held, thrown, crawled upon, and swallowed whole by the monsters they encounter, with Kong handling members of Denham's crew, including Darrow, in a variety of nuanced ways. The emphasis placed upon the interactions between visual effects and human performers is especially evident in the scene in which Kong fights three carnivorous dinosaurs. During this kinetic sequence the camera follows Darrow as Kong first lifts her into the air with one hand, then swings her round as he attempts to fight off a troop of dinosaurs with his other hand. In the chaotic fracas that follows the actress comes within metres of the giant dinosaurs' mouths. Then, after the combatants fall off a cliff the sequence continues with Kong, Darrow, and the dinosaurs tangled in a mass of vines. The momentum of the swinging dinosaurs sporadically places the actress within reach of their immense jaws, and we watch as she struggles to escape being eaten by them. Eventually Darrow ends up on the back of one of the creatures before they all fall out of the vines and onto the jungle floor. Once they are back on the ground the visceral clash ends when Kong brutally defeats the last of his adversaries, saving Darrow in the process.

The repeated interactions between Darrow, Kong, and the dinosaurs in this sequence demonstrate the (relative) ease with which CGI can overcome the problems of older techniques such as stop-motion animation. While having its own strengths this older process often had difficulties creating a convincing impression that the human performers in a scene occupied the same space as the models of the monsters. Indeed, the quality of simulated interaction afforded by CGI is integral to the 2005 remake's repositioning of Kong as a largely sympathetic figure, a character that possesses "richer emotional states" (Constandinides 127) than the original giant ape. The range and nuance of Darrow's physical interactions with Kong – she is cradled by him, lies against him for protection, and, in the film's climax, gently strokes his face before resting her head on his finger – would have been difficult

to envisage working in quite the same way with stop-motion or other visual effects techniques.

Motion capture – the technique whereby a real actor's movements are captured and can then be used as reference points to direct a virtual performance – was also of crucial importance to realise these interactions. The actor Andy Serkis performed in front of a green screen and with the other actors in the role of Kong. Whereas only Serkis's body movements had been captured when he played Gollum in the *Lord of the Rings* films, by the time he took on the role of the giant ape facial motion capture was possible. Indeed, Cynthia Erb notes that one of the significant ways in which Jackson's film differs from previous versions is in its focus on Kong's facial expressions (232). The ability to convey Kong's responses through his facial expressions further helps to anthropomorphise the giant ape, showing that he is capable of the same range of emotions as the human characters.

Alongside its use of visual effects technology to create exciting action sequences and a more emotive motion-capture, performance-driven version of Kong, Jackson's remake offers the kinds of sweeping panoramic shots of virtual vistas more commonly associated with Jackson's *Lord of the Rings* trilogy of films, including, in its extended opening and closing sections, an elaborate yet convincing CGI-augmented depiction of 1930s New York city: "we have used the computer [...to create...] towering skyscrapers [...] 20 blocks with 500 CGI vintage cars and 2,000 CGI people" (Jackson quoted in Sibley 528). These kinds of virtual set, and the shots that they enable, would become increasingly important to the big-budget US giant monster movie, recurring, in particular, in the Monsterverse films. The sheer variety in the types of spectacle that we get in *King Kong* – intimate motion capture, giant CGI creatures, historically accurate recreations of major cities, large-scale destruction – also speaks to the need to mitigate the ever-expanding financial risks of the big-budget blockbuster by appealing to as many types of audience as possible (the 2005 *King Kong* is also a romance, an adventure narrative, and contains elements of comedy); as Stan Jones suggests "the film tries to keep all options open for the film's reception" (192).

If Jackson's film represents what would become an increasingly central role for the remake in the development of the US giant monster movie (the film received generally good reviews – Roger Ebert called it "magnificent entertainment", and it made over twice its production budget at the global box office) then *Cloverfield* (2008) has proved to be the most commercially successful attempt at an 'original' giant monster movie in the last 20 years; 'original' in the sense that the film's plot is not directly linked to an established franchise or intellectual property.

Cloverfield made a healthy profit on a production budget of just $25 million and has since gone on to spawn its own multimedia franchise, including a tie-in *manga* series (*Cloverfield/Kishin*, 2008) and the films *10 Cloverfield Lane* (2016) and *The Cloverfield Paradox* (2018).

The film was apparently born from director J. J. Abrams' desire to "construct a national monster, doing for the USA what Godzilla/ Gojira had done for Japan" (quoted in North 89). Consequently, it is not surprising that the most popular way of interpreting *Cloverfield* and its giant creature has been as an allegory for 9/11. Critics have seen *Cloverfield* as "part of a wave of apocalyptic movies" (Totaro) that "engage with the post 9/11 era" (Homay King 124). Scholar Steffen Hantke writes that *Cloverfield* "not only depicts but affectively re-enacts, recreates and reproduces the massive devastation caused by the collapse of the Twin Towers" (2010, 237), while Nathan Lee in *The Village Voice* memorably christened *Cloverfield*'s monster "al-Qaedzilla" and proposed, with tongue in cheek, that the film offered a "deft simulation of that infamous September morning in order to brutalize the society that flourished from its ruin like some tacky, tenacious, condo-dwelling fungus".

Where the sympathetic aspect of Kong had been expanded upon since the 1933 original, *Cloverfield*'s central monster was designed to be "more *Jaws*-like [...] in its lack of empathy-inducing" (Homay King 127). Envisioned as akin to "an entity or an event" (Kevin Blank quoted in DiLullo) rather than a character with feelings and emotions, the film's monster is presented as largely indifferent to the population of Manhattan. As such, *Cloverfield* emphasises the concept of the giant as a threat to humanity due to its size. The creature is so gigantic that when "human beings are caught up randomly and accidentally" (Hantke 2010, 244) in its actions they are immediately placed in danger. The scale of the monster also means that the humans in the film are presented as largely powerless to stop it. Not only does it dwarf existent military technology, but the creature's immensity makes it difficult to comprehend using pre-existing conceptual frameworks relating to other sentient beings.

The difficulties in understanding the monster are mirrored in the film's presentation as found footage; as Daniel North writes, "[*Cloverfield*] simulat[es] the impression that the monster is a chaotic agent not under the control of the filmmakers, not served up for viewing as a spectacular 'pay-off'" (75). The conceit that the whole movie is "unadulterated footage of the event as filmed and experienced by a single camera" (Totaro) in "the kind of raw, shaky video that we associate with coverage of 9/11" (Stone 168) serves to justify the obscured view we get of the monster, while also suggesting that it is beyond comprehension.

Instead, characters repeatedly emphasise the limitations of their viewpoint, asking others "what did you see?", "did you guys see that?", "can you see anything?" In an early scene, a character believes he has captured the creature on film – "I have it on tape!" – but it turns out that the footage is inconclusive and reveals nothing.

Interestingly, though the film presents its monster as incomprehensible – it "remains an occluded specimen" (North 90) – it links this inexplicability to its position as a form of spectacle, that is worth trying to see. *Cloverfield* opens with a set of on-screen text, notifying the viewer that the footage they are watching is the property of the US Department of Defense and should not be duplicated. This information suggests that what we are watching is illicit and likely not intended for viewing by the public. However, in encouraging us to proceed to view the footage (the only alternative at this stage would be to exit the cinema) the film indicates that something worth watching will follow. The frequent turning of the camera in the direction of the monster, among the chaotic scenes that follow, further suggests this is something worth viewing. Indeed, the audience is encouraged to see the monster as important by the TV news reports that are dedicated to showing the impact the creature is having on Manhattan and its terrified citizens.

While *Cloverfield* may run counter to genre expectations in keeping the monster largely unseen the film still "revels in scenes of urban panic" (Hantke 2010, 242). Over the course of the film, we see the Woolworth Building collapse, the destruction of the Brooklyn Bridge, and the wholesale razing of Central Park. Indeed, several critics noted the importance of the headless Statue of Liberty in the film's marketing campaign, with the statue's detached head careening down the streets of Brooklyn helping to advertise the film's subversive attractions in a particularly striking trailer.

These aspects point towards a carnivalesque inclination that is further supported by the film's handling of its "smug, self-entitled" (Lee) central characters: upscale couple Rob and Beth, Rob's brother Jason, and their friends Marlena, Lily, and Hud (who functions as the cameraman). Like the slasher movie, which often "encourages an audience to identify with the killer and thereby gain a sadistic pleasure from his [...] murderous acts" (Hutchings 195), the wealth and privilege of *Cloverfield*'s human cast seem to invite the audience to welcome their demise. The opening section of the film introduces the characters as being self-obsessed, unable to see beyond their own personal needs and desires. This means that when their overly comfortable lives are disrupted the audience is more likely to take pleasure in their suffering than feel any empathy with their troubles.

Figure 5.1 The detached head of the Statue of Liberty comes to rest on the streets of Brooklyn.
Source Paramount Pictures, 2008

In this respect *Cloverfield* refreshes the "dark aesthetic appeal" (Stone 168) of the US giant monster movie, employing the iconography of the 9/11 attacks to suggest that hegemonic world powers like the USA are still vulnerable to debilitating attack. In opposition to other giant monster movies where the threat is vanquished or neutralised, *Cloverfield* suggests that its monster is undefeatable; the creature remains alive at the end of the narrative, while the central human characters are presumed dead.

In sharp contrast to the more ideologically bleak strain of the US giant monster movie offered by *Cloverfield*, the animated comedy *Monsters vs Aliens* (2009) directly spoofs conventions, particularly those belonging to the 1950s atomic 'big bug' instances of the genre. The film tells the story of a group of sympathetic monsters, kept imprisoned in a secret government facility, who are brought together to defeat the evil extra-terrestrial Gallaxhar. Gallaxhar wants the Earth's deposits of the precious substance quantonium and is willing to kill anyone or anything that gets in his way. The distraught president makes a deal with the monsters to fight Gallaxhar in return for the promise of their freedom. This carnivalesque situation, in which the hegemony must rely on the previously marginalised to save them, is used to explicitly challenge definitions of the term 'monster'. In *Monsters vs Aliens* it is those who represent normality that are shown to be the cruellest. After

saving humanity and repelling Gallaxhar, the monsters realise that the citizens of California still refuse to accept them because they see the monsters as different.

Perhaps the most progressive and carnivalesque aspect of *Monsters vs Aliens* is its decision to make its protagonist female. Susan Murphy, or as she becomes better known, Ginormica, is a riff on the Nancy Archer character in *Attack of the 50 Foot Woman*. When we first meet Susan, she is defined solely through her relationship to her fiancé, heart-throb weatherman Derek Dietl; she is described as "the weatherman's wife". Yet Susan's journey of self-empowerment is spelled out even more overtly than Nancy Archer's in *Attack of the 50 Foot Woman*. Hit by a meteor on the morning of her wedding, the character goes from lovesick and downtrodden – she puts aside her own dreams of a life in Paris to go along with her husband's demands to relocate for his career – to a brave and independent woman. Her giant stature sees Susan perform acts that she previously considered beyond her: "[t]hree weeks ago, if you had asked me to defeat a giant alien robot, I'd have said 'No can do'. But I did it! Me!" Kim Newman suggests that *Monsters vs Aliens* gives "the 50 Foot Woman the happy ending she was cheated out of in 1958" (2009, 71). Far from electrocuting herself (and her husband), as Nancy Archer does at the end of *Attack of the 50 Foot Woman*, Susan beats Gallaxhar, rescues her monster friends, and returns to Earth a hero. Moreover, in saving the Earth, Susan Murphy/Ginormica is not only one of very few female protagonists in the US giant monster movie but is perhaps the only female monster in the genre to be presented as entirely heroic. Her challenging of restrictive gender roles reflects "the carnival spirit [that] offers the chance to have a new outlook on the world [...] to enter a completely new order of things" (Bakhtin 255).

Monsters vs Aliens also demonstrates Hollywood's increasing wish, what Peter Caranicas calls "Hollywood's holy grail" (11), to create films that can be developed into transmedia properties. *Monsters vs Aliens'* success at the box office was followed by a short: *B.O.B.'s Big Break* (2009); two straight-to-television Halloween specials: *Mutant Pumpkins from Outer Space* (2009) and *Night of the Living Carrots* (2011); a serialised television show on Nickelodeon; a videogame published by Activision (2009), and a free mobile game: *B.O.B.'s Super Freaky Job* (2013). "Studded with snarky *Simpsons*-style humour" (Newman 2009, 71), these spin offs demonstrate not only how adaptable *Monsters vs Aliens* is as an intellectual property but also how recognisable broader giant monster movie tropes have become. *Monsters vs Aliens'* own versions of the 50-foot woman, the giant bug, and the gelatinous blob prove that such

genre figures can function across media formats, even when divorced from their direct cinematic origins.

Other film makers took different approaches to the genre during the 2000s. The "so unapologetically bad, so patently ridiculous, and so gloriously preposterous" (Hantke 234) *Mega Shark versus Giant Octopus* (2009) was the first cinematic release by The Asylum (perhaps best known for the *Sharknado* series). It follows in the paracinematic tradition of the studio's output, which "tend to parody themselves through stunt casting" and make an "overt attempt to capture camp [that] falls instead into shlock" (Barr 13). The story introduces daredevil oceanographer Emma MacNeil, played by US singer Debbie Gibson. MacNeil is studying whales in Alaska when a freak accident results in the destruction of a nearby glacier, inadvertently releasing the two giant creatures of the film's title. Shortly after, an offshore drilling platform in Japan is attacked by what appears to be a giant octopus, but the event is hushed up by the government. Back in the USA MacNeil is called in to investigate the beached carcase of a whale with unexplainably enormous wounds on its body. Her superiors blame the incident on an accident with a tanker propeller, but when she pulls a giant tooth from its remains MacNeil comes to believe the animal's death was caused by a shark attack. Though she is dismissed by her employers, MacNeil continues investigating what is going on, joining forces with her old professor Lamar Sanders and a Japanese scientist, Dr Seiji Shimada, who is visiting Sanders. It is not long before the group work out that the giant tooth is from an 18-million-year-old "apex predator" megalodon. This ancient creature, "quite possibly the largest shark ever to have lived", has been freed in what the film suggests is a cosmic "comeuppance" for global warming. Following more attacks from the giant creatures, the government forces the three scientists to work with them. A failed effort to trap the megalodon is followed by a successful attempt to bring the two monsters together using pheromones, for a "thriller in Manila"-style battle to the death.

Though the plot of *Mega Shark versus Giant Octopus* sounds no more ridiculous than that of any number of other, bigger-budgeted, giant monster movies, it differs from other films in its execution. The film's production design seems to embrace rather than conceal its inadequacies. The government laboratory in which the scientists are forced to work clearly consists of one small room with a few beakers on a table; the interior of a tanker in the film looks like a large cupboard with a blue light; obviously low-quality CGI sequences – of a submersible, of the shark swimming towards the camera – are used repeatedly in different parts of the film, while the movie employs stock footage for

all the scenes involving military vehicles. Further elements of the film foreground its failure to reach the conventional standards of Hollywood releases. Dialogue exists in an awkward middle ground, failing to either capture the cadences of ordinary speech or successfully achieve the grandiose nature of clichéd genre dialogue. At one point, a worried MacNeil tells Lamar "I keep thinking about Einstein, Oppenheimer, the destruction of it" to which the scientist's prosaic reply is "[t]his is a big one alright!"

In spite, or perhaps because, of these shortcomings, *Mega Shark versus Giant Octopus* has birthed its own mini-franchise; the film's commercial success led to several other films bearing the Mega Shark prefix: *Mega Shark versus Crocosaurus* (2010), *Mega Shark versus Mecha Shark* (2014), and *Mega Shark versus Kolossus* (2015). Further afield, the early years of the twenty-first century saw an explosion in the intentionally camp, low-budget, paracinematic giant monster movie, including The Asylum's own *Mega Piranha* (2010), *Mega Python versus Gatoroid* (2011), *Atlantic Rim* (2013), and *Megalodon* (2018); selected films in Rhi Entertainment's *Maneater* series, including *Eye of the Beast* (2007) and *Behemoth* (2011); SyFy's *Lake Placid* sequels; the third and fourth *Anaconda* films; and producer Roger Corman's *Dinocroc* (2004), *Supergator* (2007), and (the seemingly inevitable) *Dinocroc versus Supergator* (2010).

While Mark Jancovich has argued that paracinema serves to reinforce the very elitism it often purports to challenge, films like *Mega Shark versus Giant Octopus* might be considered as offering a lower-budgeted alternative to the slick, more expensive releases of Hollywood studios. If contemporary blockbusters like the *Jurassic Park/World* movies and the films in the Monsterverse often seem beholden to a form of realism, depicting monsters in a version of "reality that [...] follows the same observable laws of physics as the world [the audience] inhabits" (Prince 32) then, in contrast, the visual effects in *Mega Shark versus Giant Octopus* are used to celebrate the pleasures of consciously deviating from perceptual realism. It is important to note that this is likely not solely due to budgetary constraints; indeed, Gareth Edwards' *Monsters* (2010) illustrates that perceptual realism was possible with a budget of only $500,000. Instead, the makers of paracinematic giant monster movies like *Mega Shark versus Giant Octopus* seem to deliberately break with Hollywood's emphasis on realism. In one scene the megalodon bites a huge chunk out of the Golden Gate Bridge, leaving cartoon-like teeth marks behind, even though the bridge is made from steel. In another cartoonish sequence the giant shark jumps thousands of feet out of the ocean to take down an aeroplane full of passengers, causing

one adroit traveller to exclaim "holy shit!" Further illustrating the film's disregard for perceptual realism its use of CGI jars with the live-action elements of the film in such important areas as lighting, composition, texturing, and fidelity. In keeping with earlier low-budget examples of the giant monster movie, one of the results of the subpar visual effects is a deliberate and carnivalesque rejoinder to the giant monster movie's positioning as a vehicle for demonstrating Hollywood's representational prowess, poking fun at its sense of self-importance and claims to profundity.

Such carnivalesque tendencies are also in evidence in *Attack of the 50 Foot Cheerleader* (2012), which takes the basic formula of the *Attack of the 50 Foot Woman* and retools it, by way of *The Nutty Professor* (1996), into a teen sex comedy. In the film, nerdy science student Cassie Stratford creates a genetic compound that turns her into a more physically attractive and confident version of herself, the only side effect being that she also grows gigantic. While *Attack of the 50 Foot Cheerleader* could be a subversive critique of the pressures placed upon young women to conform to a narrow, unrealistic definition of beauty – a fellow science student complains that Stratford's "throwing all that away to be some bimbo cheerleader" – the copious female nudity does tend to undercut this interpretation. Instead, the film might be more accurately seen as evidence of the continuing commercial viability of the giant human monster movie. More specifically, *Attack of the 50 Foot Cheerleader* attempts to capitalise on the appeal of a giant (semi-)nude female body (as the original *Attack of the 50 Foot Woman*, its 1993 remake, and *Attack of the 60 Foot Centrefold* (1995) all did before it). Described as looking like a "slutty Statue of Liberty", the giant Cassie is depicted in various suggestive positions and costumes (naked in a swimming pool, wearing a skimpy cheerleader outfit) all of which show off her conventionally attractive physique. To further compound matters, her nemesis, cheerleader captain Brittany, is also injected with the serum. The film's climax then explicitly stages a fight between the two giantesses as an erotic spectacle, going so far as to locate the action in front of a raucous stadium crowd. As Cassie and Brittany wrestle, tearing off each other's clothes, the sportscasters' narration combines with shots of the crowd's reactions to cue the audience to the pleasurable nature of the display.

Rather less sexualised but still offering a somewhat regressive version of giant humans is *Jack the Giant Slayer* (2013). In terms of its visual effects the film marked a concerted attempt to move away from the lumbering depictions seen in previous genre entries including *Attack of the 50 Foot Woman* and *The Amazing Colossal Man*. To achieve this *Jack the Giant Slayer* builds upon the motion capture technology

Figure 5.2 *Two scantily clad cheerleaders fight in the middle of a sports stadium as the crowds gaze on.*
Source New Horizons Picture, 2012

used in *King Kong*, capturing real actors' facial and bodily performances simultaneously and in more detail than ever before, while pioneering Simul-Cam techniques enabled the live-action crew to interact with this footage as the film was in the process of being shot and recorded. These advances allowed for motion-captured giants that are "agile and powerful" (Cramer quoted in Failes), their physicality being ably demonstrated in the film's handful of action sequences, including a striking scene in which the giants sprint after live-action humans on horseback, outpacing the horses due to their superior size and gait. In contrast to previous trends in the subgenre, the giants in *Jack the Giant Slayer* are not presented as sympathetic characters. Instead, the film's frame narrative emphasises that these giants are monsters, driven by their hunger for humans, "blood, bones and all". These "revolting" giants are led by the grotesque, two-headed General Fallon, who plans vengeance on mankind for having been imprisoned in the elevated realm of Gantua for hundreds of years. Fallon eventually gets his chance for revenge when he gains possession of a magical crown from the king's traitorous advisor, Roderick. The crown enables the giants to leave their prison and attack the kingdom of Cloister, which they do by growing a series of magical beanstalks that give them access to the human world. Consequently, the third act of *Jack the Giant Slayer* plays out as an extended battle sequence, all

sweeping panoramas and CGI bombast. The giants uproot trees to use as makeshift missiles while the humans fire off batteries of catapults into the advancing hordes. Eventually Jack kills Fallon by dropping a magical bean down the general's throat, causing a beanstalk to grow out of his body, viscerally tearing the giant apart from inside out. Yet, while there is some carnivalesque appeal to be gained from seeing the giants go about their monstrous business (a gruesome cook with a tendency to bodily emissions is particularly grotesque) *Jack the Giant Slayer* seems unsure whether to fully embrace the subversive potential of its repulsive colossi. Ironically, given the cutting-edge motion capture we see surprisingly little of the giants throughout the film and only minimal attempts are made to imbue them with any character (though the same might be said of the humans too). In the minds of many reviewers, *Jack the Giant Slayer* was guilty of a kind of "synthetic bedazzlement" (*Screen International*), with the giants being technically spectacular but lacking the appeal of Jackson's similarly motion-captured Kong. The reasons for this might be largely financial, with the film's substantial production costs (estimated to have been at least $185 million) leading a risk-averse studio to curtail any transgressive elements in favour of a more anodyne product perceived to be suitable for a broader audience.

While similar accusations might be levelled at director Guillermo Del Toro's paean to *kaiju* cinema *Pacific Rim* (2013), the film recognises the subversive appeal of the genre in a way that *Jack the Giant Slayer* never does. *Pacific Rim* marries visual elements from Japanese *kaiju* to the form of the US giant monster movie, in the process refashioning a low-budget national cinema into a vehicle for big-budget Hollywood representational prowess. In comparison to *kaiju* films, which frequently encourage the audience to "form an emotional attachment" (Bollinger 83) to their giant creatures, Jason Barr argues that the monsters in *Pacific Rim* "are inherently flat characters [...] that] function solely as agents of destruction" (176). Even so, this shift arguably makes the film more carnivalesque. Rather than a slow build-up *Pacific Rim* gets straight down to action from its opening scenes, depicting its giant *kaiju* emerging from an interdimensional oceanic breach to destroy multiple cities and kill tens of thousands "before the film has even reached its title card" (Lyne). By bringing forward the kinds of scene that more conventionally form the basis of the giant monster movie's climax, *Pacific Rim* clearly signals a focus on destruction on an epic scale. If, as protagonist Raleigh Becket intones, "this was just the beginning" then what levels of spectacle, the audience is encouraged to ask, might the rest of the film contain?

The answer involves the Earth attempting to defend itself against these giant monsters by creating "monsters of our own"; similarly gigantic humanoid robots named Jaegers. Such a conceit helps to justify a hyperbolic form of spectacle in which "archetypal giants engag[e] in a brawl where they can utilize every weapon in their arsenals in the most outrageous fashion" (Bollinger 84). *Pacific Rim* seems to relish the opportunity to offer a bigger-budgeted version of the action sequences found elsewhere in suitmation films and television, including the many *Godzilla vs.* films, *Destroy All Monsters* (1968), and the *Ultraman* series. Indeed, *Pacific Rim*'s appeal is based almost entirely on these battle scenes which present "monsters the size of cathedrals fighting robots as tall as skyscrapers" (Nathan 120) as a pleasurable spectacle. The first instance we get of this is when we see Raleigh and his brother Yancy fight the "largest *kaiju* yet", a monster codenamed Knife in the early part of the film. However, long before the fight between the brothers' Jaeger, Gipsy Danger, and the *kaiju* begins, the film provides an extended sequence in which the gigantic robot is prepared for battle. This emphasises that the Jaeger is "simultaneously [... a] diegetic and technological spectacle" (Allen 111). First, the siblings traverse the bustling Jaeger base, like astronauts readying for take-off, before they are helped into the high-tech armour that the pilots must wear to control the Jaegers. Then, in a series of cuts that match to lights in the hanger being turned on, the huge but currently unassembled parts of Gipsy Danger are revealed in close-up, its retro-futuristic exterior belying its technologically advanced innards. After the Beckets have interfaced with their Jaeger and each other, the film depicts the convoluted process by which the giant humanoid robots physically leave the base. This involves the robot head that now contains the pilots plummeting hundreds of feet down a vertiginous shaft before it is attached to the rest of the Jaeger's huge body. The assembled Jaeger is then taxied out of the base on an enormous moving platform before the pilots inside it direct it towards the location of the offending *kaiju*. It is only at this point that the Jaeger is shown in its totality, set against a backdrop of stormy weather and crashing waves. The excessiveness of the Jaeger launch sequence speaks to the film's self-reflexivity, with the construction of the robot reflecting the film's own awareness of its status as an "extraordinary spectacle" (Stringer 5), something designed to be looked at in wonder just as the support staff for the Jaeger watch its extended launch with a mixture of consternation and awe.

Del Toro has explained that with *Pacific Rim* he wanted to recreate the feelings of "epic beauty and operatic grandeur" (quoted in Radish) evoked by specific works of art, such as Goya's *The Colossus*, which

attempt to evoke a sense of the sublime. Consequently, the film depicts its giants as almost beyond the scope of normal human comprehension. When a damaged Jaeger emerges from a huge bank of mist near the start of the film, it causes one awestruck beachcomber to exclaim "oh my God!" This sense of the numinous is also reflected in the fervour that the *kaiju* attract: one of the scientist characters, Dr Newton "Newt" Geiszler, is described as a *"kaiju* groupie" by his colleague, and there is a religious sect that believes the *kaiju* had actually been "sent from heaven" as a means of guiding humanity back to the morally correct path. The film suggests that the monumentality of the threat posed by the *kaiju* prompts the Earth's previously divided nations to come together, "across culture, religion, sex and language", because "we can only save ourselves if we work together" (Nathan 122). However, it is important to note that this is about as close as *Pacific Rim* gets to socio-political commentary, preferring, for the most part, to delight in what Keith Uhlich describes as "pure, pleasurable comic-book absurdity".

This ridiculousness is evident throughout the film, not least during its action sequences which are "incomprehensively stylized, but also undeniably entertaining and gratifying" (Nathan 85). The pleasure that *Pacific Rim* takes in large-scale scenes of mass destruction suggests a non-realist mode of address, as the director Del Toro proposed when discussing the film: "There is no corelation to the real world" (quoted in Turek). The second battle involving Gipsy Danger typifies this emphasis upon a "fantasy aesthetic" (Jamie Macdonald 171). The scene starts with a failed attempt to stop two new monsters from approaching and attacking Hong Kong. Huge waves break around the fighting giants as the *kaiju* manage to destroy the Jaegers and proceed on their way towards the imperilled city. Gipsy Danger is airlifted to the site by helicopter, where it engages in combat with one of the *kaiju*. The two colossi clash in and around the city's docks; they destroy a suspension bridge and scatter numerous shipping containers as they try to get the upper hand in the conflict. Gipsy Danger eventually triumphs, severing the monster's arm from its body and causing the beast to collapse. Raleigh cockily suggests they "check for a pulse" before firing several times into the now eviscerated corpse of the *kaiju*, and commenting "no pulse!"

He then moves on to tackle the second monster, now amid Hong Kong's heavily populated and urban central district. Shot with a saturated colour palette, the neon lights of the buildings contrast sharply with the silvers and blues of the battling giants, further emphasising the heightened reality of the film. Gipsy Danger uses an ocean liner as a weapon against the remaining *kaiju*, repeatedly battering the monster over the head with the ship and sending it flying. The *kaiju* then

reappears by jumping through a towering skyscraper, causing Gipsy Danger to respond. The shot that follows, in which the robot's huge fist

> wildly swings and misses a punch, smashing through an office building in the process; at the moment it is fully extended [...] taps a Newton's cradle on a desk that seems undisturbed amidst the sweeping destruction, gently starting the swinging of the cradle's balls [...] before the next shot follows the fist back out of the building, demolishing even more of it (Bollinger 85),

seems to confirm the film's playful lack of interest in perceptual realism. By placing such an absurdly comedic moment in the middle of a spectacular action sequence the film makers encourage the audience to take the same pleasure they do in being liberated from a slavish adherence to depicting only what is possible in the real world. Eventually the film's hyperbolic approach sees Gipsy Danger and another Jaeger, Striker, fighting the "first ever" category five *kaiju* on the depths of the ocean floor, and the explosion of not one, but two nuclear bombs. The first bomb is detonated when the pilots on board Striker sacrifice themselves so that Gipsy Danger can complete their mission to close the breach. Then Raleigh triggers Gipsy Danger's self-destruct sequence and uses the nuclear explosion that results from this action to close the breach once and for all.

If "[s]elf-reflexivity is [...] the most basic function of the carnival" (Booth 64) *Pacific Rim*, with its self-aware address, its copious references to other films, and its hyperbolic action sequences seems to demand to be read in this way. Indeed, such an interpretative framework suggests *Pacific Rim* is not so much a giant monster movie, but the biggest-(budget) celebration of other giant monster movies there has been to date, its paracinematic approach producing a space in which to consider, if only superficially, the representational pleasures of the genre both past and present.

As the 2000s progressed the concept of the shared universe, "extended film narratives that connect multiple movies, characters and storylines" (Fleury et al. 12), grew hugely in popularity. While as a genre the US giant monster movie had always been open to sequels, the four films (to date) that make up Legendary's Monsterverse – *Godzilla* (2014), *Kong: Skull Island* (2017), *Godzilla: King of the Monsters* (2019), and *Godzilla vs Kong* (2021) have proved be the most commercially successful instance of a shared giant monster movie universe at the time of writing, having made an estimated $1,950 billion at the global box office. Yet, while a shared universe might imply a common attitude or

tone the films that constitute the Monsterverse have taken sometimes wildly differing approaches to the genre.

On the surface *Godzilla* (2014) represents another attempt by a US studio to remake Ishirō Honda's original film. Yet the decision to appoint the relatively unknown Gareth Edwards as director indicates a deliberate change in direction to the 'failed' 1998 Roland Emmerich blockbuster. Notably, Edwards had broken into the mainstream with *Monsters*, mentioned earlier, a low-budget but distinctive take on the giant monster movie. The film tells the story of a US photojournalist who is sent to rescue his employer's daughter from Mexico's "infected Zone", an area that has been overrun by giant tentacled monsters. Of particular note is the fact that *Monsters* was shot on one camera and that Edwards created the film's visual effects using consumer-level software. The film grossed over $4 million on a budget of $500,000 and drew acclaim from critics who responded to its unique creative vision: "the anti-James Cameron" (Bradshaw); "shoestring and sci-fi filmmaking at its best" (Jolin). The appointment of Edwards as director of *Godzilla* might therefore be viewed as part of an attempt to produce something innovative within the often-homogenised blockbuster space. Equally, the director's relative lack of experience might also have endeared him to a Hollywood system in which "directors have become largely interchangeable" (Fleury et al. 13); only employed to oversee the day-to-day process of film making, while the important decisions – those likely to impact on the overarching franchise – are handled by a producer or studio executive.

Despite it being the first instalment of the Monsterverse franchise, Edwards manages to create something distinct from other contemporary giant monster movies like *Cloverfield* or *Pacific Rim*. In contrast to those films, this version of *Godzilla* spends as much time exploring the human cost of the giant monsters' actions as it does on providing spectacular action sequences involving the monsters themselves. The film charts the often-traumatic experiences of a small set of characters; in particular Lieutenant Ford Brody, as he attempts to get back to his wife and son in the USA. The actions of these human characters take place against a backdrop involving monsters whose immense size means they are shockingly indifferent to the devastation they cause; nevertheless, the film encourages us to take an interest in them. In its opening scenes, we watch a flashback in which tremors caused by a newly awoken Gojira trigger a near-meltdown at a Japanese nuclear power plant, killing Brody's mother Sandra, and leaving his father Joe traumatised. As a result of Sandra's death, Joe becomes obsessed with trying to expose the truth of what happened, believing

it to be more than a "natural disaster" or a "military mistake". His obsession mirrors that of MONARCH, a secret organisation set up in the 1950s with the express purpose of controlling and studying the giant creatures they have named MUTOs (Massive Unidentified Terrestrial Organisms). While the monsters are uninterested in the human characters, these self-same characters are inexorably drawn towards the giant creatures.

In keeping with similar depictions in *Cloverfield* and *Pacific Rim*, *Godzilla* portrays its giants as sublime, with the "alpha predator" Gojira described as "a god to all intents and purposes". The MUTOs' size and power are used to highlight humanity's powerlessness. The might of the armed forces is ineffectual as the omnipotent Gojira towers above them "with battleships stuck on top of him as he stands, and fighter jets looking like gnats in his presence" (Barr 144). Indeed, when the military's plan to destroy the giant monsters fails, MONARCH scientist Dr Isihiro Serizawa resignedly claims that all humanity can do now is "let them fight". While such a set up might suggest that the film is encouraging an audience to take the usual pleasures in seeing established hegemonic structures overturned, the effort that Edwards' film puts into making its human characters sympathetic, coupled with its sombre tone in depicting the devastating consequences of giant monsters fighting in major urban centres, make it difficult to see the film as carnivalesque. Instead, it achieves a "apocalyptic melancholia" (Kermode) evident in the film's final sequence, which sees a strike team airdrop into a now devastated San Francisco, not to stop the three MUTOs, who remain largely oblivious to the soldiers' actions, but to deactivate a warhead that has been carried into the Chinatown district by one of the giant creatures. The disparity between the MUTOs and the military is underscored as the film cuts between wide-angle shots of the colossal monsters fighting, civilians cowering in the wreckage, and Brody's strike team, who by this point are trying to complete their mission and stay out of the way of the giant monsters altogether. This motif of humanity's powerlessness is present right until the end of the film when Brody deactivates the warhead while Gojira defeats the other two MUTOs. In the closing scenes Brody is finally reunited with his family and a triumphant Gojira returns to the sea after being declared the "King of the Monsters" by a thankful but emotionally battered populace.

The film makers' intentions to use *Kong: Skull Island* to establish a shared universe are apparent from the film's opening credits. Emulating the newsreel style of *Godzilla*, *Kong: Skull Island*'s title sequence intercuts a montage of historical footage with shots that explicitly mention MONARCH, the secret scientific organisation

featured in Edwards' film. Indeed, MONARCH and its logo become a key signifier of *Kong: Skull Island*'s connections to *Godzilla*. After a prologue in which two Second World War pilots crash-land on a remote island in the south Pacific and encounter the titular Kong, the film shifts to 1973 and a close-up of the MONARCH logo on a briefcase.[3] We find out that the suitcase belongs to MONARCH's head, Bill Randa, who is in Washington to try to acquire government funding for a mission to the uncharted Skull Island, "a place where myth and science meet". Alongside establishing MONARCH as a point of connection between the various Monsterverse films, *Kong: Skull Island* also introduces the "Hollow Earth" theory, which proposes that there are "massive underground spaces, isolated from the surface world" that serve as habitats for "ancient species" and that help to explain how the shared universe's many giant creatures have not previously been discovered. This concept of "an ecosystem out there the likes of which we can't imagine" recurs in subsequent franchise entries, *Godzilla: King of the Monsters* (2019), and in *Godzilla vs Kong* (2021): it forms a central part of those films' plots.

In contrast to the seriousness of the 2014 *Godzilla*, *Kong: Skull Island* adopts a more subversive and self-reflexive tone, embracing the carnivalesque side of the genre. During the early part of the film a senator suggests MONARCH's belief in "imaginary monster[s]" is like the "aluminium foil hat that I like to wear on weekends" and a playful criticism of the military–industrial complex underpins much of the film's narrative. In particular, *Kong: Skull Island* uses its early 1970s setting to foreground the fallibility of the USA. Depictions of (soon to be disgraced) President Richard Nixon recur throughout the narrative (on TV, as a bobblehead) while the Vietnam War is employed as shorthand for US "military and diplomatic failure" (Friedman 9). When MONARCH request an escort of soldiers for their venture to Skull Island, the platoon that gets assigned to accompany them are depicted as likeable buffoons, overly confident in their ability to get the mission done. The regiment they are drawn from is led by Lieutenant-Colonel Preston Packard, who is "wound pretty tight" and feels let down by the US government's handling of the war in Vietnam. The Captain Ahab-like lieutenant-colonel views the mission to Skull Island as his last chance to right the wrongs that have been done to him and those he has served

[3] Though, in its initial stages, *Kong: Skull Island* was intended as a sequel to Jackson's remake of *King Kong*, as the film went through the pre-production process it was fashioned into a key part of the shared universe or Monsterverse of films planned by Legendary Pictures.

with, exclaiming at one point "this is one war we're not gonna lose!" The group are also joined by ex-British Special Air Service Captain James Conrad, who is employed as a tracker, and anti-war photographer Mason Weaver.

The Vietnam-era setting of *Kong: Skull Island* enables the film to engage with readings of the original *King Kong* as pro-imperialist, offering a carnivalesque presentation in which, as one character suggests, "east is best, west is worst". An early scene in which soldiers in helicopters drop (seismic) bombs upon the lush, forested landscape of Skull Island seems designed to evoke similar scenes of wanton destruction in Vietnam movies like *Apocalypse Now* (1979) and *Platoon* (1986). Yet here, the soldiers are not safe. An uprooted tree is hurled through the windscreen of one helicopter while it is flying over, as Kong reveals himself by aggressively defending his idyllic home, killing many of the soldiers and grounding the rest. This early sequence sees Kong outmatch US military might by virtue of his own gigantic size and power. The ensuing revelation that "ancient species" like the one to which Kong belongs "owned this earth long before mankind" can be read in terms of the similarly unsettling realisation in Vietnam that "[US] military might was not unlimited" and that "some wars were simply unwinnable" (Friedman 9–10). Subsequent scenes in the film depict the soldiers as ill- equipped for an environment with which they are unfamiliar, further emphasising the film's refashioning of ideas and images tied to the Vietnam conflict. A giant spider is killed but not before it skewers several soldiers with its bamboo-like legs; giant reptilian skull crushers emerge without warning, Vietcong-like, from vents in the island's landscape; and the group cross mass graves with dinosaur bones piled high. Where the 1933 *King Kong* depicted its island natives as "*Savage, Superstitious, Bestial, Childlike, Evil*" (quoted in Rony 176), in *Kong: Skull Island* the indigenous lifestyle is presented as utopian. With distinct echoes of the communist Vietnamese, we learn the locals have "no crime, no personal property, they're past all that". *Kong: Skull Island*'s climax further emphasises the Vietnam metaphor: the obsessed Packard confronts Kong in a night-time attack that sees the giant ape knocked unconscious with napalm. However, just when Packard is about to rewrite the 'wrongs' of Vietnam and defeat the giant ape, the other soldiers realise the colonel is wrong, that their intervention was misplaced, and that they should abandon their mission, leaving the island and Kong to re-establish their own, 'natural' balance at the end of the film.

In a significant change to the plot of the original film (and the two previous remakes) *Kong: Skull Island* ends with Kong very much alive, the camera tracking in on the giant ape as he beats his chest and roars. This upbeat ending is in line with the sense of levity on display

elsewhere in the film while also signalling *Kong: Skull Island*'s status as one part of a larger, interconnected network of films, in which Kong was expected to return. A brief Marvel Studios-style post-credits scene returns us to the work of MONARCH and their franchise-perpetuating discovery of cave paintings depicting a host of other giant monsters, including Gojira and the three-headed Ghidorah. These types of scene, which "continue to expand the universe" (Cogan and Massey 16), were to become of great importance to the concept of the shared cinematic universe, alerting audiences to the continuing nature of the narrative and the likelihood of more releases tied to the franchise.

Demonstrating just how pervasive the concept of the shared universe had become by the mid-2010s, *Jurassic World* (2015), co-produced by Legendary Pictures, exists in the same fictional world as the original trilogy of films, extending its conceit to suggest that dinosaurs have now become relatively commonplace. To demonstrate this the film opens with 11-year-old dinosaur fanatic Gray Mitchell and his older brother Zach *en route* to visit the titular park, where their aunt Claire Dearing is operations manager. While Gray is excited, Zach is apathetic, more interested in girls than the prehistoric creatures. Although the park is depicted as a commercially successful tourist attraction, this is a world in which "no one's impressed by a dinosaur any more". We see scenes of young children riding baby dinosaurs as Zach complains "this place is for little kids". Consequently, like the Monsterverse films, *Jurassic World* seems obliged to scale-up its eponymous creatures, as Dearing suggests to a group of potential investors "consumers want them bigger, louder, more teeth". Within the diegetic world of the film this insatiable desire for something "bigger, faster, louder, better" results in the creation of the *indominus rex*: "designed based on a series of corporate focus groups. Like in the same way a lot of movies are" (Trevorrow quoted in McGovern). The *indominus rex* is intended to re-energise customer interest in dinosaurs, reintroducing the "thrill" of seeing something truly new and spectacular. Jurassic World's scientists achieve this feat through gene splicing, creating a hybrid creature that will renew excitement in large part because the *I. rex* is "bigger than the *T. rex*".

Interestingly, the film uses the creation of the dinosaur as a means of criticising the business practices of contemporary Hollywood. While heroic ethnologist Owen Grady argues that "dinosaurs [are] wow enough", in keeping with the park's management team Dearing suggests that there is a continual need to "up the wow factor" to help drive ticket sales and please shareholders. The corporate motives for creating the *I. rex* result in the franchise's first out-and-out dinosaur villain, what director Colin Trevorrow calls "an abomination" (quoted

in McGovern). Like the rhetoric that often surrounds the contemporary big-budget Hollywood blockbuster, the *I. rex* is framed as a synthetic and soulless entity. Grady and Dearing discover that the hybrid dinosaur "kills for sport", taking pleasure in causing destruction. The suggestion is that the *I. rex* is dangerous because it is the product of exploitative capitalist practices. It embodies the ruthlessness of a system driven by monetary gain above any moral or ethical considerations. Given the film's adroit criticisms of corporate exploitation, it is a little ironic that the commercial success of *Jurassic World* re-energised the franchise, in turn leading to two further cinematic sequels (so far), a Netflix series (*Jurassic Park: Camp Cretaceous* (2020–2022), a theme park ride, and a series of related videogames.

In contrast to some of the more innovative work taking place outside the USA (such as *Monsters, A Monster Calls* (2016), and *Colossal* (2016)) Hollywood seemed to remain almost exclusively focused on trying to outdo the size and spectacle of previous films, often at the cost of the genre's more pleasurably subversive elements; indeed, Hantke goes so far as to propose that "as a metaphor with relevance for anything outside the doors of the movie theatre, the giant creature has – for the time being – more or less ceased to matter" (2023, 46). Consequently, 2018 saw the release of the biggest big shark movie yet, *The Meg* (2018). Replicating the set up of *Deep Blue Sea*, in which a bunch of characters stationed on a remote oceanic base end up fighting to stay alive when a monstrous creature attacks, *The Meg* replaces that film's hyper-intelligent group of sharks with a prehistoric, giant megalodon. At the start of *The Meg* something huge attacks a crewed research submersible exploring the deepest part of the Marianas Trench. When crack rescue diver Jonas Taylor is called in to try to recover the sub, he discovers that a megalodon, "a massive prehistoric killing machine" able to "bite a whale in half", has been inadvertently unleashed. While *The Meg* sporadically realises its potential – an extended homage to the Amity beach scene in *Jaws* sees the megalodon attack a gurning holiday maker in a Zorb – critics seemed to feel the movie was not carnivalesque enough, resulting in "a film about a shark as big as a football pitch that still somehow commits the cardinal sin of being boring" (Hewitt).

If *The Meg* tries to outdo previous sharksploitation films by giving audiences "the largest shark that ever existed" then *Godzilla: King of the Monsters* seems to base its appeal on providing more fights between more giant creatures than we have ever seen in a Hollywood film before. Yet, like *The Meg*, the film's emphasis on excessive spectacle seems to necessitate a move away from the subversive aspects of the genre. Indeed, where previous films had often depicted the natural world as

taking a form of poetic revenge on the representatives of a corrupt hegemony, the plot of *Godzilla: King of the Monsters* follows the efforts of MONARCH scientists Drs Ishirō Serizawa and Vivienne Graham as they attempt to stop a group of eco-terrorists from using a device called the ORCA to awaken and control a set of monsters located in outposts around the world. These MUTOs, now renamed Titans, total "17 and counting", and include Mothra in China, Rodan in Mexico, and the ominously codenamed "Monster Zero", otherwise known as Ghidorah, in Antarctica. The errant eco-terrorists believe that by releasing the Titans humanity's pollutive tendencies will be curbed and the Earth's "natural balance" restored. Unfortunately, Ghidorah turns out to be a non-native, "invasive species" which, upon release, plans to marshal the other Titans into transforming the planet so that humanity goes extinct. Luckily Godzilla, who has now assumed a protective role since the events of the 2014 film, is on hand to combat the Titans. First Godzilla fights the newly roused Ghidorah, then Ghidorah takes on Rodan, after which Godzilla confronts Ghidorah again, then battles Ghidorah for a third time helped by Mothra, who in turn battles Rodan. Finally, Mothra sacrifices itself to empower Godzilla who, newly re-energised, is now able to defeat Ghidorah.

It is difficult not to see *Godzilla: King of the Monsters'* numerous scenes of giant monsters fighting one another as some sort of end point for the genre's focus on spectacular destruction. Yet, in one sense, while the film succeeds in demonstrating Hollywood's ability to mobilise cutting-edge special effects technology, arguably the sheer number of visually spectacular battles contained in the film serves to drain them of their carnivalesque potential. For if the carnival is a temporary break, an "ephemeral transgression" (Stam 91), from the conventional order of things, then the ceaseless, repetitive nature of the action sequences in *Godzilla: King of the Monsters* makes them depressingly ordinary. While the film proved profitable enough to see a sequel greenlit (in the form of *Godzilla vs Kong* (2021)) *Godzilla: King of the Monsters* highlights the renewed tensions between the US giant monster movie's status as a vehicle for Hollywood to demonstrate its representational prowess, and its long-standing, ideologically subversive impulses. It is easy to see how, given the current dominance of a franchise model of film making, the empty bombast offered by depicting larger and larger monsters being excessively destructive might prove appealing. Yet without a sense of narrative causation, or a feeling of consequence, the genre risks losing its carnivalesque appeal and producing more and more "thunderously boring blockbuster[s]" (Travis).

Conclusion

The US Giant Monster Movie: Size Does Matter has attempted to provide a comprehensive critical survey of the US giant monster movie since its origins in the early twentieth century right through to the present. Central to this exploration has been a reading strategy that suggests the giant monster movie has been a vehicle for Hollywood to demonstrate its own representational prowess; its ability to mobilise resources in a manner that other competing film industries cannot. The emphasis on increased scale and size inherent to the giant monster movie lends itself to this task, providing an appropriate canvas on which to evidence this 'superiority'. Using the concept of the carnivalesque, drawn from the work of Mikhail Bakhtin, this study has also sought to highlight the subversive potential of the US giant monster movie. Bakhtin suggested that the carnival represented a temporary break, a Dionysian space in which established power structures were overturned and those involved were reminded that hierarchical structures are fragile and fallible. In a similar vein, the US giant monster movie offers audiences a couple of hours in which they can take pleasure in vicariously witnessing the destruction of the symbolic markers of the hegemony. This reading of the genre does of course raise the question whether the product of a multinational media corporation can ever be considered subversive. While the answer to this query is, by its very nature, a subjective one, this book proposes that, given the circumstances in which it is produced, the US giant monster movie is often surprisingly dissident. Although it is true that the representatives of power generally manage to defeat or repel monster(s) by the end of many giant monster movies (though there is some evidence of their failure in more recent films) this closure is only provided after repeated instances in which the creature is shown overcoming the best efforts of the military–industrial complex. Indeed, one of the key attractions of the genre is witnessing the inventive way visual effects – some cutting-edge, some less so – are used to realise the monster's devastating actions. To this end

this book has considered how special effects have been integral to the appeal of the giant monster movie, helping film makers to realise ever-larger and more diverse creatures, and enabling them to portray these monsters interacting with human performers in increasingly complex and nuanced ways. The present conclusion is designed to offer a useful summary of each chapter's findings, while providing some sense of further developments in the genre.

Chapter 1 examined some of the earliest examples of the US giant monster movie. Focusing on *The Lost World*, the *Kong* cycle of films, and *The Beast from 20,000 Fathoms*, this chapter charted the origins of the genre and its initial development. These pioneering films help to demonstrate the importance of special effects, introduced the idea of a sympathetic monster, and established the self-reflexive address that would recur through many subsequent examples of the form. While *The Lost World* was the first to be released, it was *King Kong* that really crystallised many of these elements into recognisable genre conventions. A self-styled epic, Mark McGurl writes of *King Kong* that "the identity of the film is deeply imbricated in the technology of enlargement" (440). Yet while the film has bigness at its core, in both the huge size of its ape but also its wildly ambitious scope and expensive production values, it also offers audiences a chance to marvel, subversively, at the destruction meted out by Kong as he runs amok in New York. The chapter then looked at the subsequent entries in the *Kong* cycle, *Son of Kong* and *Mighty Joe Young*, exploring how industrial factors led to changes in the genre. More specifically, because of their reduced budgets both films introduced a self-reflexive levity that would quickly become an integral part of the US giant monster movie. The chapter finished by considering how *The Beast from 20,000 Fathoms* retooled genre conventions in a less expensive format but one equally popular to the *Kong* cycle, one that keeps *King Kong*'s emphasis on size as spectacle as well as its carnivalesque pleasures of a monster rampaging across a recognisable urban cityscape.

Chapter 2 looked at giant monster movies from the 1950s. In the number of the films released, the 1950s represented the peak for giant monster movies in the USA. Many of these entries borrowed elements from the plot of *The Beast from 20,000 Fathoms*. Consequently, *Them!*, *It Came from Beneath the Sea*, and *Tarantula* all depict their giant creatures as resulting from the misuse of atomic power, popularising what would quickly become the principal explanation for gigantism in films of the decade. This recurrent motif added a further, subversive element to the genre, with numerous giant monster movies now (at least implicitly) criticising the scientific establishment. Further subversion

came in consequence of the Paramount Consent Decree, which opened US cinemas to a host of lower-budget film makers, some of whom produced interesting work. Chapter 2 offers in-depth analyses of some of these films, including *The Amazing Colossal Man* and *Attack of the 50 Foot Woman*, and explores the alternatives that they offer to the 'big bug' cycle of films. Both focus upon human characters who grow into giants. *The Amazing Colossal Man* examines the psychological effects of that process while *Attack of the 50 Foot Woman* offers a progressive and carnivalesque depiction of a female character whose unnatural growth enables her to reject the repressive patriarchal values of the era following the Second World War (albeit temporarily).

To follow the 1950s peak the third chapter starts by considering the difficulties faced by genre films in the 1960s. Taking *Valley of the Giants* as a representative example, the chapter explores film makers' not entirely successful attempts to marry genre conventions with broader contemporary trends. The discussion then moves ahead to the 1970s, to examine selected examples of the 'nature attacks' film. Not all the examples in this subgenre qualify as giant monster movies, but those that do – *Night of the Lepus*, *Jaws*, *Grizzly*, *The Food of the Gods*, *King Kong* (1976), and *Prophecy* – share a broadly environmentalist message. In more Bakhtinian terms, the concept of nature fighting back can be read as a decidedly carnivalesque upsetting of conventional hierarchical relations between humans and animals. The giant size of the creatures in this subgenre might be thought to reflect the scale of the problem, with their monstrous behaviour often depicted as a legitimate reaction to humanity's destructive treatment of the natural world. While spectacle continued to be a key appeal of the genre throughout the 1970s a number of these films seemed to struggle on this front, with even big-budget examples like *King Kong* and *Prophecy* being criticised for their subpar visual effects. This chapter explores some of the reasons for this, including the growing limitations of practical effects. The chapter ends by considering a series of films released in the 1980s and early 1990s that seemed to consciously steer away from the more grandiose elements found elsewhere in the genre. These films – *Alligator*, *Q: The Winged Serpent*, *The Blob* (1988), and *Tremors* – focus on blue-collar heroes and often position their monsters as class avengers, bringing a form of carnivalesque justice to the powerful and the corrupt.

Given its significance for the genre the impact of CGI on the giant monster movie during the 1990s is the focus of Chapter 4. The chapter considers how computer-generated imagery re-energised the genre, with the size and scale of the giant monster once again functioning as an effective vehicle for Hollywood studios to demonstrate their technical

prowess. In particular, *Jurassic Park* showed what could be accomplished with the nascent technology, depicting human performers interacting with a range of CGI dinosaurs and a level of perceptual realism never seen before. So innovative was the film that it took until the end of the 1990s before other studios released their own competitors. However, this chapter examines how, once the floodgates were opened, CGI became the dominant means of realising giant monsters on cinema screens. The effects the technology had on the carnivalesque nature of the giant monster movie were twofold. Firstly, CGI would eventually free film makers from the constraints of the physical. Secondly, the initially prohibitive cost of this new technology would mean that those who chose to use it heavily often had to ensure that their films appealed to as large an audience as possible. Film makers hedged their bets by emulating what had come before, in this case *Jurassic Park*, both in content (that film's preoccupation with genetic engineering) and style (its focus on photorealism). Chapter 4 examines some of the more interesting examples that followed Spielberg's film. Unable or unwilling to achieve the levels of perceptual realism seen in *Jurassic Park* some of these films chose instead to become increasingly self-reflexive. The chapter ends by discussing *Eight Legged Freaks*, suggesting that it is notable for being a US giant monster movie that uses CGI in an anti-realist fashion, an approach that is still largely unexplored in the genre.

Given the increasingly crowded media landscape Chapter 5 looks at the varied responses that film makers adopted to try to keep the US giant monster movie appealing. Some studios turned to the familiar to compete, with the recognisable stalwarts of the genre (King Kong, Godzilla) proving useful vehicles to attract audiences, while other studios sought to establish new intellectual properties to help them stand out. The chapter also considers how cinematic trends, such as found footage and computer animation, cross-pollinated with the giant monster movie and what the consequences of these were for the carnivalesque nature of the genre. Perhaps the most pervasive and influential development in cinema during the period covered in this chapter was the shared universe. Accordingly, the chapter examines Legendary Pictures' Monsterverse and explores how selected films in this shared universe negotiate the demands of franchise film making. In keeping with the bifurcation of the US giant monster movie the chapter also looks at the growth in low-budget, self-conscious paracinema, in the work of The Asylum, whose 'so bad they're good' monster movies represent an overtly carnivalesque approach to the genre. Films such as *Mega Shark vs Giant Octopus* parody both the diegetic and the

extradiegetic conventions of the US giant monster movie, proving just how embedded a part of the popular culture the genre has become.

As it enters the third decade of the twenty-first century, the US giant monster movie stands at something of a crossroads. As Chapter 5 suggests, the genre is now so well recognised that it can sustain any number of parodies and spoofs, yet, while contemporary US giant monster movies such as *Cloverfield* and *Pacific Rim* claim to offer something original, each of these films still heavily draws upon established genre conventions and iconography. In an era in which "hybridity and genre intermixing eclipse more traditional demarcations of genre production and consumption" (Harries 281) perhaps this is inevitable. While *Love and Monsters* (2020) is technically an original intellectual property it too has ties to an existing genre: the young adult, post-apocalyptic, adventure narrative. In the film scientists launch chemical bombs at an asteroid that threatens to destroy the Earth, but the fallout from these rockets causes all cold-blooded animals to grow exponentially. Rather than focus on these scientists, the film charts loveable loser Joel Dawson's attempt to return to his girlfriend after they are separated following the disaster. Dawson's defining characteristic at the start of the film is freezing in fear when confronted by the giant creatures, distancing him from the more traditional men of action associated with the genre's heyday. *Love and Monsters*, which was nominated for a visual effects Oscar, presents Dawson with a menagerie of giant monsters, including a mutated frog, snail, and crab, which evoke "the spirit of legendary Ray Harryhausen" (Desowitz) in their exaggerated designs. The uncanny effect of seeing previously miniature animals mutated into huge and dangerous predators represents a surprisingly underexplored means of overturning conventional hierarchies, something that the film further leans into by locating many of its action set-pieces in recognisable suburban environments.

Taking a decidedly different approach to *Love and Monsters*, 2020's *Underwater* builds instead upon the sense of the monster as numinous found in *Cloverfield, Pacific Rim*, and several entries in the Monsterverse shared universe. The film opens with central character Norah Price reflecting upon her feelings of powerlessness: "there are things will happen and make you feel powerless, and make you feel insignificant". The narrative that follows manifests this sentiment, stressing the vulnerability of the film's human characters as they try to deal with the consequences of a huge tremor that destroys part of their research facility located seven miles below the ocean's surface. In a throwback to the 'nature attacks' films explored in Chapter 3, *Underwater* suggests that humanity's actions – drilling into the deep ocean floor – were a

terrible mistake, as Price exclaims "we did this. We drilled the bottom of the ocean. We took too much and now she's taking back." It turns out that the crew's actions have unleashed a host of monstrous creatures, all of which seem intent on killing them. Among these monsters, and directly responsible for the earthquake, is a colossal creature (with echoes of Lovecraft's Cthulhu), who towers above the sizeable research facility, and dwarfs the human characters. While the film's ending might be seen as giving in to Hollywood conventions – Price blows up the reactor running the base and destroys the monster in the ensuing nuclear-level explosion – just before this happens, a short yet visually striking sequence depicts the now doomed Price staring out in awestruck rapture at the colossal monster. suggesting that the current trend for giant monsters to invoke a "stupor, a blank feeling of wonderment, an astonishment that strikes one dumb, a kind of amazement absolute" (Carroll 1990, 166) might now have established itself as a recurrent part of the genre. For a brief but nevertheless subversive moment she experiences an overwhelming "fascination" (Carroll 166) with the monster's power, taking pleasure in how its size enables it to transcend quotidian human concerns.

While the examples discussed so far borrow from the cinematic conventions of the genre, there may equally be potential for the creative rejuvenation of the US giant monster movie in looking to other kinds of media. In particular, videogame companies have long understood the carnivalesque appeal of watching giant monsters destroying urban centres. Examples from *Rampage* (1986), through *King of the Monsters* (1991), to the more recent *Dawn of the Monsters* (2020) and *Kaiju Wars* (2022), have found success by giving players control of the genre's oversized creatures and, with this, the direct opportunity to wreak havoc for themselves. Considering that it tasks the player with hunting down these giant monsters, rather than playing as the monster, it is surprising that the most recent videogame series to borrow from the *kaiju* genre and achieve really substantial success has been Capcom's *Monster Hunter*. With combined sales of 88 million units, it was only a matter of time before a cinematic adaptation of the series was mooted, but it would take until 2020 for director Paul W. S. Anderson to bring the Japanese videogame franchise to the big screen. Critically derided for a string of previous videogame adaptations, with *Monster Hunter* Anderson manages to produce a film that is entertaining but inconsistent in emulating the games on which it is based. While the film includes some of the more idiosyncratic elements of Capcom's games (most notably the humanoid cats known as Palicos) and effectively recreates several of its giant creatures (Black Diablos and Gore Magala stand out),

the plot, which sees a platoon of US Army soldiers transported into the 'New World' of the game, significantly deviates from the source material and seems designed to pull in a broader action-movie audience.

Though *Monster Hunter* failed to make a profit at the box office, it might benefit from the long tail that has seen other mid- to low-budget giant monster movie series such as *Anaconda* and *Deep Blue Sea* find success both on home media and through streaming services such as Netflix, Prime Video, and Shudder. Indeed, the US giant monster movie's future might depend on its ability to adapt to these types of streaming platforms and services. Netflix has already hosted animated series *Kong: King of the Apes* (2016–2018), the Japanese-American co-production *Pacific Rim: The Black* (2021–2022), and the original, computer-animated film *The Sea Beast* (2022). The first live-action streaming series to be based on a pre-established US giant monster movie property – *MONARCH: Legacy of Monsters* – is currently in production for Apple TV+. Starring Kurt and Wyatt Russell the series, which is set in the Monsterverse, promises to follow "one family's journey to uncover its buried secrets and a legacy linking them to the secret organization known as MONARCH" (White).

Whatever the future for the US giant monster movie ends up being it seems certain the genre will continue in some form. The spectacular and subversive appeal of giant monsters causing wide-scale destruction chimes with audiences' unwavering desire to witness the "overturning and the counterhegemonic subversion of established power" (Stam, 93), even if only for a carnivalesque hour or two.

Works Cited

Abbott, Stacey. "Blockbuster SF Film." In *The Routledge Companion to Science Fiction*. Eds Mark Bould et al. London and New York: Routledge, 2009. 468–472.
Acland, Charles R. *American Blockbuster: Movies, Technology, and Wonder*. Durham, NC and London: Duke University Press, 2020.
Alaimo, Stacy. "Discomforting Creatures: Monstrous Natures in Recent Films." In *Beyond Nature Writing: Expanding the Boundaries of Ecocriticism*. Eds Karla Armbruster and Kathleen R. Wallace. Charlottesville and London: University Press of Virginia, 2001. 279–296.
Allen, Michael. "Talking about a Revolution: The Blockbuster as Industrial Advertisement." In *Movie Blockbusters*. Ed. Julian Stringer. London and New York: Routledge, 2003. 101–113.
Anonymous. "The Son of Kong." *Variety*. 31 December 1932. Available at: https://variety.com/1932/film/reviews/the-son-of-kong-1200410676/.
Anonymous. "Another Jungle Monster." *The New York Times*. 30 December 1933. Available at: https://www.nytimes.com/1933/12/30/archives/another-jungle-monster.html.
Anonymous. "*Jack the Giant Slayer*." *Screen International*. 27 February 2013. Available at: https://www.proquest.com/trade-journals/jack-giantslayer/docview/1313231613/se-2.
Arnold, Gary. "The Shameful *Prophecy*." *Washingtonpost.com*. 16 June 1979. Available at: https://www.washingtonpost.com/archive/lifestyle/1979/06/16/the-shameful-prophecy/c1907a7f-ff49-45b0-aa9c-95fa319969b1/.
Audissino, Emilio. "'The Shark Is Not Working' – But the Music Is: Scoring a Hit with *Jaws*." In *The Jaws Book: New Perspectives on the Classic Summer Blockbuster*. Eds I. Q. Hunter and Matthew Melia. New York, London et al.: Bloomsbury, 2022. 65–78.
Bahrenburg, Bruce. *The Creation of Dino De Laurentiis' King Kong*. London: Star, 1976.
Bakhtin, Mikhail. *Rabelais and His World*. Trans. Helene Iswolsky. Bloomington: Indiana University Press, 1984.
Balio, Tino. "Hollywood Production Trends in the Era of Globalisation,

1990–99." In *Genre and Contemporary Hollywood*. Ed. Steve Neale. London: BFI, 2002. 165–184.

Barr, Jason. *The Kaiju Film: A Critical Study of Cinema's Biggest Monsters*. Jefferson, NC: McFarland, 2016.

—— and Camille D. G. Mustachio. "Introduction." In *Giant Creatures in Our World: Essays on Kaiju and American Popular Culture*. Eds Camille D. G. Mustachio and Jason Barr. Jefferson, NC: McFarland, 2017. 1–15.

Behlmer, Rudy. "*King Kong*: Up Close and Personal." Blu-Ray booklet. *King Kong*. Merian C. Cooper and Ernest Schoedsack. Warner Home Video, 2005.

Bell, James (ed). *Sci-Fi: Days of Fear and Wonder*. London: BFI Publishing, 2014.

Beltrán, Mary. "Más Macha: The New Latina Action Hero." In *Action and Adventure Cinema*. Ed. Yvonne Tasker. London and New York: Routledge, 2004. 186–200.

Benshoff, Harry. "The Monster and the Homosexual." In *The Monster Theory Reader*. Ed. Jeffrey Andrew Weinstock. Minneapolis and London: University of Minnesota Press, 2020. 226–240.

Biskind, Peter. *Easy Riders Raging Bulls: How the Sex 'n' Drugs 'n' Rock 'n' Roll Generation Saved Hollywood*. London: Bloomsbury, 1998.

Bogue, Mike. *Apocalypse Then: American Japanese Atomic Cinema, 1951–1967*. Jefferson, NC: McFarland, 2017.

Bollinger, Nicholas. "Archetypes at War: *Kaiju* as Cult Icons in *Pacific Rim*." In *Giant Creatures in Our World: Essays on Kaiju and American Popular Culture*. Eds Camille D. G. Mustachio and Jason Barr. Jefferson, NC: McFarland, 2017. 77–91.

Booth, Paul. *Digital Fandom: New Media Studies*. New York: Peter Lang, 2010.

Bowen, Chuck. "Review: Chuck Russell's *The Blob* on Twilight Time Blu-Ray." *Slantmagazine.com*. 21 October 2014. Available at: https://www.slantmagazine.com/dvd/the-blob-1988/.

Bradshaw, Peter. "*Monsters* – Review." *theguardian.com*. 2 December 2010. Available at: https://www.theguardian.com/film/2010/dec/02/monsters-review.

Brown, Eric C. "Introduction." In *Insect Poetics*. Ed. Eric C. Brown. Minneapolis: University of Minnesota Press, 2006. ix–xxiii.

Buckland, Warren. "A Close Encounter with *Raiders of the Lost Ark*: Notes on Narrative Aspects of the New Hollywood Blockbuster." In *Contemporary Hollywood Cinema*. Eds Steve Neale and Murray Smith. Abingdon and New York: Routledge, 2008. 166–177.

Bullock, Paul. *Constellations: Jurassic Park*. Liverpool: Liverpool University Press, 2020.

Butcher, Daisy and Janette Leaf. "Introduction." In *Crawling Horror: Creeping Tales of the Insect Weird*. Eds Daisy Butcher and Janette Leaf. London: The British Library, 2021. 7–11.

Canby, Vincent. "William Girdler's Not-Quite-So-Toothsome *Grizzly*." *Nytimes.com*. 13 May 1976. Available at: https://www.nytimes.com/1976/05/13/archives/william-girdlers-notquitesotoothsome-grizzly.html.

Caranicas, Peter. "Bibles Hold Tentpole Revivals: Biz Moves Backstory to Forefront." *Variety*. 29 June 2009.

Carroll, Noel. "*King Kong*: Ape and Essence." In *Planks of Reason: Essays on the Horror Film*. Ed. Barry Keith Grant. Metuchen, NJ and London: The Scarecrow Press, 1984. 215–244.

——. *The Philosophy of Horror or Paradoxes of the Heart*. New York and London: Routledge, 1990.

Carson, Rachel. *Silent Spring*, 40th anniversary edn. Boston, MA and New York: Houghton Mifflin, 2002.

Child, Ben. "*Jack the Giant Slayer*: Big News or the Height of Nonsense?" *theguardian.com*. 23 November 2012. Available at: https://www.theguardian.com/film/filmblog/2012/nov/23/jack-the-giant-slayer-killer.

Cogan, Brian and Jeff Massey. "'Yeah? Well MY God has a HAMMER': Myth-Taken Identity in the Marvel Cinematic Universe." In *Marvel Comics into Film: Essays on Adaptations Since the 1940s*. Eds Matthew J. McEniry, Robert Moses Peaslee and Robert G. Weiner. Jefferson, NC: McFarland, 2016. 10–19.

Cohen, Jeffrey Jerome. "Monster Culture (Seven Theses)." In *The Monster Theory Reader*. Ed. Jeffrey Andrew Weinstock. Minneapolis and London: University of Minnesota Press, 2020. 37–56.

Colavito, Jason. *Knowing Fear: Science, Knowledge and the Development of the Horror Genre*. Jefferson, NC and London: McFarland, 2008.

Collins, Andrew. "*Lake Placid* Review." *Empireonline.com*. 1 January 2000. Available at: https://www.empireonline.com/movies/reviews/lake-placid-review/.

Conan Doyle, Sir Arthur. *The Lost World*. Oxford, New York et al.: Oxford University Press, 1998.

Constandinides, Costas. *Celluloid Adaptation: Rethinking the Transition of Popular Narratives and Characters Across Old and New Media*. New York and London: Continuum, 2012.

Cook, D. A. *Lost Illusions: American Cinema in the Shadow of Watergate and Vietnam, 1970–1979*. New York: Scribner's, 2000.

Cooper, Ian. "Ron Underwood." In *Contemporary North American Film Directors: A Wallflower Critical Guide*. 2nd edn. Eds Yoram Allon, Del Cullen and Hannah Patterson. London and New York: Wallflower Press, 2022. 543–544.

Copeland, Marion. *Cockroach*. London: Reaktion Books, 2003.

Corman, Roger and Jim Jerome. *How I Made a Hundred Movies in Hollywood and Never Lost a Dime*. New York: Da Capo Press, 1998.

Creed, Barbara. "Horror and the Carnivalesque: The Body-Monstrous." In *Fields of Vision: Essays in Film Studies, Visual Anthropology and Photography*. Eds Leslie Devereaux and Roger Hillman. Berkeley, Los Angeles and London: University of California Press, 1995. 127–159.

Crook, Simon. "The Top 10 Worst Special Effects." *Empire*, May 2007.

Crow, David. "*Godzilla vs. Kong* Review." 29 March 2021. Denofgeek.com. Available at: https://www.denofgeek.com/movies/godzilla-vs-kong-review/.

Daniels, Robert. "*Godzilla vs. Kong*: Pure Spectacle in a Battle for the Ages." 29 March 2021. 812filmreviews.com. Available at: https://812filmreviews.com/2021/03/29/godzilla-vs-kong-pure-spectacle-in-a-battle-for-the-ages/.

Debus, Allen A. *Prehistoric Monsters: The Real and Imagined Creatures of the Past That We Love to Fear*. Jefferson, NC and London: McFarland, 2010.

Dentith, Simon. *Parody: The New Critical Idiom*. London and New York: Routledge, 2000.

Desowitz, Bill. "How *Love and Monsters* Became the Dark Horse in the Visual Effects Oscar Race." *Indiewire.com*. 15 April 2021. Available at: https://www.indiewire.com/2021/04/love-and-monsters-visual-effects-nomination-1234630534/.

DiLullo, Tara. "*Cloverfield*: Reinventing the Monster Movie." AWN.com. 21 January 2008. Available at: https://www.awn.com/vfxworld/cloverfield-reinventing-monster-movie.

Dixon, Wheeler Winston. *Synthetic Cinema: The 21st-Century Movie Machine*. Cham, Switzerland: Palgrave Pivot, 2019.

Duncan, Ian. "Introduction." In Conan Doyle, Sir Arthur. *The Lost World*. Oxford, New York et al.: Oxford University Press, 1998. vii–xxi.

Duncan, Jody. *The Winston Effect: The Art and History of Stan Winston Studio*. London: Titan Books, 2006.

Eagan, Daniel. *America's Film Legacy: The Authoritative Guide to the Landmark Films in the National Film Registry*. New York and London: Continuum, 2010.

Ebert, Roger. "*Eight Legged Freaks*." rogerebert.com. 17 July 2002. Available at: https://www.rogerebert.com/reviews/eight-legged-freaks-2002.

——. "The Heart of a Big Gorilla." rogerebert.com. 12 December 2005. Available at: https://www.rogerebert.com/reviews/king-kong-2005.

Elsaesser, Thomas. "The Pathos of Failure: American Films in the 1970s." *Monogram*, no. 6 (October). 1975. 13–19.

Erb, Cynthia. *Tracking King Kong: A Hollywood Icon in World Culture*. 2nd edn. Detroit, MI: Wayne State University Press, 2009.

Everman, Welch. *Cult Horror Films: From 'Attack of the 50 Foot Woman' to 'Zombies of Mora Tau'*. New York: Citadel, 1993.

Failes, Ian. "No Small Feat: Making *Jack the Giant Slayer.*" *www.fxguide.com*. 8 March 2013. Available at: https://www.fxguide.com/fxfeatured/no-small-feat-making-jack-the-giant-slayer/.

Felton, D. "The Blob." In *The Ashgate Encyclopaedia of Literary and Cinematic Monsters*. Ed. Jeffrey Andrew Weinstock. London and New York: Routledge, 2016. 54–55.

Fiscus, James W. *Famous Movie Monsters: Meet King Kong*. New York: The Rosen Publishing Group, 2005.

Fleury, James, Bryan Hikari Hartzheim, and Stephen Mamber. "Introduction: The Franchise Era." In *The Franchise Era: Managing Media in the Digital Economy*. Eds James Fleury, Bryan Hikari Hartzheim, and Stephen Mamber. Edinburgh: Edinburgh University Press, 2019. 1–30.

Freeland, Cynthia A., *The Naked and the Undead: Evil and the Appeal of Horror*. Boulder, CO: Westview Press, 2000.

Friedman, Lester D. "Introduction: Movies and the 1970s." In *American Cinema of the 1970s: Themes and Variations*. Ed. Lester D. Friedman. Oxford: Berg, 2007.

Fritz, Ben. *The Big Picture: The Fight for the Future of Movies*. New York: Houghton Mifflin, 2018.

Gambin, Lee. *Massacred by Mother Nature: Exploring the Natural Horror Film*. Albany, GA: BearManor Media, 2018.

Gomery, Douglas. "The Hollywood Blockbuster: Industrial Analysis and Practice." In *Movie Blockbusters*. Ed. Julian Stringer. London and New York: Routledge, 2003. 72–83.

Griffiths, Keith. "The Manipulated Image." *Convergence*. 9:4. 2003. 12–26.

Hall, Sheldon. "Blockbusters in the 1970s." In *Contemporary American Cinema*. Eds Linda Ruth Williams and Michael Hammond. Maidenhead and New York: Open University Press, 2006. 164–183.

Hall, Sheldon and Steve Neale. *Epics, Spectacles and Blockbusters: A Hollywood History*. Detroit, MI: Wayne State University Press, 2010.

Hantke, Steffen. "The Return of the Giant Creature: *Cloverfield* and Political Opposition to the War on Terror." *Extrapolation*. 51:2, 2010. 235–257.

——. *Cloverfield: Creatures and Catastrophes in Post-9/11 Cinema*. Jackson: University Press of Mississippi, 2023.

Hardy, Phil. *The Encyclopaedia of Science Fiction Movies*. London: Octopus, 1986.

Harries, Dan. "Film Parody and the Resuscitation of Genre." In *Genre and Contemporary Hollywood*. Ed. Steve Neale. London: BFI, 2002. 281–293.

Harryhausen, Ray and Tony Dalton. *Ray Harryhausen: An Animated Life*. London: Aurum Press, 2003.

Hassell, Holly. "The 'Babe Scientist' Phenomenon: The Illusion of Inclusion in 1990s American Action Films." in *Chick Flicks: Contemporary Women at the Movies*. Eds Suzanne Ferriss and Mallory Young. New York and London: Routledge, 2008. 190–203.

Hathaway, Liam. "Monsters by the Millions: An Eco-Cultural History of the Killer Bug Film." De Montfort University, Leicester. November 2021. Unpublished doctoral thesis. Available at: https://ethos.bl.uk/OrderDetails.do?uin=uk.bl.ethos.857493.

Hendershot, Cyndy. *I Was a Cold War Monster: Horror Films, Eroticism and the Cold War Imagination*. Bowling Green, OH: Bowling Green State University Popular Press, 2001.

Hewitt, Chris. "*The Meg* Review." empireonline.com. 8 August 2008. Available at: https://www.empireonline.com/movies/reviews/meg-review/.

Higashi, Sumiko. "Movies and the Paradox of Female Stardom." In *American Cinema of the 1950s: Themes and Variations*. Ed. Murray Pomerance. Oxford: Berg, 2005. 65–88.

Higgins, Bill. "In 1925, *Lost World* First Brought Dinosaurs to Life." *Hollywood Reporter*. 424:22, 20 June 2018, p. 88. Gale General OneFile, link.gale.com/apps/doc/A545670213/ITOF.

Hollings, Ken. "*Gojira Mon Amour*." In *Science Fiction/Horror: A Sight and Sound Reader*. Ed. Kim Newman. London: BFI Publishing, 2002. 138–144.

Holt, Jennifer. "1989: Movies and the American Dream." In *American Cinema of the 1980s: Themes and Variations*. Ed. Stephen Prince. Oxford: Berg, 2007. 210–231.

Hunter, I. Q. "Trash Horror and the Cult of the Bad Film." In *A Companion to the Horror Film*. Ed. Harry M. Benshoff. Malden, MA et al.: John Wiley, 2014. 483–500.

—— and Matthew Melia. "Introduction." In *The Jaws Book: New Perspectives on the Classic Summer Blockbuster*. Eds I. Q. Hunter and Matthew Melia. New York, London et al.: Bloomsbury, 2022. 1–15.

Hutchings, Peter. *The Horror Film*. Essex: Pearson Education, 2004.

James, Jonathan. "The Overlook Film Festival 2017 Interview with Roger Corman." Daily Dead. 2 May 2017. Available at: https://dailydead.com/overlook-film-festival-2017-interview-roger-corman/.

Jancovich, Mark. *Horror*. London: Batsford, 1992.

——. *Rational Fears: American Horror in the 1950s*. Manchester and New York: Manchester University Press, 1996.

—— and Derek Johnston. "Genre, Special Effects and Authorship in the Critical Reception of Science Fiction Film and Television During the 1950s." In *It Came from the 1950s! Popular Culture, Popular Anxieties*. Eds Darryl Jones, Elizabeth McCarthy, and Bernice M. Murphy. Basingstoke and New York: Palgrave Macmillan, 2011. 90–107.

Jewell, Richard B. *Slow Fade to Black: The Decline of RKO Radio Pictures*. Berkeley: University of California Press, 2016.

Johnson, Derek. "Foreword." In *The Franchise Era: Managing Media in the Digital Economy*. Eds James Fleury, Bryan Hikari Hartzheim, and Stephen Mamber. Edinburgh: Edinburgh University Press, 2019. xiii–xvi.

Jolin, Dan. "*Monsters* Review." empireonline.com. 29 October 2010. Available at: https://www.empireonline.com/movies/reviews/monsters-review/.
Jones, Darryl, Elizabeth McCarthy, and Bernice M. Murphy. "Introduction." In *It Came from the 1950s! Popular Culture, Popular Anxieties*. Eds Darryl Jones, Elizabeth McCarthy, and Bernice M. Murphy. Basingstoke and New York: Palgrave Macmillan, 2011. 1–16.
Jones, Jason C. "Godzilla Adaptations and Erasure of the Politics of Nuclear Experience." In *The Atomic Bomb in Japanese Cinema: Critical Essays*. Ed. Michael Edwards. Jefferson, NC: McFarland, 2015. 34–55.
Jones, Stan. "Ape Redux: *King Kong* and the Kiwis." In *Fear, Cultural Anxiety and Transformation: Horror: Science Fiction and Fantasy Films Remade*. Eds Scott A. Lucas and John Marmysz. Lanham, MD: Lexington Books, 2009. 181–198.
Katz, David. "From Asylum: The People Who Brought You (A Movie Kinda Sorta Like) *Pacific Rim*." GQ.com. 11 July 2013. Available at: https://www.gq.com/story/sharknado-atlantic-rim-pacific-rim-asylum-movie-spoof.
Kaye, Don. "Western Kaiju Movies: From *The Lost World* to *Cloverfield*." Denofgeek.com. 8 March 2016. Available at: https://www.denofgeek.com/movies/western-kaiju-movies-from-the-lost-world-to-cloverfield/.
——. "*Prophecy*: A Monster Movie That Needed a Better Monster." Denofgeek.com. 27 November 2019. Available at: https://www.denofgeek.com/movies/prophecy-1979-a-bad-monster-movie/.
Keane, Stephen. *Disaster Movies: The Cinema of Catastrophe*. London and New York: Wallflower Press, 2006.
Kelley, Bill. "Jack is Back!" *Cinefantastique*. 4:2. 1973. 16–25.
Kelper, Brian. "*A Night at the Museum*: Digging Up *The Relic* 25 Years Later." bloody-disgusting.com. 16 March 2022. Available at: https://bloody-disgusting.com/editorials/3707403/a-night-at-the-museum-digging-up-the-relic-25-years-later/.
Kermode, Mark. "*Godzilla* Review – 2014 Reboot Shows an Appreciation of Honda's Original." theguardian.com. 18 May 2014. Available at: https://www.theguardian.com/film/2014/may/18/godzilla-review-gareth-edwards-reboot-mark-kermode.
Kiang, Jessica. "30 Years Later, *Tremors* Is Still a Perfect Monster Movie, and It Keeps Getting Better." RottenTomatoes.com. 19 January 2020. Available at: https://editorial.rottentomatoes.com/article/30-years-later-tremors-is-still-a-perfect-monster-movie-and-it-keeps-getting-better/.
Kincaid, Paul. "On the Origins of Genre." In *Speculations on Speculation: Theories of Science Fiction*. Eds James Gunn and Matthew Candelaria. Lanham, MD: The Scarecrow Press, 2003. 41–53.
King, Geoff. *Spectacular Narratives: Hollywood in the Age of the Blockbuster*. London and New York: I. B.Tauris, 2000.

———. "Spectacle and Narrative in the Contemporary Blockbuster." In *Contemporary American Cinema*. Eds Linda Ruth Williams and Michael Hammond. Maidenhead and New York: Open University Press, 2006. 334–355.

King, Homay. "*The Host* versus *Cloverfield*." In *Horror After 9/11: World of Fear, Cinema of Terror*. Eds Aviva Briefel and Sam J. Miller. Austin: University of Texas Press, 2011. 124–141.

Kinnard, Roy. *Beasts and Behemoths: Prehistoric Creatures in the Movies*. Metuchen, NJ and London: The Scarecrow Press, 1988.

Komoi.com Team. "*Godzilla vs Kong* Box Office Update: Monster Saga Doubles Its Investment to Become a Huge Success." 16 May 2021. Available at: https://comicbook.com/anime/news/godzilla-vs-kong-box-office-100-million-goal-update/.

Kramer, Peter. "Would You Take Your Child to See this Film? The Cultural and Social Work of the Family-Adventure Movie." In *Contemporary Hollywood Cinema*. Eds Steve Neale and Murray Smith. London: Routledge, 1998. 294–311.

———. "'She Was the First': The Place of *Jaws* in American Film History." In *The Jaws Book: New Perspectives on the Classic Summer Blockbuster*. Eds I. Q. Hunter and Matthew Melia. New York, London et al.: Bloomsbury, 2022. 19–32.

Kristeva, Julia. "Word, Dialogue and Novel." In *The Kristeva Reader*. Ed. Toril Moi. Trans. Alice Jardine, Thomas Gora, and Leon S. Roudiez. New York: Columbia University Press, 1986. 34–61.

Lee, Benjamin. "*Godzilla vs Kong* Review – Duelling Monsters Make for One Hell of a Show." 29 March 2021. theguardian.com. Available at: https://www.theguardian.com/film/2021/mar/29/godzilla-vs-kong-review-duelling-monsters.

Lee, Nathan. "*Cloverfield* Is One Giant, Incredibly Entertaining 'Screw You!' to Yuppie New York." Villagevoice.com. 15 January 2008. Available at: https://www.villagevoice.com/2008/01/15/cloverfield-is-one-giant-incredibly-entertaining-screw-you-to-yuppie-new-york/.

Lemkin, Jonathan. "Archetypal Landscapes and Jaws." In *Planks of Reason: Essays on the Horror Film*. Ed. Barry Keith Grant. Metuchen, NJ and London: The Scarecrow Press, 1984. 277–289.

Lennard, Dominic. *Brute Force: Animal Horror Movies*. Albany: State University of New York Press, 2019.

Lindsey. "Classics of the Corn: *Attack of the Crab Monsters* (1957)." The Motion Pictures. 24 August 2013. Available at: https://themotionpictures.net/2013/08/24/classics-of-the-corn-attack-of-the-crab-monsters-1957/.

Luckhurst, Roger. *Science Fiction: A Literary History*. London: The British Library, 2017.

Lyne, Charlie. "*Pacific Rim*: Mass Destruction and Modern Cinema." theguardian.com. 13 July 2013. Available at: https://www.theguardian.com/film/2013/jul/13/mass-destruction-and-modern-cinema.

Lyons, Kevin. "*Unknown Island* (1948)." 18 April 2020. The EOFFTV Review. Available at: https://eofftvreview.wordpress.com/2020/04/18/unknown-island-1948/.

Macdonald, Jamie. "The Ideology of Disaster: Godzilla, Gorillas and Geopolitics in the Global 21st Century." In *Giant Creatures in Our World: Essays on Kaiju and American Popular Culture*. Eds Camille D. G. Mustachio and Jason Barr. Jefferson, NC: McFarland, 2017. 161–177.

MacDonald, Laurence E. *The Invisible Art of Film Music: A Comprehensive History*. 2nd edn. Lanham, MD et al.: The Scarecrow Press, 2013.

Malcom, Derek. "Steven Spielberg's *Jaws* Review – Archive, 1975." theguardian.com. 22 December 2016. Available at: https://www.theguardian.com/film/2016/dec/22/jaws-steven-spielberg-1975-review-derek-malcolm.

Man, Glenn. "1975: Movies and Conflicting Ideologies." In *American Cinema of the 1970s: Themes and Variations*. Ed. Lester D. Friedman. Oxford: Berg, 2007. 135–156.

Mann, Craig Ian. "America, Down the Toilet: Urban Legends, American Society and *Alligator*." In *Animal Horror Cinema: Genre, History and Criticism*. Eds Katarina Gregersdötter, Johan Hoglund, and Nicklas Hållén. London: Palgrave Macmillan, 2015. 110–125.

Mathijs, Ernest and Jamie Sexton. *Cult Cinema*. Malden, MA et al.: Wiley Blackwell, 2011.

McCarthy, Todd. "Film Review: *Jurassic Park*." Variety.com. 7 June 1993. Available at: https://variety.com/1993/film/reviews/jurassic-park-2-1200432562/.

McConaughey, Matthew. *Greenlights: Raucous Stories and Outlaw Wisdom from the Academy-Award Winning Actor*. London: Headline, 2020.

McDonald, Keith and Roger Clark. *Guillermo Del Toro: Film as Alchemic Art*. New York and London: Bloomsbury, 2014.

McGovern, Joe. "Colin Trevorrow on *Jurassic World*'s Monster Star *Indominus Rex*." Ew.com. 25 May 2015. Available at: https://ew.com/article/2015/05/25/meet-new/.

McGurl, Mark. "Making It Big: Picturing the Radio Age in *King Kong*." *Critical Inquiry*. 22:3. 1996. 415–445. Available at: www.jstor.org/stable/1344016.

Melville, Jonathan. *Seeking Perfection: The Unofficial Guide to Tremors*. Edinburgh: Fountainbridge Press, 2015.

Mendik, Xavier and Steven Jay Schneider. "A Tasteless Art: Waters, Kaufman and the Pursuit of 'Pure' Gross-Out." In *Underground USA Filmmaking Beyond the Hollywood Canon*. Eds Xavier Mendik and Steven Jay Schneider. London and New York: Wallflower Press, 2002. 204–220.

Milne, Tom. "Food of the Gods." *The Monthly Film Bulletin*. 43:513. 1976. 213.

Mizejewski, Linda. *Divine Decadence: Fascism, Female Spectacle, and the Makings of Sally Bowles*. Princeton, NJ: Princeton University Press, 1992.

Morton, Ray. *King Kong: The History of a Movie Icon from Fay Wray to Peter Jackson*. New York: Applause Theatre and Cinema Books, 2005.

Mozzafar, Omer M. "Chicago: City of Imagination." In *World Film Locations: Chicago*. Ed. Scott Jordan Harris. Bristol: Intellect Books, 2013. 6–7.

Muir, John Kenneth. *Horror Films of the 1970s*. Jefferson, NC: McFarland, 2002.

——. *Horror Films of the 1990s*. Jefferson, NC: McFarland, 2011.

Murphy, Bernice M. *The Rural Gothic in American Popular Culture: Backwoods Horror and Terror in the Wilderness*. New York and Basingstoke: Palgrave Macmillan, 2013.

Nathan, Ian. *Guillermo Del Toro: The Iconic Filmmaker and His Work*. London: White Lion, 2021.

Ndalianis, Angela. "Dark Rides, Hybrid Machines and the Horror Experience." In *Horror Zone*. Ed. Ian Conrich. London and New York: I. B.Tauris. 2010. 11–26.

Neale, Steve. "'The Last Good Time We Ever Had?' Revising the Hollywood Renaissance." In *Contemporary American Cinema*. Eds Linda Ruth Williams and Michael Hammond. Maidenhead and New York: Open University Press, 2006. 90–114.

Negra, Diane. "1981: Movies and Looking Back to the Future." In *American Cinema of the 1980s: Themes and Variations*. Ed. Stephen Prince. Oxford: Berg, 2007. 43–62.

Newman, Kim. *Apocalypse Movies: End of the World Cinema*. New York: St Martin's Griffin, 2000a.

——. "*The Lost World* Review." 1 January 2000b. Empireonline.com. Available at: https://www.empireonline.com/movies/reviews/lost-world-review/.

——. "*Godzilla* 1998." In *Science Fiction/Horror: A Sight and Sound Reader*. Ed. Kim Newman. London: BFI Publishing, 2002. 145.

——. "Monsters vs Aliens." *Sight and Sound*. 19:6. 2009. 71.

——. "Mutants and Monsters." In *It Came from the 1950s! Popular Culture, Popular Anxieties*. Eds Darryl Jones, Elizabeth McCarthy, and Bernice M. Murphy. Basingstoke and New York: Palgrave Macmillan, 2011. 55–71.

Nietzsche, Friedrich. *Beyond Good and Evil*. Trans. Helen Zimmern. West Sussex: Capstone, 2020.

Noonan, Bonnie. *Gender in Science Fiction Films, 1964–1979 A Critical Study*. Jefferson, NC: McFarland, 2015.

North, Daniel. "Evidence of Things Not Quite Seen: *Cloverfield*'s Obstructed Spectacle." *Film & History*. 40:1. 2010. 75–92.

Paszylk, Bartlomiej. *The Pleasure and Pain of Cult Horror Films: A Historical Survey*. Jefferson, NC and London: McFarland, 2009.

Pierson, Michelle. *Special Effects: Still in Search of Wonder*. New York and Chichester: Columbia University Press, 2002.

Pomerance, Murray. "1957. Movies and the Search for Proportion." In *American Cinema of the 1950s: Themes and Variations*. Ed. Murray Pomerance. Oxford: Berg, 2005. 177–200.

Poole, W. Scott, *Monsters in America: Our Historical Obsession with the Hideous and the Haunting*. Waco, TX: Baylor University Press, 2011.

Prince, Stephen. *Digital Visual Effects in Cinema: The Seduction of Reality*. New Brunswick, NJ and London: Rutgers University Press, 2012.

Quinn, Anthony. "'Toy Franchise with a Deafeningly Loud Movie Attached': *Pacific Rim* Film Review." 12 July 2013. *Independent*. Available at: https://www.independent.co.uk/arts-entertainment/films/reviews/toy-franchise-deafeningly-loud-movie-attached-pacific-rim-film-review-8703541.html.

Radish, Christina. "Comic Con: Guillermo Del Toro and Charlie Hunnam Talk *Pacific Rim*, Giving the Robots a Personality, Ghost Stories, *Prometheus* and More." Collider.com. 16 July 2012. Available at: https://collider.com/guillermo-del-toro-charlie-hunnam-pacific-rim-interview/.

Romano, Aja. "The Mako Mori Test: *Pacific Rim* Inspires a Bechdel Test Alternative." 18 August 2013. The Daily Dot. Available at: https://www.dailydot.com/parsec/fandom/mako-mori-test-bechdel-pacific-rim/.

Rony, Fatimah Tobing. *The Third Eye: Race, Cinema and Ethnographic Spectacle*. Durham, NC: Duke University Press, 1996.

Rovin, Jeff. *From the Land Beyond Beyond: The Making of the Movie Monsters You've Known and Loved*. New York: Berkeley Windhover Books, 1977.

Rubey, Dan. "The *Jaws* in the Mirror." *Jump Cut: A Review of Contemporary Media*. 1976. Available at: https://www.ejumpcut.org/archive/onlinessays/JC10-11folder/JawsRubey.html.

Ryan, Jack. *John Sayles, Filmmaker*. Jefferson, NC and London: McFarland, 1998.

Ryfle, Steve. *Japan's Favorite Mon-Star: The Unauthorized Biography of "The Big G"*. Toronto, Ontario: ECW Press, 1998.

Salmose, Niklas. "We Spiders: Spider as the Monster of Modernity in the Big Bug and Nature-on-a-Rampage Film Genres." In *Animal Horror Cinema: Genre, History and Criticism*. Eds Katarina Gregersdötter, Johan Hoglund, and Nicklas Hållén. London: Palgrave Macmillan, 2015. 146–167.

Schatz, Thomas. "The New Hollywood." In *Movie Blockbusters*. Ed. Julian Stringer. London: Routledge, 2003. 15–44.

Schmidt, Gary A. *Renaissance Hybrids: Culture and Genre in Early Modern England*. London and New York: Routledge, 2013.
Schoell, William. *Creature Features: Nature Turned Nasty in the Movies*. Jefferson, NC: McFarland, 2008.
Schuman, Bruce. *The Seventies: The Great Shift in American Culture, Society and Politics*. Boston, MA: Da Capo Press, 2002.
Sconce, Jeffrey. "'Trashing' the Academy: Taste, Excess, and an Emerging Politics of Cinematic Style." *Screen*. 36. 371–393.
Scott, B. "Review of *Eight Legged Freaks*." Ign.com. 16 July 2002. Available at: https://www.ign.com/articles/2002/07/16/review-of-eight-legged-freaks.
Seitz, Matt Zoller. "*Godzilla vs. Kong*." 29 March 2021. Rogerebert.com. Available at: https://www.rogerebert.com/reviews/godzilla-vs-kong-movie-review-2021.
Senn, Bryan. *A Year of Fear: A Day-by-Day Guide to 366 Horror Films*. Jefferson, NC and London: McFarland, 2007.
Shawhan, Jason. "In the Late '90s, an Unlikely Bestseller Became a Rip-Roaring Museum Monster Movie." Avclub.com. 27 April 2021. Available at: https://www.avclub.com/in-the-late-90s-an-unlikely-bestseller-became-a-rip-r-1846771584.
Shone, Tom. *Blockbuster*. London: Simon & Schuster, 2004.
Short, Jase. "Monsters of the Rift: *Kaiju* as Ciphers of Unbalance." In *Giant Creatures in Our World: Essays on Kaiju and American Popular Culture*. Eds Camille D. G. Mustachio and Jason Barr. Jefferson, NC: McFarland, 2017. 59–76.
Shumway, David R. *John Sayles: Contemporary Film Directors*. Urbana, Chicago and Springfield: University of Illinois Press, 2012.
Sibley, Brian. *Peter Jackson: A Film-Maker's Journey*. London: HarperCollins Entertainment, 2006.
Slowik, Michael. "Reassessing *King Kong*; or, The Hollywood Film Score, 1933–1934." In Slowik, Michael. *After the Silents: Hollywood Film Music in the Early Sound Era, 1926- 1934*. New York: Columbia University Press, 2014. 230–265.
Smith, Molly C. "*Kong: Skull Island* Gives First Look at Movie Monster." 10 November 2016. EW.Com. Available at: https://ew.com/article/2016/11/10/kong-skull-island-first-look-movie-monster/.
Snead, James. *White Screens, Black Images: Hollywood from the Dark Side*. New York and London: Routledge, 1994.
Sontag, Susan. "The Imagination of Disaster." In *Liquid Metal: The Science Fiction Film Reader*. Ed. Sean Redmond. New York and Chichester: Columbia University Press, 2007. 40–47.
Stallybrass, Peter and Allon White. *The Politics and Poetics of Transgression*. Ithaca, NY: Cornell University Press, 1986.
Stam, Robert. *Subversive Pleasures: Bakhtin, Cultural Criticism and Film*. Baltimore, MD and London: The Johns Hopkins University Press, 1989.

Stephens, Walter. *Giants in Those Days: Ancient History and Nationalism.* Lincoln: University of Nebraska Press, 1989.
Stewart, Susan. *On Longing: Narratives of the Miniature, the Gigantic, the Souvenir, the Collection.* 10th edn. Durham, NC and London: Duke University Press, 2007.
Stockman, Tom. "*The Giant Spider Invasion* – The Blu Review." Wearemoviegeeks.com. 18 June 2015. Available at: http://www.wearemoviegeeks.com/2015/06/giant-spider-invasion-blu-review/.
Stone, James. "Enjoying 9/11: The Pleasures of *Cloverfield*." *Radical History Review.* 2011:111. 2011. 167–174.
Stringer, Julian. "Introduction." In *Movie Blockbusters.* Ed. Julian Stringer. London and New York: Routledge, 2003. 1–14.
Taves, Brian. "*The Lost World*." Date unknown. Library of Congress. Available at: https://www.loc.gov/static/programs/national-film-preservation-board/documents/lost_world.pdf.
Telotte, J. P. "The Movies as Monster: Seeing in *King Kong*." *The Georgia Review.* 42:2. 1988. 388–398. Available at: www.jstor.org/stable/41399404.
Totaro, Donald. "*Cloverfield*: An Intimate Apocalypse." *Offscreen.* 12:2. 2008.
Towlson, Jon. *The Turn to Gruesomeness in American Horror Films, 1931–1936.* Jefferson, NC and London: McFarland, 2016.
Travis, Ben. "*Godzilla: King of the Monsters* Review." Empireonline.com. 28 May 2019. Available at: https://www.empireonline.com/movies/reviews/godzilla-king-monsters-review/.
Tsutsui, William. *Godzilla on My Mind: Fifty Years of the King of Monsters.* New York: St Martin's Griffin. 2004.
Turek, Ryan. "Shock Interview: Gullermo Del Toro on the Development, Destruction and Family-Friendly *Pacific Rim*." Shocktillyoudrop.com. 8 July 2013. Available at: http://www.shocktillyoudrop.com/news/174835-shock-interview-guillermo-del-toro-on-the-development-destruction-and-family-friendly-pacific-rim/.
Uhlich, Keith. "*Pacific Rim*: Movie Review." timeout.com. 8 July 2013. Available at: https://www.timeout.com/us/film/pacific-rim-movie-review.
Warren, Bill. *Keep Watching the Skies! American Science Fiction Movies of the Fifties, The 21st Century Edition.* Jefferson, NC: McFarland, 2017.
Weaver, Tom, David Schecter, Robert J. Kiss, and Steve Kronenberg. *Universal Terrors 1951–1955: Eight Classic Horror and Sci-Fi Films.* Jefferson, NC: McFarland, 2017.
Webber, Roy P. *The Dinosaur Films of Ray Harryhausen: Features, Early 16mm Experiments and Unrealized Projects.* Jefferson, NC and London: McFarland, 2004.
Weinstock, Jeffrey Andrew. "Introduction: A Genealogy of Monster Theory." In *The Monster Theory Reader.* Ed. Jeffrey Andrew Weinstock. Minneapolis and London: University of Minnesota Press, 2020. 1–36.

White, James. "Apple's MonsterVerse Series Adds Anna Sawai, Kiersey Clemons and Joe Tippett." empireonline.com. 30 June 2022. Available at: https://www.empireonline.com/tv/news/apple-monsterverse-series-adds-anna-sawai-kiersey-clemons-and-joe-tippett/.

Williams, Tony.*Larry Cohen: The Radical Allegories of an Independent Filmmaker*, revised edn. Jefferson, NC: McFarland, 2014.

——. "Female Oppression in *Attack of the 50-Foot Woman*." *Science Fiction Studies*. 12:3. 1985. 264–273.

Wilmington, Michael. "The First *Lost World* in 1925, Film of Arthur Conan Doyle's Dinosaur Classic Rocked the Nation." *Chicago Tribune*, 8 June 1997. 7.

Wisker, Gina. *Horror Fiction: An Introduction*. London and New York: Continuum, 2005.

Wood, Michael. "Foreword: Happy Days." In Peter Biskind. *Seeing Is Believing: Or How Hollywood Taught Us to Stop Worrying and Love the 50s*. London: Bloomsbury, 2001. ix–xi.

Wood, Robin. *Hollywood From Vietnam to Reagan ... and Beyond*. New York: Columbia University Press, 2003.

Wyatt, Justin. *High Concept: Movies and Marketing in Hollywood*. Austin: University of Texas Press, 1994.

Yacowar, Maurice. "The Bug in the Rug: Notes on the Disaster Genre." In *The Film Genre Reader III*. Ed. Barry Keith Grant. Austin: University of Texas Press, 2003. 277–295.

Index

9/11 135, 137
10 Cloverfield Lane (2016) 135
2001: A Space Odyssey (1968) 80
20,000 Leagues Under the Sea (1954) 84

A Monster Calls (2016) 152
Abbott, Stacey 13
Airport (1970) 80
Alien (1979) 9, 84
Alien franchise 8
Aliens (1986) 9, 85
Alligator (1980) 2, 8, 98–100, 102, 114, 121, 122, 157
Amazing Colossal Man, The (1957) 21, 63, 64–67, 69, 70, 90, 120, 141, 157
American International Pictures 62, 75
Anaconda (1997) 16, 104, 112–114, 161
Anacondas: Hunt for the Blood Orchid (2004) 6–8, 20, 124
Animal Horror Cinema: Genre, History, and Criticism (2015) 3
Apocalypse Now (1979) 150
Arnold, Jack 59
Atlantic Rim (2013) 140
atom bomb 21, 48, 51, 54–55, 56, 57, 58, 59, 60, 62, 64, 68, 75, 85, 117–118, 146, 156

Attack of the 50 Foot Cheerleader (2012) 141
Attack of the 50 Foot Woman (1958) 3, 21, 63, 67–70, 138, 141, 157
Attack of the 60 Foot Centrefold (1995) 141
Attack of the Crab Monsters (1957) 21, 63, 73–74
Attack of the Giant Leeches (1959) 74–75
Avatar (2019) 17

Bakhtin, Mikhail 3, 155
 carnivalesque 3–5, 8, 9, 16, 19, 21, 22, 23, 25, 26, 29, 30, 31, 32, 36–37, 38, 43, 46, 47, 49–51, 54, 57, 60, 62, 63, 65, 69, 71, 73–74, 77–78, 79–80, 81, 83, 85–86, 88, 93, 95, 97, 99, 102, 104, 105, 106, 109–110, 111, 112, 114, 117–118, 119, 120, 121, 131, 132, 136, 137, 138, 141, 143, 149–150, 152, 153, 155, 157, 158, 160, 161
 grotesque body 37, 143
 Rabelais and His World (1965; 1984) 3–4
Beast from 20,000 Fathoms, The (1953) 2, 5, 11, 12, 14, 15, 21, 25, 47–51, 54, 55, 56, 57, 58, 59, 70, 156

Beginning of the End (1957) 63
Behemoth (2011) 140
Benshoff, Harry 11
Big Ass Spider! (2013) 3, 8–10
big bug cycle 22, 54–55, 63, 81, 85, 116, 117, 137
Black Scorpion, The (1957) 70, 71–72
Blob, The (1958) 63, 72–73, 87
Blob, The (1988) 101–102, 157
blue collar 10, 22, 78, 98, 99, 102, 157
B.O.B.'s Big Break (2009) 138
B.O.B.'s Super Freaky Job (2013) 138
Bonnie and Clyde (1967) 77
border transgression 6, 112, 114
Bullock, Paul 31
Burroughs, Edgar Rice 25

Carroll, Noel
 complex discovery plot 54
 fusion 16, 48
 magnification 16, 48
CGI 2, 14, 17, 22, 23, 83, 104, 105, 106–108, 109, 111, 112, 114, 117, 118, 120, 121, 122, 124, 125, 126–127, 129, 131, 132–134, 139, 141, 143, 157–158
Close Encounters of the Third Kind (1977) 84
Cloverfield (2008) 2, 6, 23, 134–137, 147, 148, 159
Cloverfield Paradox, The (2018) 135
Cohen, Jeffrey Jerome 6, 8, 20
Cohen, Larry 100
colonialism 18, 31, 32, 43, 64, 93, 113, 150
Colossal (2016) 152
Colossus, The 144
comedy 10, 21, 38–39, 40, 41, 88, 95, 103, 125
conformity, fears of 57, 72–73
Cooper, Merian C. 2, 25, 26, 32, 33, 35
Corman, Roger 73, 74, 85
Creature with the Atom Brain (1955) 58

Creed, Barbara 4, 69
 "Horror and the Carnivalesque: The Body Monstrous" 5
Cthulhu 160
Cyclops, The (1957) 63, 64

Dawn of the Monsters (2020) 160
Deadly Mantis, The (1957) 12, 70–71, 72
Deep Blue Sea (1999) 23, 110, 121, 124–125, 152, 161
Deep Rising (1998) 16, 23, 121–122, 124
Destroy All Monsters (1968) 144
destruction (urban) 5, 11–12, 26, 31, 37, 39, 40, 47, 54, 57–59, 69, 71, 105, 119, 120, 131, 134, 136, 143, 145, 146, 152, 153, 155, 156, 161
Dinocroc (2004) 140
Dinocroc versus Supergator (2010) 140
disaster movies 11–12, 80, 84, 114
Doyle, Arthur Conan 25
 The Lost World (1912) 27, 28, 30, 31
Dynamation 14

Earth vs the Flying Saucers (1956) 72
Easy Rider (1969) 77, 78
eco-horror *see* nature attacks subgenre
Eight Legged Freaks (2002) 3, 8, 16, 22, 23, 121, 124, 125–126, 158
Empire of the Ants (1977) 63
Environmental Protection Agency 81
Erb, Cynthia 2, 3, 5, 10, 11, 32, 33, 34, 36, 43, 45, 46, 47, 93, 134
Eye of the Beast (2007) 140

Food of the Gods, The (1976) 22, 89–91, 96, 157
found footage 135–136
franchising 129, 134
Frankenstein 11, 13, 62
Franzetta, Frank 17

GEM actors 113
gender stereotypes 103–104, 111, 123, 157
genetic engineering 110, 124
Ghostbusters (1984–) 85
Giant Claw, The (1957) 21, 70, 71–72, 83
Giant Gila Monster, The (1959) 11
Giant Spider Invasion, The (1975) 22, 87–88, 89, 90, 102, 125
Godfather, The (1972) 92
Godzilla/Gojira (1954) 1, 11, 12, 62, 81, 87, 118, 135
Godzilla (1998) 117–119, 120, 131, 147
Godzilla (2014) 23, 146, 147–148, 149, 158
Godzilla: King of the Monsters (2019) 23, 146, 149, 152–153
Godzilla vs Kong (2021) 2, 17–18, 146, 149, 153
Gordon, Bert I. 63, 64, 78, 90
Graduate, The (1967) 77, 78
Great Gatsby, The (1974) 92
Gremlins (1984) 125
Grizzly (1976) 22, 88–89, 96, 157
Grizzly II: Revenge (2020) 89

Harryhausen, Ray 14, 27, 33, 45, 47, 48, 49, 58, 59, 72, 80, 83, 104, 159
Hathaway, Liam 3
Heart of Darkness (1899) 131
Hollywood
 blockbuster cinema 13, 14, 80–81, 84, 85, 91, 105, 129
 criticism of 40, 151–152
 fiscal crisis 80
 new wave 77
 overseas markets 18
 representational prowess 13–14, 21, 34, 35, 54, 77, 83, 84, 105, 155
 shared universes 23, 146–147, 151, 158
horror genre 10–11, 71, 85, 89, 114, 136
hybridity 10, 84–85, 114, 159

imperialism *see* colonialism
Incredible Shrinking Man, The (1957) 65, 68
Independence Day (1996) 118
It Came from Beneath the Sea (1955) 6, 12, 14, 16, 21, 54, 57–59, 61, 63, 72, 156
It Came from Outer Space (1953) 102

Jack the Giant Slayer (2013) 141–143
Jancovich, Mark 53, 56, 57, 59, 63, 65, 66, 68, 69, 73, 140
Jaws (1975) 1, 11, 16, 22, 77, 78, 83, 84–87, 88, 89, 90, 91, 92, 94, 98, 102, 105, 106, 108, 135, 157
Jurassic Park (1993) 2, 12, 22, 105–111, 114, 117, 118, 119, 120, 124, 125, 131, 132, 133, 140, 158
Jurassic Park: Camp Cretaceous (2020–2022) 152
Jurassic World (2015) 151–152
Jurassic World: Fallen Kingdom (2018) 16–17, 140

kaiju 1, 11, 18–19, 143, 145, 146
Kaiju Wars (2022) 160
Keane, Stephen 11
King, Geoff 26
King Kong
 as giant 16
 as sympathetic 11, 85, 93, 95, 130, 133–134, 135, 156
King Kong (1933) 1, 5, 6, 11, 14, 15, 17, 21, 25, 26, 27, 32–38, 39, 40, 41, 42, 43, 45, 46, 48, 50, 54, 61, 63, 81, 86–87, 93, 95, 120, 130, 132, 135, 150
King Kong (1976) 2, 16, 22, 78, 83, 84, 91–95, 96, 108–109, 117, 130, 131, 157
King Kong (2005) 10, 11, 23, 130–134, 142, 158
King Kong Lives (1986) 95
King Kong vs Godzilla (1962) 77
King of Kings, The (1927) 34

King of the Monsters (1991) 160
Knight, Charles R. 30
Kong cycle 21, 53, 56, 57, 64, 66, 110, 156
Kong: King of the Apes (2016–2018) 161
Kong: Skull Island (2017) 6, 11, 23, 146, 148–151

Lake Placid (1999) 16, 122–123
Lord of the Rings, The (2001–2003) 134
Lost Continent (1951) 42
Lost World, The (1925) 2, 12, 13, 21, 25, 27–32, 33, 34, 36, 38, 39, 42, 61, 156
Lost World, The (1998) 109, 117
Love and Monsters (2020) 159
Luckhurst, Roger 12

Mathijs, Ernest and Jamie Sexton 4
Meg, The (2018) 124, 152
Mega Piranha (2010) 140
Mega Python versus Gatoroid (2011) 140
Mega Shark versus Crocosaurus (2010) 3, 140
Mega Shark versus Giant Octopus (2009) 20, 23, 139–141, 158
Mega Shark versus Kolossus (2015) 140
Mega Shark versus Mecha Shark (2014) 140
Megalodon (2018) 140
Mendik, Xavier and Steven J. Schneider 4, 5
Mighty Joe Young (1949) 14, 15, 21, 25, 43–47, 49, 156
Mighty Joe Young (1998) 119–120
Mimic (1997) 104, 110, 115–117, 124
Mimic 2 (2001) 124
Mimic 3: Sentinel (2003) 124
MONARCH: Legacy of Monsters (2023–) 161

Monster that Challenged the World, The (1957) 70
Monster Hunter (2004–) 160
Monster Hunter (2020) 160–161
Monsters (2010) 12, 140, 147, 152
Monsters vs Aliens (2009) 23, 137–139
Monsterverse 23, 140, 146–151, 158, 159, 161
Mothra (1961) 77
Mustachio, Camille D. G. and Jason Barr, definitions of *kaiju* movies 1, 3
Mutant Pumpkins from Outer Space (2009) 138
Mysterious Island (1961) 80

nature attacks subgenre 11–12, 22, 46, 81–83, 90–91, 92–93, 96–97, 111, 119, 157, 159
Nietzsche, Friedrich 19, 20
Night of the Lepus (1972) 77, 81–83, 88, 96, 157
Night of the Living Carrots (2011) 138
Notzilla (2020) 3
nuclear power *see* atom bomb
Nutty Professor, The (1996) 141

O'Brien, Willis 13, 27, 28, 35, 43, 49, 72
O'Selznick, David 26
Omen, The (1976) 97
One Million B.C. (1940) 41–42

Pacific Rim (2013) 18, 23, 143–146, 147, 148, 159
Pacific Rim: The Black (2021–2022) 161
paracinema 23, 114, 120–121, 139, 140, 146, 158
Paramount Consent Decree 54, 62, 157
parody 3, 22, 23, 39, 112, 139, 158, 159

INDEX

perceptual realism 22, 83, 106, 118, 125, 140, 158
Planet of the Apes (1968) 80
Platoon (1986) 150
Poseidon Adventure, The (1972) 80
Prophecy (1979) 22, 78, 83, 84, 96–97, 157

Q: The Winged Serpent (1982) 2, 16, 100, 157

radioactivity *see* atom bomb
Rampage (1986) 160
Rampage (2018) 14–15
'Reaganomics' 98
Reign of Fire (2002) 19–20
Relic, The (1997) 6, 16, 104, 110, 114–115, 116

science fiction 12–13, 80, 114
Scoedsack, Ernest B. 2, 32, 33
Sea Beast, The (2022) 161
self-reflexivity 5, 8, 21, 22, 23, 26, 33, 36–38, 39, 43–46, 66, 67, 87, 90, 102, 110, 112, 119, 121, 132, 144, 146, 149, 156, 158
Se7en (1995) 115
Sharknado series (2013–2018) 124, 139
Silent Spring (1962) 91
slasher *see* horror genre
Son of Kong (1933) 25, 38–41, 42, 44, 46, 63, 95, 102, 156
Sontag, Susan 12–13
special effects *see* visual effects
Spielberg, Steven 22, 78, 84, 85, 88, 105, 106, 108, 109, 111, 117, 158
Stam, Robert 4–5, 86
Star Wars (1977–) 17, 84, 85
Steiner, Max 33–34
Stephens, Walter 26
Stewart, Susan 16
stop-motion 13, 27, 35, 36, 40, 43, 44, 48, 58, 71, 83, 94, 134
streaming 161

sublime 145, 160
subversiveness 5–6, 8, 19, 21, 26, 27, 31–32, 33, 36–38, 54–55, 62, 77, 98–100, 101–102, 119, 122, 124, 137, 149, 155, 156, 160, 161
Supergator (2007) 140

Tarantula (1955) 11, 12, 21, 54, 59–62, 63, 65, 87, 102, 125, 156
The Asylum 20, 72, 112, 139, 158
Them! 1, 2, 11, 12, 15, 16, 21, 54, 55–57, 59, 70, 72, 156
Toho 2, 13, 62, 75, 117
Towering Inferno, The (1974) 80
Transmedia 138
Tremors (1990) 10, 16, 102–104, 111, 119, 121, 125, 157
Tremors 2: Aftershocks (1996) 124
Tremors 3: Back to Perfection (2001) 124
Tremors 4: The Legend Begins (2004) 124
Troma 5
Tsutsui, William 1, 62
Turner, Terry 15–16
Two Lost Worlds (1950) 42

Ultraman series 144
Underwater (2020) 159–160
Unknown Island (1948) 42–43

Valley of Gwangi (1969) 80
Verne, Jules 25
Village of the Giants (1965) 63, 77, 78–80, 90, 157
visual effects 13–14, 21, 56, 61–62, 63, 71–72, 73, 118–119, 123, 126–127, 131–133, 153, 155–156
 bad effects 72, 73, 75, 83, 93–94, 96, 157
 motion capture 134, 141–142
 spectacular vistas 17, 134
 transitional period 83–84

War of the Colossal Beast (1958) n67
Wells, H. G. 78, 90
Winston, Stan 108

Wisker, Gina 5
Wood, Robin 6, 11

Yacowar, Maurice 11–12, 83

Printed and bound by CPI Group (UK) Ltd, Croydon, CR0 4YY